pop brands

mediated
youth

Sharon R. Mazzarella
General Editor

Vol. 11

PETER LANG
New York • Washington, D.C./Baltimore • Bern
Frankfurt • Berlin • Brussels • Vienna • Oxford

NICHOLAS CARAH

pop brands

branding, popular music, and young people

PETER LANG
New York • Washington, D.C./Baltimore • Bern
Frankfurt • Berlin • Brussels • Vienna • Oxford

Library of Congress Cataloging-in-Publication Data

Carah, Nicholas.
Pop brands: branding, popular music, and young people /
Nicholas Carah.
p. cm. – (Mediated youth; v. 11)
Includes bibliographical references and index.
1. Music and youth—Social aspects. 2. Mass media and youth.
3. Branding (Marketing)—Social aspects. 4. Popular music—
Social aspects. I. Title.
HQ799.2.M35C36 302.230835—dc22 2009038353
ISBN 978-1-4331-0564-7 (hardcover)
ISBN 978-1-4331-0565-4 (paperback)
ISSN 1555-1814

Bibliographic information published by **Die Deutsche Nationalbibliothek**.
Die Deutsche Nationalbibliothek lists this publication in the "Deutsche
Nationalbibliografie"; detailed bibliographic data is available
on the Internet at http://dnb.d-nb.de/.

Cover photo taken by the author

The paper in this book meets the guidelines for permanence and durability
of the Committee on Production Guidelines for Book Longevity
of the Council of Library Resources.

© 2010 Peter Lang Publishing, Inc., New York
29 Broadway, 18th floor, New York, NY 10006
www.peterlang.com

Printed in the United States of America

For Nicola

Contents

Acknowledgments

This book began life as a series of questions I had about popular culture and marketing. As I've grappled with the ideas in this book, attempted to figure out the right questions to ask and tried to find the most rewarding pathways I've been very fortunate to be given advice from my advisors, colleagues and friends. In particular, I owe much to Eric Louw and Zala Volcic. As advisors on my PhD project, and then as colleagues, thank you both for the many conversations we've had, and advice you've shared, as I've developed this project. Mark Andrejevic has also been very generous reading and discussing arguments and ideas over the past few years. Our informal reading group, together with Lincoln Dahlberg and Giles Dodson, was a great space to think through key issues and ideas in communications and cultural fields. I am also grateful to Lynn Schofield-Clark for her extensive insight into my dissertation which helped to extend several of the ideas and arguments in this book.

I am very thankful to Sharon Mazzarella who first invited me to develop a book for the Mediated Youth series. Sharon has provided me with advice and direction throughout the process of developing my research project into a book. Mary Savigar and Sophie Appel at Peter Lang have also been very helpful in editing and getting the manuscript ready for publication. Big thanks must also go to Eileen Glass and Ian Carah for reading the first drafts of the manuscript. And, thanks to Matthew Petersen for helping out with images and production of the manuscript.

I am also grateful to Virgin Mobile Australia for granting permission to reprint an excerpt from their Right Music Wrongs campaign by Stig Richards at Thought by Them.

Thanks must also go to the folks who work and play in the cultural spaces I explore in this book. I'm grateful for their time and insight in illuminating their social world and their role in creating it.

And finally, much love to Nicola who is a constant source of fun, action and much needed perspective. Here's to more good times.

Preface

Studying brands in culture

Contemporary accounts of branding emphasize the productive activity undertaken by consumers and citizens in the construction of brand meaning and value. In this book I explore the interconnections between young people, popular music and corporate brand-building. These intersections unfold in both physical and mediated social space.

This book is organized into three main parts. The first chapter examines different approaches to conceptualizing and studying brand-building. I engage with both strategic accounts of brand-building and critical accounts of the impact of branding on social life in order to explore the contradictions and paradoxes of the relationship between branding and social life. The middle of the book, from chapter two to chapter five, studies the productive brand-building activity of young people, musicians and other participants in the culture industry. The final three chapters explore the social narratives of brands in a savvy and reflexive popular culture.

Examining brand-building labor raises questions about the flexible, interactive and participatory nature of mediated social life. While brands (with their strategic interests) argue that experiential branding empowers consumers and citizens, critics question the extent of this empowerment. The relationship between strategic and critical accounts of mediated social life serves as a key prism for conceptualizing how people make sense of and act in a mediated social world. Savvy participants reflexively negotiate between these discourses in order to avoid being a passive dupe.

When I first began exploring the interaction between corporate branding practices and popular music culture in 2003, I followed street teams within a straight-edge hardcore music scene. Street teams are a marketing practice whereby corporations, through local marketing agencies, recruit young people in subcultural groups and give them branded merchandise and promotional items to distribute in their peer networks. The items include stickers, CDs, DVDs, magazines, t-shirts, event tickets and other products. In the local culture I was exploring, street teams were closely connected with hardcore bands. Both bands and corporations used street teams to promote themselves. Street teams performed a kind of labor for the bands and corporations they distributed material for. This labor was both material and immaterial. It involved the material distribution of promo-

tional items. But more significantly, the real value for corporations, and the reason they wanted young people to do this brand-building work in local cultural spaces, was the taste and meaning-making resources they brought to the role of a street teamer. They had the right cultural capital to embed brands deeply within social space. Many of the street teamers didn't necessarily see their activity as unpaid labor though. They felt rewarded for their actions in terms of status, merchandise and access to gigs and events that came with being in a street team.

As I examined street teams, spent time at the hardcore night clubs they were connected to and spoke with street team members I began to realize there were at least two ways through which I could think about what they were doing. I could consider it from a strategic perspective and evaluate it as a new form of brand-building. If I chose to do this I would consider how effective street teams were at creating brand value for corporations. I could however, also consider street teams from a critical perspective. If I chose to do this I would consider how branding programs like street teaming commodify and commercialize social life. It became apparent that the two approaches were fundamentally different.

The difference between the two approaches is essentially that a critical approach to branding examines marketing and culture within its social, historical and economic context. In contrast, a strategic approach serves the instrumental goals of corporations. The strategic perspective has no real questions about capitalism as a social system, whereas the critical perspective does. The strategic mindset wants to work out how to play the game better; the critical mindset wants to question the rules of the game. This difference has persisted since the beginning of mass communications research (Smythe and Dinh, 1983). To marketers, branded social spaces are just a new and efficient form of brand-building. But to critics, they are the outcome of the historical and spatial transformations of our social world caused by capital.

Capital has profoundly changed the spatial organization of our social world (Harvey, 2000, 2001; Lefebvre, 1991). The emergence of capital as a social and economic system drove the colonization of the developing world since the Industrial Revolution. It reordered space by building large urban cities with their mix of residential and industrial space. Capital drove the development of transport infrastructure such as railways, roads and air travel. It has been instrumental in the development of communications infrastructure such as telephone, cable and satellites that underpins the information society (Giddens,

1990; Harvey 1989, 2003; Jameson 1991; 1998; Schiller, 1999; Thompson, 1995). Experiential branding is a new strategy for capital accumulation, but it is also situated historically within capital's accumula-accumulation of physical, mediated and social space. Brands are developed in physical retail spaces, clubs and music festivals. They are also constructed through interactive websites, social networking sites and other forms of media production. Branding entwines the physical and mediated production of space.

In the first chapter I engage with multiple approaches to young people, popular culture and branding. I draw on cultural and media studies, marketing and branding literature, critical theory (including contemporary critiques of branding and audience labor) and the political economy of communications. These perspectives serve as a theoretical framework to critically engage with empirical material collected through ethnographic fieldwork between 2005 and 2009. The ethnographic approach engages participant-observation at live music events, retail spaces and online, analysis of cultural and branded texts (print, broadcast and online), and interviews with young media-makers, music fans, musicians, culture industry workers and brand builders at global corporations.

I trace the intersections between corporations, popular music culture and young people. They intersect in highly regulated, physical and mediated social spaces. Spaces like corporate websites and music events are publicly accessible but privately owned and operated. The social action occurring in these spaces is contingent upon the communicative architecture of the space. Following a contemporary ethnographic method I aim to demonstrate the 'relationship between forms of heterogeneous action rather than trying to identify and explore culture as a whole' (Silverman, 2004, p. 9). I take a critical, interpretive and reflexive stance to these social spaces, paying attention to how they are constructed and how participants engage with them.

Taste, meaning and media making

From chapters two through to five I explore the interaction between young people and corporate brand-building through several branding programs. I examine the productive activity of young people who embed brands and their narratives within popular culture. In the second chapter I examine the manifestos and mythologies of authentic popular music that corporations engage with. I explore how young music fans relate to the claims corporations make about live music and authenticity. I illustrate how young people's taste and meaning-

making practices constitute a form of affective labor that builds brand value. Corporations harness the taste-making practices of young music fans in the process of building valuable brands. In the second and third chapters I draw on fieldwork from two branded music events: Coca-Cola's Coke Live and Virgin's V festival.

Coca-Cola ran Coke Live in Australia between 2004 and 2006. Coke Live was a marketing communications program that engaged with Australia's live music culture. The program comprised the largest all-ages music tour in Australia, an interactive multimedia website, programs supporting independent bands and musicians, music television and print and TV advertising. The two most significant elements of Coke Live in Australia were the interactive website and the all-ages music event. Young music fans had to use the interactive website to accumulate rewards points that they could then spend to secure tickets to the all-ages music festival. Tickets to the festival had to be purchased with rewards points. The points could only be accumulated online by entering the barcodes off Coke bottles or by entering social, cultural and demographic data. The more personal details participants logged on the site the more points they accumulated. The all-ages tour was the largest of its kind in Australia, for many young people it was the easiest way for them to see their favorite pop bands perform live. The performances by bands were interwoven with branded content on big screens, endorsements of Coca-Cola by celebrities, filmed trips to meet the bands backstage and promotional events for Coke Live partners (like XBOX and Motorola). Similar variations of Coke Live have been run in other national markets in the past five years including the United States, several nations in Europe and the Middle East, New Zealand and Asia-Pacific. Each local version was adapted to local cultural tastes and media practices. Coke Live integrates traditional branding methods like advertising with experiential branding techniques. Coke Live illustrates how brands are socially and experientially constructed through the activity of marketers, musicians and young music fans.

The V festival is a live music festival run by Virgin (and other corporate partners) in Australia (since 2007), the United Kingdom, United States, Canada and other nations. Like Coke Live the V festival is supported by a website with a mix of branded and popular music content. Prior to the festival the V festival website releases exclusive content, podcasts and vodcasts. As part of the 2009 festival Virgin also staged a Right Music Wrongs campaign where they asked music fans to vote Vanilla Ice 'guilty' or 'innocent' of crimes against music. Virgin use their website to collect information off their audience (through

email lists and audience surveys) and engage them in savvy taste-making practices. Through Right Music Wrongs the audience was encouraged to nominate examples of 'musical wrongs,' discuss the nominations, and to post their own comments and questions about the V festival. The V festival is staged in a similar fashion to other live music events. Music fans buy tickets for cash and are largely enticed to the festival by the chance to see their favorite bands live. There are a few key elements of the festival that distinguish it from other live music events: the festival site features many Virgin logos and installations, the selection of bands reflects niche musical tastes that appear to target an adopter market, the festival promotes cell phone and digital camera use, and Virgin Mobile customers get treated like celebrity VIPs (access to special bars, hair and make-up services, and toilets). Where Coke Live offered pious and sincere manifestos of support for authentic popular music, the V festival undertakes a more reflexive and nuanced engagement with young music fans and their meaning-making practices.

In the third chapter I illustrate how young music fans' meaning- and taste-making practices are connected with their media-making activities. Young people produce both individual brands and a social context for the practice of branding. The labor of brand-building involves both producing affect (taste, meaning, authenticity and enjoyment) and information commodities. The central point around which young people's meaning- and media-making practices unfold is the live performance of popular music. Young people at music festivals participate in the mediation of the live performance and its articulation with corporate brands.

The centrality of the live performance to mediation and brand-building leads, in the fourth chapter, to an examination of the role that musicians undertake in the construction of valuable brands. The period in which this research was conducted is marked by fundamental and rapid change in the music industry. The decline of the traditional record business has diminished the importance of the musical recording as a commodity and increased the importance of musicians and their live performances as commodities that validate commodified social spaces (Connolly and Krueger, 2006). If young people won't buy musical recordings, then corporations need to find more efficient ways of commodifying popular music.

In a rapidly changing music industry, bands and musicians find that they no longer just commodify their musical recordings. They also earn an income by connecting their image, meanings, values, and performances to corporate brand-building activities. Throughout this

chapter I draw on observation of branded live music events and pro-grams and interviews with the musicians involved. I attempt to tra-verse the contested terrain of being an authentic musician working within a thoroughly commodified social world. To illustrate these con-tested negotiations between brands and bands I talk with musicians involved in branding programs run by Coca-Cola, Virgin, Jack Da-niel's, Tooheys beer and Jagermeister liqueur. Of these programs, I engage in depth with Tooheys' Uncharted and Jagermeister's Jager Uprising. These two programs are emblematic of other branding pro-grams that engage 'unsigned' or up-and-coming bands and musicians (examples of similar programs include Virgin's Garage2V, Jack Da-niel's JD Set, V energy drink's Local Produce, and Nokia's Connecting Beats).

The Jager Uprising was run by Jagermeister in Australia in 2005 and 2006. The program gave local indie bands the chance to perform live in local music venues. The program attempted to engage with tas-temakers in local music scenes in Australia's capital cities. Bands played the Jager Uprising gigs for guaranteed positive coverage in the local street press, the chance to play in a good venue in the city's local scene and to win time in a recording studio. Jagermeister's strategy was aimed at local indie music aficionados, who are perceived to be influential in the local music and bar scene. Jager Uprising was a lo-cal adaptation of a program Jagermeister has run for many years in hard rock cultures in the USA. The Australian distributors were told to adapt the USA strategy for the Australian market.

Where Jagermeister's focus was local, Toohey's is national. Too-heys Uncharted is a program whereby unsigned bands compete to win a band development package that includes a record deal, a spot on a major music festival and national media exposure. Bands enter the competition with a demo that is showcased on the Uncharted website. From there bands are selected for the finals, where they spend time with industry insiders who give them advice, and perform at a show-case gig in an inner city venue, before one band is selected as the winner of the band development package. Both Tooheys and Jager-meister promote their programs as a socially responsible investment in the Australian music scene. One of the festivals that bands who win Uncharted get the chance to tour on is the Big Day Out. In both Jager Uprising and Tooheys Uncharted musicians contribute their performances and taste-making practices to the brand in exchange for access to media and exclusive zones of production in the culture in-dustry (venues, festivals, recording studios, and industry executives).

In chapter four I examine musicians who participate in brand-building programs in the hope of getting exposure and access to the closed zones of production of the culture industry. In chapter five I move to examine young media makers who are recruited into brand-building programs. I focus on young music fans who participated in HP's Go Live branding program. Go Live offered a young music fan the chance to go backstage to interview bands and report on the action at the Big Day Out. HP's Go Live was one of many partnerships developed between the Big Day Out and corporate brands (Virgin, Converse, V energy drink, Durex, Le Specs, Sony Ericsson, Lipton, Phillips, Jack Daniel's and Tooheys have all had branding partnerships with the Big Day Out in recent years). The development of the Big Day Out helps to illustrate the growing interconnection between branding and popular music culture. Since beginning in 1992, the Big Day Out has become Australia's largest summer music festival. The festival acquired much of its cultural capital by emerging alongside the explosion of 'alternative' music. The Big Day Out has successfully integrated this history into its creation myth and brand value. Since the festival began in 1992 it hasn't only made money from selling over 2 million tickets,[1] it has also made money by selling its audience as a captive group of young people who are influential in their peer networks. The 'media rights' to the Big Day Out are managed by the experiential marketing firm Peer Group Media. Their audience offers a unique value proposition for corporate partners. Music festivals, like traditional media businesses, produce audiences for sale (Smythe, 1981). The advantage they have over the traditional media business is a capacity to integrate multiple media channels and social spaces around the enjoyment of popular music culture. Experiential branding leverages the latent surplus value in popular music festivals like the Big Day Out. For many years the Big Day Out audience was an underperforming asset, by putting the audience to work performing valuable brand-building labor they 'unlock' their latent value.

Like the music fans at Coke Live and the V festival, the participants in the HP Go Live program offer their taste, meaning- and media-making practices to the brand. In distinction to the music fans in chapters two and three, these participants however see their labor for the brand as a form of cultural work where they are paid in opportunities and experience that they hope will pay off in the future. They hope to one day 'make it' in the creative and cultural industries and feel that brand-building labor is one way to acculturate themselves, meet the right people and get access to the right spaces. To them, offering their cultural capital to the brand helps them to build their own

cultural capital. I move, in chapter six, to consider how these young people who undertake the labor of building particular brands also produce branding as a holistic social and political logic. Their work creates the branded social world within which brands thrive. As these activities unfold, brands get articulated with, and play an active role in shaping, social, cultural, political and ethical discourses. Branding becomes a prism through which young people envision their participation in the social world.

The social narratives of brands

Throughout this book I emphasize the social activity of brand-building. Brands aren't inert logos, they are the product of constantly evolving social relations. From a strategic perspective brands are most valuable when they aren't offered as 'cultural blueprints but as cultural resources, as useful ingredients to the production of the self' (Holt, 2002, p. 82). One of the narratives of contemporary life I aim to unpack in this book is the assumption that in an interactive media culture, brands that open themselves up to constant consumer innovation thrive; they both become more valuable and engender more progressive and empowering politics and social relations. The social lives of brands are more messy and complex than they first appear.

To accommodate savvy consumers and a social world with contradictory and competing interests, brands take up a variety of techniques. Holt (2002) aptly overviews these techniques; he argues that brands develop ironic and reflexive persona. They distance themselves from overt attempts at persuasion. By appearing disinterested brands authentically engage with social life. They coattail on what Holt (2002) calls cultural epicenters, weaving themselves into expressive cultural spaces and communities. They engage with and create origin myths. Adidas was there at the birth of hip-hop; Virgin was there when punk music emerged; Jack Daniel's articulates itself with southern American music traditions. Brands partner up with taste makers (young music fans, musicians and culture industry workers) who embed the brand within social life.

Brands that attempt to engage with the social world in an authentic and disinterested manner strike several contradictions (Holt, 2002). Throughout the book I attempt to illuminate these contradictions and the ways in which they are significant from both strategic and critical points of view. Brands find that consumers are increasingly skeptical of their contrived ironic distance. Consumers counter brands' irony with their own irony and cynicism. As brands engage

with origin myths and cultural spaces, they unintentionally alter the way authenticity works within popular culture. Where it was once pious and sincere, it becomes slippery, distant and ironic.

Experiential branding is the corporate response to a series of changes over the past generation (economic, political, social, cultural, and technological). In responding to these challenges experiential branding has bred its own internal contradictions. Brands need to appear disinterested, when they plainly aren't. Brands want to appear authentic, yet notions of authenticity in a commodified popular culture are fundamentally contrived. Brands want to be seen as good corporate citizens, yet there are significant gaps between the brand's rhetoric and the corporate mode of production. Brands want consumers to be active meaning makers in the branding project but find that consumers can take the brand in unspecified directions or place harsh demands on it. This poses both strategic questions for marketers and critical philosophical and political questions for theorists and critics of branding.

Holt (2002, p. 89) echoes other theories of branding (cf. Arvidsson, 2005; Firat and Dholakia, 1998; Hearn, 2008; Thompson and Coskuner-Balli, 2007; Zwick and Knott, 2009) in concluding that the market:

> thrives on...unruly bricoleurs who engage in nonconformist producerly consumption practices. Since the market feeds off of the constant production of difference, the most creative, unorthodox, singularising consumer sovereignty practices are the most productive for the system. They serve as grist for the branding mill that is ever in search of new cultural materials.

Marketers would see Holt's conclusion as a strategic issue. At the same time that experiential branding effectively harnesses the labor of consumers through their meaning-making practices, it also opens itself up to the possibility that consumers may drive the brand in unspecified directions and make challenging demands on the corporation.

Marketers need to strategically develop experiential branding programs that effectively harness consumers' and other taste and meaning makers' labor at the same time they effectively control the brand-building process. This is why I use the term brandscape throughout this book. Although this term is used only in the cultural marketing and critical branding literature (Goldman and Papson, 2006; Sherry, 1998; Thompson and Arsel, 2004), it effectively captures the strategic logic of experiential branding: corporate branding is about facilitating a social space that produces profitable brands,

which involves engaging the right taste and meaning makers, giving them the right cultural resources, and controlling the production of meanings. Global network capitalism is characterized by just-in-time factories that reflexively respond to new production demands (Lash and Urry, 1994; Louw, 2001). The brandscape fits within this logic; it is a reflexive social space that produces profitable brands by constantly adapting to market change.

Critics of branding would see Holt's (2002) conclusion as reflective of an intensification of capital's penetration of social space and life. They would dispute the 'liberatory' claims of marketers like Firat and Venkatesh (1998). Where marketers see consumers actively producing meaning and authentic brands, critics see this as part of capital's accumulation of social space. To critics, consumer activity and empowerment are really just free labor given to corporations as part of a thoroughly commodified social life.

In chapter six I examine the narratives of social responsibility that brands craft and the savvy responses to those narratives from young music fans. I organize this exploration around two installations at Virgin's V festival, one a public safety campaign to curb drunken violence and another a stealthy linking of cigarettes and popular music. In each of these instances I examine how brands are subtly woven into social life. The exploration of multiple brand-building activities and spaces and the narratives of social responsibility that brands craft leads, in chapter seven, to a consideration of the role marketers play in building profitable brands.

In chapter seven I draw on interviews with marketers involved in experiential branding to articulate two important and contradictory themes. Marketers construct an emphatic narrative that experiential branding and branded social space empowers consumers like never before, enabling them to direct the brand-building action and make the key decisions about brand values and the role of brands in social life. This narrative of empowerment is premised on consumer activity in branded social spaces that generates unprecedented data about social life. The interactive and mediated nature of branded social spaces enables marketers to develop sophisticated return on investment mechanisms. At the very moment when brands claim to radically empower consumers, they also exploit their labor and social world more efficiently than ever before.

The final chapter of the book links the narratives that are emerging around experiential branding with similar discourses regarding interactive media, web 2.0, blogging, citizen-journalism and other participatory projects in a wired society. I view these narratives of partic-

ipation and empowerment in light of contemporary critical political theories of identity politics and labor. I ask how productive ironic and cynical participation in a branded social world is. I argue that the most troublesome aspect of a branded social world appears to be its incapacity to reflect on the practices of branding, and acknowledge their limitations. This inability to be self-reflective inhibits participants from imagining fundamentally different political and social formations. Young people are very 'skilled' brand builders. They even thoroughly enjoy brand-building (though they might also see right through it). In all their feverish meaning- and media-making action though, are they being ensconced in a social world that obfuscates its material reality? Brands might offer young people resources to build a 'self' of their choice, but what of the political (not to mention social, cultural and ecological) world that self lives in?

Chapter One

'Money and TV destroyed this thing!':
Mediated Youth, Popular Music and the Brandscape

'Money and TV destroyed this thing!'

In 2006, Iggy & The Stooges took to the main stage of Australia's Big Day Out summer music festival and unleashed an authentic blast of original garage rock. Iggy Pop, dubbed by the music press as the Godfather of Punk, implored the audience to get up on stage. 'Fuck security!' he screamed, 'Get up here!' Security resisted. Iggy became agitated about the regulation of the event and the passivity of the crowd. 'Money and TV destroyed this thing!' he growled at the crowd.

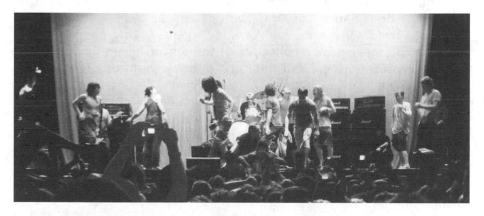

Iggy & The Stooges performing at the 2006 Big Day Out. Note the raised cameras in the audience capturing the action as Iggy leans over the front of stage into the crowd, while audience members he has invited on stage dance around him. Photo: Nicholas Carah.

Iggy's claim points to a paradox at the heart of popular culture. Money and TV arguably created popular music. Popular music, as we know it, has always been a commercial product. Yet, popular musicians and audiences retain a sense of authenticity and realness within their experiences of popular culture. Iggy Pop offers an example of a

pop music performer that audiences take to be original and authentic. In the 1970s he was legendary for incendiary and raw performances characterized by wild stage antics, self-mutilation and excessive volume. Iggy Pop & The Stooges are a building block in punk music's foundational myth. They are connected with the emergence of punk music in New York clubs like CBGB. These significant myths are mobilized in the commodification of popular music.

Popular music, as we have known it since the middle of last century, is a product of the culture industry (Adorno and Horkheimer, 1997). By examining the relationship between popular music and corporate branding I explore how the industrial production of culture influences social, cultural and political life. I begin this analysis with two interconnected questions. Firstly, how does popular music come to be authentic and meaningful to audiences? And secondly, how is popular music deployed to build profitable corporate brands? With these two questions I set out to examine how the culture industry functions in the context of contemporary popular music, web 2.0, cell phones, digital cameras, and corporate involvement in our social world.

This book explores how brands are created as a series of social relations. At first glance, corporate brands appear to be created within corporate head offices and advertising agencies and then disseminated to the market as a collection of influential meanings. At least, this is how corporations and their critics have traditionally conceived of advertising and marketing. In recent years, corporations, citizens and critics have realized that brand creation isn't simply a linear one-way communications exchange. Brands are mobile, reflexive and adaptable objects that enable corporations to accumulate capital. They are not simply monolithic monologues. Instead, they unfold within social space. The intersection between popular music and branding provides a vibrant social space to explore contemporary brand-building.[1]

Market researchers and social commentators pontificate that 'Generation Y' or the 'youth market' is too savvy for traditional corporate branding. They reject 'interruption' marketing like broadcast advertising. Instead, they seek out corporate brands that they take to be 'real' and 'authentic.' Rather than bombard them with persuasive messages, corporations need to naturally and organically integrate into their lifestyle. Adam Zammit of Peer Group Media, a communications agency that holds the commercial rights for several Australian music festivals, exemplifies this conception of young people. He claims

that corporations need to find relevant roles within the social lives of young people. To his mind, '(music) festivals continue to offer a real bear-hug opportunity, a genuine tactile exchange, but in stepping into that relationship brands need to create a real role for themselves.'[2]

Iggy Pop's performance at the Big Day Out was surrounded by branded spaces created by Peer Group Media. In these spaces corporations set out to meaningfully 'bear hug' the youth market as part of their experience of popular music culture. The Virgin Mobile Recharge Zone, V Energy Drink Mist Tent, Tooheys Extra Dry Snowdome, Duracell Water Tanks, and HP Go Live pavilion all provided spaces where festival goers relaxed, cooled down, and enjoyed themselves within a branded space. In each of these spaces the audience was invited to interact with a corporate brand as part of their music festival experience. Young people's enjoyment of the music festival built brand equity for global corporations. Music fans play a vital role in bringing corporate brands to life.

Douglas Rushkoff examined how corporations came to be intimately involved in popular music culture in his film *The Merchants of Cool*.[3] In the mid-1990s corporations recognized that young people were cynical about celebrity endorsements. Sprite embraced this cynicism. They launched an advertising campaign in which celebrities visibly accepted large sums of money to endorse the soft drink. Sprite effectively said, 'You think corporations are fakes and liars? Well, we think corporations are fakes and liars too!' Young people quickly grew tired of this cynical anti-marketing marketing. Sprite, like many of the corporations I examine in this book moved toward developing 'credible' and 'authentic' relationships with popular musicians and young people. Corporate involvement in social spaces like music festivals is presented to young people as inherently authentic and empowering. Corporations set out to support the popular music culture that young people find real and authentic. The corporations at the Big Day Out say, 'You like Iggy Pop? Well, we like Iggy Pop too!' Corporations have become savvy at embedding themselves within social space. Young people are adept at recognizing corporate involvement in their culture and are cynical about corporate claims to authenticity. Ultimately though, it doesn't matter what young people think about branding. Brands are brought to life through social action, not necessarily through what young people think about them.

In cultural brand-building, popular musicians play the important role of being the *real thing*. Performers like Iggy Pop validate the Big Day Out as an authentic space. Once validated by the performance of

authentic popular music, corporations can use the Big Day Out to imbue their brands with similar authentic meanings and values. The brands at the Big Day Out are both parasites that feed off the authentic energy of popular music and proselytes that zealously defend the meaningful cultural myths that they seek to harness (Holt, 2006).

Originally, brands were a trademark attached to a product that communicated value to consumers. In contemporary culture, brands are embedded within social relations. They specify particular lifestyles and contexts of consumption. Brands become valuable through the social actions of consumers. A corporation can create an advertising campaign attributing particular meanings and values to a brand, but those meanings and values only become 'real' once consumers validate them through their social actions. Jack Daniel's Whiskey claims in its brand mythology to be the drink of choice for rock musicians. This claim is only made meaningful by hard-rocking musicians who drink Jack Daniel's. Zizek (1989, p. 106) illustrates this point clearly in his description of the Marlboro brand. While the brand connotes American myths (cowboys and prairies), 'it does not become meaningful until "real" Americans start to identify themselves (in their ideological self-experience) with the image created by the Marlboro advertisement—until America itself is experienced as Marlboro country.' Brands are 'open ended objects' brought to life via consumer action (Arvidsson, 2005; Lury, 2004).

Brands are at the centre of corporate business strategy. They are assets to be managed (Aaker, 1991, 1996). Brand loyalty reduces the cost of keeping old customers and attracting new ones. Brand awareness makes brands present in the social world and imagination of consumers and citizens. Perceptions of quality and associations customers and the public make with brands increase their likelihood of purchasing products and services and integrating the brand into their life and identity. Increasingly, brand equity is crafted through building brand identities and personalities that come alive within social space and the imagination of consumers (Aaker, 1996; Holt, 2004). Iconic brands speak for whole corporations (particular organizations of capital accumulation) rather than individual commodities. The commodity (and its real mode of production) is 'absent' from the brand (Goldman and Papson, 1999, p, 19).

Through consumers brands can take on a life of their own and acquire unintended meanings. Corporations cannot exactly specify what a brand means, even though they might try. In contemporary society corporations turn toward managing the cultural, social and political

spaces within which brands are constructed. Corporate brands aren't just visual logos. They are 'resources that generate value' for corporations by managing the spaces within which consumers and citizens construct meaning (Arvidsson, 2005, p. 238).

Rather than focus solely on brands, I examine social spaces within which brands are created. Popular music culture spaces like the Big Day Out can be thought of as brandscapes (Sherry, 1998; Goldman and Papson, 2006; Thompson and Arsel, 2004). Brandscapes are cultural spaces where corporate brands are built experientially by consumers and corporations (Ponsoby-McCabe and Boyle, 2006). In the brandscape, popular music and corporate brands are symbiotically created in ways that young people find authentic, enjoyable and empowering. The experiential construction of brands has strategic implications for the way that corporations and marketers build brands. They construct branding campaigns that integrate with popular culture practices and spaces. These brand-building practices also have implications for the way that citizens understand how brand-building shapes popular culture, society and politics. The brand is an open, reflexive and living object within popular culture.

I approach branding through two lenses: strategic and critical. Throughout this book, by *strategic* I mean the instrumental approach of marketers whose intention is to accumulate capital by developing efficient and effective brand-building apparatuses. By *critical* I mean the examination of the social relations and conditions of production inherent in brand-building practices. From a critical perspective I examine the way in which dominant groups (like corporations and marketers) craft particular spaces that obfuscate the uneven power relationships involved in the accumulation of capital. I introduce both of these perspectives here to situate them within their differing historical trajectories. These different trajectories help to explain and explore the contested nature of contemporary communications, media and popular culture.

A brief history of marketing and branding

To understand branding we need to examine how marketing developed as a system for thinking about and acting in the world. Marketing emerged from the profound impact that the Industrial Revolution had on economic, social, cultural and political structures (Bartels, 1976; Kitchen, 2003; McQuire, 2008; Shaw and Jones, 2005). Marketing is an instrumental way of organizing social exchanges around the

buying and selling of commodities. The industrial production of commodities required a system that stimulated demand for products and developed consumption-oriented lifestyles. Early forms of marketing communication such as advertising played an important role in the development of modern urban life (McQuire, 2008).

Marketing is an instrumental and strategic mode of acting and thinking. Marketers set out to effect change in the world. They set out to make people behave in particular ways in order to serve the strategic goals of corporations (Kitchen, 2003; Mickelthwaite and Wooldridge, 2003; Sheth et al., 1988; Wilkie and Moore, 2003). Modern marketing developed in the early 1900s from the rational scientific management paradigms of the time. Following World War II marketing developed rapidly, coinciding with the economic and population growth that fuelled the development of demand-generating strategies and a mass consumer market (Shaw and Jones, 2005; Wilkie and Moore, 2003). During this period the practices and theories of marketing management developed (Kotler, 2000). Key marketers emerged who developed frameworks for segmenting, targeting and positioning products in the marketplace (Halbert, 1964; McInnes, 1964). Foundational concepts such as product differentiation and market segmentation (Smith, 1956), the product life cycle (Wasson, 1960, 1968), consumer orientation and the marketing mix (Borden, 1964; McCarthy, 1960) emerged in this period.

During the 1970s the boundaries of marketing practice and thought expanded rapidly. Marketers began to realize the role that marketing played in shaping society (Lazer, 1969). Kotler (1989) illustrated the role that marketing could play in public life through influencing the attitudes, values and behaviors of citizens. These developments expanded the frame of marketing to include a wide field of social interaction (Zwick, Bonsu and Darmody, 2008). Marketers thought that they could solve social problems and make a positive contribution to society. In the past ten years, marketing theory and practice have been caught up in another profound shift. Vargo and Lusch (2004) propose that the 'dominant logic' of marketing has shifted from products to services. Where a product is a tangible object, a service is an intangible social exchange. A service is produced in the immaterial interaction between producers and consumers (Brown et al., 1994; Fisk et al., 1993). As a consequence, marketers have to engage with consumers as active subjects in the production of brand value. In conjunction with this shift, cultural accounts of marketing have emerged that situate branding within the production of postmo-

dern social life (Firat and Dholakia, 2006; Holt, 2002; McCracken, 2005; Tharp and Scott, 1990).

Contemporary conceptions of marketing propose that consumers do not passively internalize the meaning that marketers embed in their communications (Bradshaw et al., 2006a, 2006b; Firat and Dholakia, 2006; Mittelstaedt et al., 2006; Venkatesh and Meamber, 2006). Consumers actively produce meaning. This shift in marketing thought and practice is central to understanding how brands operate as immaterial and experiential processes within popular culture. In the traditional, product-centered, marketing management approach, a brand was a bundle of signs and meanings associated with a product. The corporation created these signs and meanings, attached them to a product, and distributed them to consumers. Even though, in reality, consumers and citizens have always played an active role in the construction of brand meaning and value within social life, marketers have treated them as if they were passive recipients of brand meanings. From the new services and culture-oriented perspectives, brands are mobile and reflexive objects that both structure and embed themselves within social and cultural spaces. The consumer is a co-producer of the consumption experience and brand value (Schembri, 2006; Vargo and Lusch, 2004). The consumer is an actor in the value and knowledge creation process. This conception of the consumer has changed the way brands are created.

Contemporary brands are embedded within social space. Marketing takes itself to be a natural part of social life. Marketers act to institutionalize the spaces and people that produce meaning. They set out to play a role in the construction of these social realities. The brand is caught up in a state of perpetual co-creation between corporation, marketer, cultural industries, cultural participants and consumers. The brand is a social relation that takes place within the brandscape. Consequently, marketers manage and regulate the constant co-production of the brand across multiple sites of meaning-making. The people who make brands are not just corporate marketing professionals. They also include a diffuse network of citizens, consumers, and cultural participants. Corporations construct brandscapes in order to harness the social spaces within which brands are made. As Schroeder (2009, p. 124) argues:

> If brands exist as cultural, ideological, and sociological objects, then understanding brands requires tools developed to understand culture, ideology, and society, in conjunction with more typical branding concepts, such as brand equity, strategy and value.

I use the concept of the brandscape to describe the experiential brand-building spaces and practices of global corporations. The brandscape can be thought of as an experiential social space where marketers engage consumers in the co-creation of brand meaning (Sherry, 1998). Sherry (1998, p. 112) defines the brandscape as a

> material and symbolic environment that consumers build with market-place products, images and messages, that they invest with local meaning, and whose totemic significance largely shapes the adaptation consumers make to the modern world.

In the brandscape consumers and corporations negotiate shared meanings and values (Sherry, 1998). Consumers play an active role in constructing brands through their consumption and cultural practices. They are active meaning makers who take the predetermined aspects of a brand's meaning and adapt them to their local cultural spaces, practices, identities and lifestyles. The brandscape is constructed on the premise that consumers often 'appropriate the meanings of global brands to their own ends, creatively adding new cultural associations, dropping incompatible ones, and transforming others to fit with local cultural and lifestyle patterns' (Thompson and Arsel, 2004).

The concept of the brandscape emerged from an anthropological approach to branded retail environments like Starbucks and Niketown (Sherry, 1998; Thompson and Arsel, 2004). When you enter a Starbucks you step into a space that is constructed to produce a specific social experience. The combined imagery, smell, taste, sounds and social interaction with consumers and staff construct a particular experience around the consumption of coffee. Starbucks consumers come to know coffee through the Starbucks experience. In a Starbucks store the Starbucks brand comes to life and is made to represent particular values. The coffee is good, the service friendly, and you are reassured that the product has particular values like 'fair trade.' Similarly, a Niketown store is a space specifically constructed to communicate the values and personality of the Nike brand. Video screens, interactive displays, athletic and friendly staff and other communicative elements bring the Nike personality to life.

By examining these retail environments researchers demonstrated how brands were created through social experiences and how corporations could manage these social experiences (Sherry, 1998; Thompson and Arsel, 2004; Holt, 2004). For instance, consumers come to sense the values and personality of the Starbucks brand not just

through the advertising but through the social interaction occurring within the Starbucks store. Once you realize that brands are created through social interactions, it becomes apparent that these social interactions don't just take place within retail environments. They can take place anywhere. The Starbucks brand is also brought to life outside of the Starbucks store. It is built in the office, or in other social settings, when you offer to do the coffee run for friends or colleagues, or you tell friends you are craving a Mint Mocha Chip Frappucino coffee with Chocolate Whipped Cream. Of course, once a brand comes to life within our social worlds, then it can take on a life of its own. I might decide that I have a different concept of what coffee is really all about and say, 'I hate Starbucks'; 'I think they exploit growers in the developing world'; 'their coffee tastes bad, I know a little café around the corner that makes much better coffee,' or 'I hate being asked for my name' and so on. A brand is a living thing and corporations cannot completely control it. Despite their best efforts, some brands are cool and others are uncool, and sometimes brands that were cool become uncool and vice versa. Through experiential branding and the construction of the brandscape corporations create, monitor, understand and influence the social settings within which brands are created.

The brandscape is a structure through which corporations influence and structure cultural spaces and practices. The brandscape is a space where the global brand is adapted to local cultural spaces, values and practices. I will also use it as a model for thinking about how brands function within popular culture. Marketers argue that consumers are empowered to construct brands that fit with their lifestyles, values and identities. Corporations can no longer prescribe brand values to consumers; instead they must engage consumers in the brand-building process. These brand-building activities may make consumers appear to be active and empowered; we must however, consider how the action of consumers makes brands more valuable and their corporate owners more profitable.

The brandscape and the industrial production of meaning

Experiential branding and the brandscape can also be thought of as a contemporary articulation of the culture industry. Adorno and Horkheimer (1997) described the culture industry as an interconnected series of social institutions that produce culture to conform to the dominant ideology of the mass society. Meaning is industrially pro-

duced in the mass society by professionals who serve the interests of
the organizations they work for.

The culture industry critique demonstrated how culture is ent-
wined with the ideological and economic structures of capitalism. The
popular music we enjoy arrives in our ears through a complex net-
work of industrial production (Frith, 2007). For the most part we don't
have a direct relationship with popular music performers; instead the
music that they produce is mediated by the culture industry. The cul-
ture industry invests money in recording popular music and in mak-
ing popular music celebrities. This music is distributed to us via many
mediated networks such as radio, television and the web. We listen to
it on devices like stereos, mp3 players and cell phones. We spend
money purchasing merchandise, attending live music concerts, and in
some cases buying the products that our favorite popular music stars
endorse. Sometimes they endorse products explicitly through sponsor-
ship and cross-promotion deals; other times they endorse products
implicitly through what they wear, phones they use, cars they drive
and lifestyles they lead. In each of these instances, popular music cul-
ture interrelates with broader institutions and social processes. When
studying the culture industry we can't seal off a particular cultural
artifact for study. We must continually think about how it is embed-
ded within, and is a part of, wider social processes. Culture produced
within the culture industry incorporates the social and economic rela-
tions that produce it.

The culture industry is instrumental in shaping the way we perce-
ive and think about the world. It wins our consent to capitalist society
by embedding us within it. Adorno and Horkheimer (1997, p. 131) ar-
gued that the culture industry 'occupies men's senses from the time
they leave the factory in the evening to the time they clock in the next
morning.' This process subsumes labor into the 'narratives of the cul-
ture industry.' While Adorno and Horkheimer's ideas are grounded
within the time in which they were writing, we can think about how
this critique plays out in contemporary society by noting the ways in
which we interface with the media and other forms of industrially
produced culture. On any given day we listen to the radio or watch TV
in the morning; we listen to mp3 players as we travel around the city;
we surf the internet once we get to work or college, and we watch
films and television in the evenings. In each of these experiences we
make our lives meaningful and enjoyable, and we develop a sense of
who we are and what our place in the world is, through the apparatus
of the culture industry. The culture industry filters and structures our

experiences of social reality. It naturalizes the world in which we live. When we listen to our favorite song, watch a film, a game of sport, or a television show, we very rarely (if ever) find ourselves contemplating the conditions of its production and the way it structures our social reality. We rarely see cultural artifacts as a part of a system that every day produces society and our place within it.

A critical view of the culture industry implores us to view culture and society as constructed. This critical perspective asks us to see society as a structure that serves the interests of those who are powerful. The culture industry performs the work of concealing unequal social relations, of making the world and our place within it appear natural. The culture industry naturalizes capital as a form of social organization. It manufactures the ideologies of capitalist society. Branding is a contemporary manifestation of this process. Experiential branding engages people in forms of culture that also produce profitable corporate brands and hence naturalize those brands within everyday life. In this process cultural practices empower the accumulation of capital.

The culture industry critique has been criticized for understating the role that consumers play in creating meaning through their consumption of cultural commodities (Jarvis, 1998, p. 74). These criticisms though, often simplify Adorno and Horkheimer's dialectical argument. Adorno and Horkheimer emphasize that the 'triumph' of the culture industry is that consumers are compelled to participate and buy its products 'even though they see through them' (Adorno and Horkheimer, 1997, p. 167). Adorno and Horkheimer think about the industrial production of culture dialectically: the culture industry exploits people at the same time it relies on their avid participation. It contains the conditions for increasing democratization and interaction in public life at the same time it exploits these conditions for the strategic accumulation of capital. The production process of the culture industry produces systematic illusions. The audience participates in the repetition, regulation and commodification of culture. People participate in the production of commodities, corporate brands and popular music that they find meaningful. The culture industry's consumers aren't 'inert victims' because the industry relies on their 'avid participation' (Adorno and Horkheimer, 1997). Adorno emphasizes the extent to which 'cultural consumption has become sheer hard work' (Jarvis, 1998, p. 75). Social life lived in the culture industry is a form of ersatz labor, by which citizens produce surplus value for corporations.

Even though ordinary people actively participate in making cultural commodities meaningful, the culture industry 'impedes the development of autonomous individuals who judge and decide consciously for themselves' (Adorno, 1991, p. 106). This is perilous because autonomy is a 'precondition for democratic society.' Adorno asserts that the culture industry encloses and regulates the public space within which citizens might autonomously produce meaning (Adorno, 1991, p. 109). Participants in experiential branding programs perform a 'pseudo-diversity', where they think they are making autonomous choices. Instead, they largely use resources provided by the culture industry to make choices from a finite selection of brand names and commodities. Consumers are encouraged to recognize themselves as free and empowered, when in reality they are performing actions within an instrumental space that produces surplus value for corporations.

The produce of the culture industry (films, popular music, fashion, and brands) has a 'false-specificity.' Cultural artifacts appear different from each other when in reality they are all underpinned by the same instrumental conditions of production. For instance, consumers may differentiate themselves from their peers by wearing Converse rather than Nike sneakers. They might attach different meanings to each sneaker brand. Different tastes in sneakers may signal different values and identities. This sense of difference though is illusory. Regardless of the appearance of difference between Converse and Nike sneakers and the people who wear them, they are both a commodity produced under the same conditions of production for the same purpose. If you removed the labels from each sneaker and could remove the meanings associated with each style from the consumer's mind, they would be the same sneaker. Whatever differences may appear between products of the culture industry, they ultimately appear shallow when we consider their fundamental similarities.

So far, I have canvassed two different ways of thinking about branding. The strategic view of brands emanates from marketing theory and practice. The critical view of brands emanates from a culture industry critique. We can see two very different conceptions of the industrial production of culture (of which branding is a part) within public life. Marketers position their branding activities as empowering. They grant consumers the power to actively participate in the production of brand meanings. A critical view contends that this sense of empowerment is deceptive. In reality, the active participation of consumers in brand-building only produces brand equity and surplus

value and sutures over the power relations at work in the industrial production of culture.

The impasse between critical and strategic approaches to the study of industrialized culture has existed since the beginning of mass communications research. Dallas Smythe (Smythe 1981; Smythe and Dinh 1983) implores communications researchers to engage with administrative and professional communications discourses, such as branding and marketing, to understand how these discourses are used to operate liberal democratic capitalist society. Smythe's approach is very much a critical one; however, he seeks to understand exactly what administrative, strategic, and professional communicators do. I follow the spirit of Smythe's approach to the contemporary communications environment. His critical approach acknowledges the strategic efficiency of marketers, and their effectiveness in supporting the institutions of power and capital. Smythe claims that by understanding the language of professional communicators and how they deploy this language to strengthen and defend their positions and institutions, we can develop a more meaningful and powerful understanding of society and culture.

Popular music, branding and ideology

To critically examine how the meaningful experiences people have with popular music intersect with brand-building we need to develop a critical account of how people think and act in the world. Global corporations set out to convince citizens and consumers that they are authentically and meaningfully interested in their social world. In doing so, they set up particular ways of thinking about the social world and the role of citizens and corporations within it. To marketers, branding empowers consumers by supporting and investing in their social experiences. Such a view obscures the ways in which corporations extract surplus value from social life in order to accumulate capital. Corporations also argue that experiential branding empowers citizens by offering them a role in shaping the values, ethics and personality of brands. In response to this claim, we should consider the ways in which consumers perform particular forms of labor for global corporations. We should also consider how they are subjected to forms of surveillance within branded spaces and how branding shapes particular ways of thinking about ethics, society and politics that don't question the role of corporations in the global world.

The branded social spaces corporations construct can be thought of as hegemonic structures because branding programs are integral in shaping cultural spaces and practices. The hegemonic brandscape enables space for many different brand meanings to be articulated, but ultimately it seeks to legitimize branding as the dominant ideology of the space. The hegemonic brandscape 'shapes consumer lifestyles and identities by functioning as a cultural model that consumers act, think and feel through' (Thompson and Arsel, 2004). Consumers and citizens don't just shape brands. Brands also play a powerful role in shaping citizens' and consumers' cultural, social and political identities and values.

To marketers, experiential branding programs are socially responsible because they empower local content producers and invest in the creative industries that support them. They reflect and promote local culture, and they create mutually beneficial relationships between corporations and local cultures. Marketers contend that brands produced within culture by cultural participants are inherently authentic and ethical. This rhetoric obscures the work that young people and popular musicians do to make commodities meaningful, to integrate commodities into popular culture, and to create surplus value for corporations. Examining participation in these spaces raises questions about the use of cultural space by corporations.

In this difference between strategic and critical approaches to branding we can discern a basic social antagonism between those who think branding activities play a positive role in our society and those who think the same branding activities are detrimental. Each of these positions is normative. That is, each is a worldview constructed around how people think the world 'should be.' This fundamental gap or antagonism between strategic and critical views of branding is significant. A subject cannot coherently align with both. For instance, I am skeptical of any marketer who professes a sincere concern for the social, cultural and ecological impacts of the corporation they work for. Ultimately, for them to keep their job their concerns must be overridden by the strategic interests of the corporation. Likewise, any critical activist who thinks they can effect real social change within the capitalist system at some point has to decide if problems like the looming ecological crisis, the financial and economic crisis sparked by the sub-prime mortgage industry in the US, endemic poverty, exploitation of labor in the developing world or other social problems that concern them can be solved by the market or whether the market is in fact a central part of the problem. This is important because through

their branding programs corporations simultaneously construct brands and social reality. These branded social spaces preclude any consideration of what impact branding has on social life.

To make claims about the positive social, cultural and ecological impacts of their branding and business activities, marketers adopt the language of their critics. As critics and activists demand that corporations support local cultures, engage in fair trade, or act on concerns about climate change, corporations savvily respond to these calls for action by adopting them as their own. In doing so, they don't fundamentally alter the role of corporations in the global society. Instead, they develop responses to their critics that don't undermine their own dominance.

Where global corporations have been criticized for being monolithic institutions that disseminate brand monologues, they respond by localizing their brand-building practices and embedding themselves in the spaces and practices of local people. These engagements with people do not meaningfully place the corporation within a historical and systemic context. Instead, marketers translate criticism into strategic concepts that savvily respond to contemporary cultural conditions. Marketers use the ideas of empowerment and authenticity to create a discourse of capital as a liberating and emancipating social, cultural and political system. Experiential brand-building is a form of creative destruction. Where Sony famously employed teams of engineers to 'destroy' their current gadgets in order to come up with new ones, global corporations encourage the market to constantly reshape and reinvent their brands.

Where corporations speak of empowerment and authenticity within contemporary cultural spaces, critics denote a complexity in the savvy cultural response to capital's 'injunction' to feel empowered (Zizek, 1989). The contemporary critical position, that in capitalist society 'unprecedented freedom' is coupled with 'unprecedented impotence' (Bauman, 2000, p. 23), reflects a lengthy trajectory of Marxist thought. Capital's immunity to criticism, and ability to generate value from its own crises and contradictions, is a feature of Gramsci's notion of hegemony, the Frankfurt School's culture industry, and the lengthy history of ideology critique (Adorno and Horkheimer, 1997; Althusser, 1971; Bauman, 2000; Goldman and Papson, 1996, 2006; Gramsci, 1971; Marcuse, 1965; Marx, 1990; Zizek, 1989).

Ideology critique provides a framework through which we can understand the way marketers, citizens and consumers use language and social life to craft meaningful accounts of how they think and act

in the world. The classic Marxist conception of ideology is that people do not understand the material conditions of their social world: 'they do not know what they do.' Marx illustrates how the capitalist mode of production obscures social relations. Producers do not see the social relations embodied in the commodities they produce. This commodity fetishism, the mistaking of social relationships for objective relationships, obscures the social character of labor, and consequently, the extraction of surplus value through the labor process (Marx, 1990, p. 164).

The capitalist mode of production shapes a social world that naturalizes capitalist relations (Marx, 1990, p. 175). Marx contends that economic conditions determine social life and consciousness and that social life mediates, obfuscates and naturalizes economic conditions. Marx's notion of an economic base determining a legal, social and cultural superstructure is frequently dismissed as overly deterministic. His claim could lead to a conclusion that ideology simply denotes citizens as 'dupes' who do not understand their own material conditions of existence.

Adorno and Horkheimer (1997) pioneered a reworking of the Marxist critique that accommodated the development of mass culture in the 20th century. The conception of the culture industry illustrates how popular culture is integral to the reproduction of capital. The culture industry obscures the social relations of production. Zizek (1989, p. 24) demonstrates that this more sophisticated critique illustrates how ideology is:

> Not just a question of seeing things (that is, social reality) as they 'really are'...the main point is to see how reality itself cannot reproduce itself without this so-called ideological mystification. That mask is not simply hiding the real state of things; the ideological distortion is written into its very essence.

Leading on from the Adorno and Horkheimer's critique of ideology, the provocative and productive question Zizek (1989, p. 24) poses is, 'Does this concept of ideology as naïve consciousness still apply to today's world?' In response Zizek puts forward the notion of cynical reason as the dominant mode of ideology in contemporary culture. Cynical reason makes the critical-ideological procedure of unmasking reality 'as it really is' absurd. He argues that:

> The cynical subject is quite aware of the distance between the ideological mask and the social reality, but he nonetheless still insists upon the

mask. The formula as proposed by Sloterdijk, would be: 'they know very well what they are doing but still they are doing it.' Cynical reason is no longer naïve, but is a paradox, of an enlightened false consciousness: one knows the falsehood very well, one is well aware of a particular interest hidden behind an ideological universality, but still one does not renounce it.

As we explore the production of popular music and corporate brands I will illustrate how contemporary branding is reliant on forms of cynical and savvy ideology. Corporate brands are produced symbiotically with people's identities and social worlds. Citizens and consumers are dependent on brands and branding for their own identity and their own social symbolic order even though they see right through it. The cynical subject takes the critique of branding into account in advance of their participation in branded social space. Cynicism and savviness fireproof their subjectivity against the inherent contradictions of participating in a branded social world. Participants, just like brands, are savvy, reflexive and mobile subjects.

Adorno and Horkheimer (1997, p. 167), writing at the moment when the culture industry first emerges, already perceive that the 'triumph of the culture industry is that consumers feel compelled to buy and use its products even though they see through them.' Our avid participation in popular culture, involves a lot of productive activity on our part. And, even though we enjoy it, this activity produces social formations that reinforce capitalist society. Freedom in liberal capitalist society is an alienating freedom, people are free to choose different ideas, but these ideas reflect the same economic coercion (Adorno and Horkheimer, 1997, p. 166).

To penetrate the slippery, cynical social world, where we are acutely aware of our unprecedented freedom and unprecedented impotence (Bauman, 2000), Zizek (1989, p. 27) offers us the conception of ideological fantasy, 'cynical reason with all its ironic detachment, leaves untouched the fundamental level of ideological fantasy, the level on which ideology structures the social reality itself.' Branding is part of a culture industry that produces the enjoyable fantasies that structure our social reality. If the formulation of ideology is simply not 'knowing' and understanding the material reality of social life, then a simple procedure of unmasking this concealed reality would 'emancipate' people. Such a notion of ideology assumes that if people only knew how capitalists exploited their labor, they would no longer participate in a capitalist society. What such an account overlooks is how dependent people are on this mode of exploitation, how much their

identity and their sense of enjoyment and participation in social life are embedded within a capitalist context of production.

Ideological illusions, therefore, are not located simply in what people 'know,' in how they understand their social reality. Zizek (1989, p. 27) argues that what is left out of this account of ideology is a 'distortion that is already at work in the social reality itself, at the level of what the individuals are doing, and not only what they think or know they are doing.' Even though they might 'know' some aspect of reality is distorted, they act 'as if' it were not:

> They are fetishists in practice, not in theory. What they 'do not know,' what they misrecognise, is the fact that in their social reality itself, in their social activity – in the act of commodity exchange–they are guided by the fetishistic illusion.

Ideology serves as a support for our social reality; it is an illusion that makes reality functional and enjoyable. If we were confronted constantly with the social antagonisms caused by the economic mode of production life wouldn't be as much fun. As cynical subjects, we are happy to assist in producing a popular culture that enables us to suture over and ignore them.

Fantasy provides a support for reality. Ideology is not our 'partial' knowledge of our social relations and material conditions. That is, it is not that we don't understand fully how the world works. Instead, it is a totalizing fantasy that obfuscates its own antagonisms. Ideology gives us narratives, meanings and ideas that make our social world possible and enjoyable. It embeds us as subjects within a series of meanings and symbolic relationships that make sense to us. If, as western liberal consumers, we were confronted every day with the misery and exploitation involved in the physical sweatshop production of our clothes, our iPods, cell phones, computers, and so on, it would be hard for us to maintain a sense of ourselves and our lifestyles as having ethically meaningful substance. Popular culture helps us to rearticulate the meanings we attach to commodities. Branding is a mechanism for crafting popular culture that enables us to suture over the antagonisms of global networked capitalism.

Savvy citizens are inherently skeptical. They are intuitively suspicious of the motivations and strategic intentions of the media and corporate brands. Marketers cater to this contemporary savviness by 'showing (the audience) how mediated appearances are constructed by the culture industry' (Andrejevic, 2004, p. 16). Cultivating the 'savvy attitude becomes a strategy for protecting artifice by exposing it' (An-

drejevic, 2004, p. 16). That is, the savvy audience thinks that because they can see the apparatus which strategically exploits them, they are not 'really' exploited. Savviness encompasses the response of contemporary audiences to their perception that marketing's (and capital's) discourse of empowerment is not 'really' empowering. The savvy position is a response to having no alternative but to participate.

The point of drawing on these critical accounts of capital is to demonstrate how contemporary branding is part of capital's drive to accumulate capital by seizing the surplus value created in particular modes of production. Marx (1990, p. 672) demonstrates how:

> Surplus value... is in substance the materialization of unpaid labor-time. The secret of self-valorization of capital resolves itself into the fact that it has at its disposal a definite quantity of the unpaid labor of other people.

The brandscape is a social space within which consumers and citizens appear and feel free to enjoy and participate in popular culture, this enjoyment and participation though obfuscate the way the brandscape operates as a strategic productive mechanism for the accumulation of capital. Furthermore, by situating branding and the brandscape within critiques of capital from Marx onward, we can articulate its historical context. Where marketers would claim that experiential branding is a contemporary development in response to a changing market, a critical historical perspective enables us to illustrate how the brandscape is emblematic of capital's reification of social life.

The brief account of ideology I have sketched out here, and will return to at key moments in this book, attempts to capture a holistic contemporary critique of capitalism. I will attempt to juxtapose this radical critique, emanating from Marx, with the liberal empowerment rhetoric of marketers and marketing theorists. My intention is that this juxtaposition will prove useful for thinking about the limits of both marketing's and critical theory's ways of thinking about and acting in the world.

Chapter Two

Music...as It Should Be: The Work of Meaning Making

Meaning making

The meaning-making activity of music fans is a form of immaterial labor. Their activity produces the immaterial content of commodities and the social context of production (Arvidsson 2005, Hearn 2008, Terranova 2000). In this chapter I explore the affective product of young people's labor. By affective I mean the enjoyment, shared meanings, values, and mythologies of authenticity produced by young people through their involvement with popular culture. Young people's taste and meaning-making practice is central to making brands valuable mobile media objects. In chapter three I extend this argument by illustrating how meaning-making is channeled into me-dia-making practices. These two chapters explore Coca-Cola's Coke Live and Virgin's V music festivals. I begin with Virgin's and Coca-Cola's manifestos of authenticity before exploring the way young people engage with these brands' rhetorical claims around the per-formance of live music.[1] This enables an examination of the contrived and constructed character of authenticity within popular culture.

The real music manifesto

For the 2009 V festival, global brand Virgin attempted to rehabilitate pop music pariah Vanilla Ice. As part of Virgin's Right Music Wrongs campaign Vanilla Ice was contracted to publicly repent for his musical sins. Right Music Wrongs set out to have snarky and cynical fun with musical taste. Vanilla Ice was put 'on trial.' If the public voted him innocent he would play live at the V festival, if he was voted guilty he would be forced to come on stage and apologize for his musical crimes. Virgin also invited the audience to submit other musical 'wrongs' for judgment. Billy Ray Cyrus, Kenny G, Peter Andre, and New Kids on the Block were all put forward. Virgin, like other brands, savvily ap-propriated mythologies of real and authentic popular music and en-gaged the live performance of music to legitimate their claims to authenticity.

Virgin offered a Right Music Wrongs manifesto that set out to re-habilitate and defend notions of authentic popular music:

> In a world awash with the insincerity of reality pop stars and pre-fabricated, formulaic, celebrity seeking, silicone enhanced lip sync-ers, something has gone desperately, dangerously wrong. It is time to make a stand and support just causes. It is time to stand up, jump about and be counted. It is time to remember that out there, in garages, basements, bedrooms, studios, once smokey bars, stadiums and in fields across the country, real people are playing real music with real purpose. Real music isn't about the instrument, it is about the intent. The composers concern is getting it out, not how cool it is or how far it goes.

> Real music is the Sex Pistols playing badly, The Presets surprise that anyone actually likes their biggest single, Radiohead experimenting with delivery methods and Sigur Ros standing on a hillside in the Icelandic wildness sound checking to a herd of sheep. Real music is Tony Wilson signing the Joy Division contract on a napkin in his own blood. Even if the contract was ultimately worthless.

> Real Music is not ours to judge. It isn't defined by being underground or popular. It doesn't set out for stardom any more than it is diminished if it sells a million copies. It is not about genres. It can be quiet and consi-dered, or loud and obnoxious but it is not artificially sweetened, mass produced, celebrity seeking mediocrity with a marketing plan at its core. Real Music was good when it was some scribbled notes on a napkin, good when it was a demo, good when at its peak and good on an anthology of past hits. Real Music is two DJs discussing a bass-line, two drummers talking skins, the last listen to the master before committing to the mix, the artwork on the case, the release date for the tickets, seeking news on-line, discovering bootlegs and mash-ups, the friends running across a field for the start of a set, photos shared, stories told, the songs sung out loud, the encore, losing your phone in the mud and not caring, the kick on, the cab home, the hangover, breakfast at 3pm, putting on head-phones and walking to the beach, closing your eyes, calling friends, tell-ing tales, comparing notes, watching videos and getting ready to do it all again. Real Music is a passion whether for one person or one hundred million. It makes us individual and it makes us want to share our indivi-duality.[2]

Right Music Wrongs took the ideology of live music and put it to work to build the Virgin brand. The audience's sincere, cynical and ironic expressions of musical taste all became brand content, which made the Virgin brand a reflexive and valuable media object. Vanilla Ice's tour of Australia began with tearful and mock-sincere apologies on YouTube, television and radio. 'I'm sorry for the hair-dos, the bag-

gy pants, the scandals, the lies, the games, and I'm sorry about the music,' he wept. Vanilla Ice's apology is emblematic of the contemporary expressions of authenticity in popular culture because it contains a double moment. At the same time it expresses sincere notions of what audiences take authenticity to be, it offers a savvy wink that suggests he 'knows' that these very notions of authenticity he takes seriously are constructed and contrived (Goldman and Papson, 1996, 1999). The savvy wink is a strategy to re-route consumer criticism by 'foregrounding the constructed nature of the text' (Goldman and Papson 1996, p. 74). Virgin is a valuable contemporary brand because it has the reflexive ability to incorporate competing and contrasting notions of taste. Where other brands get 'caught out' piously defending cultural values, Virgin opens itself up to, and embeds itself within, popular culture's taste and meaning-making activities.

Where Virgin's Right Music Wrongs campaign was savvy and reflexive, Coca-Cola's 'music as it should be' manifesto was pious and sincere.[3] Coke Live's summer music festival television advertisement offered a manifesto of music culture values couched within a chaotic visual narrative of a teenage girl's summer music festival experience. The advertisement voiceover instructed young music fans to let go of their inhibitions in the search for the 'one they want.' 'The one you want' is both the bottle of Coke the girl gets and a cool and edgy boy she falls in love with. Coca-Cola evokes meaningful cultural ideals: wild and anarchic music performances, falling in love, and even a savvy nod to the commodification of music in a dig at the 'overpriced merchandise' at music festivals (Klein, 2008). As the girl simultaneously discovers the two interwoven objects of her desire: the edgy boy and the ice-cold bottle of Coke, the narrator instructs music fans that this is summer 'as it should be.'

The girl and the boy start making out and going around the festival together. The advertisement is assembled with a collage of different 'screens' created by foolscap pads, notebooks and scraps of paper overlaid or stapled together. Their romance collides and merges with images that signify an authentic summer music festival: muddy sneakers, wild boys, moshing crowds, and energetic live music performances. The images form a dreamscape of a student sitting at a desk fantasizing about being at a summer rock festival. Coca-Cola harnesses intimate cultural knowledge to craft a manifesto of what authentic music experiences should be. They engage their young audience by demonstrating a savvy knowledge of cultural codes, symbols and narratives.

The Coke Live advertisements were directly instructive about cultural values. They were saturated with symbols of rock music mythology: devotion to rock music and rock stars, excessive volume, electric guitars, wild crowds, TVs in hotel swimming pools, and, predictably, generational conflict between young people and their parents. Douglas Holt (2006) suggests that brands proselytize for the cultural values and myths that they parasitically feed off. Holt's 'dialectical' theory of consumer branding suggests that brands survive through a series of internal contradictions. Coca-Cola produced several advertisements during the Coke Live program that piously defended notions of authentic music culture. Each advertisement repeated the word 'should' to make a normative claim about what music culture ought to be like. According to Coca-Cola music should make you want to aspire to all the mythologies of rock culture: dropping out of school, rebelling against your parents, upsetting the neighbours with loud music and wild parties, spending all your pay on concert tickets, throwing TVs in hotel swimming pools, deriding lip syncers and fakes, and idolizing lead singers. All of these things make music what it 'should be.'

The advertisements create a cultural manifesto for the brand. They assign the brand ethics, values and meanings. The Coke brand stands for something. Coca-Cola's 'music as it should be' manifesto presents music fans and musicians as liberated, empowered and free subjects who simultaneously consume Coke and enjoy popular music. The advertisement connects Coke with the mythologies of live music. The festival depicted in the advertisement is markedly different from the mediated brand-building spaces of the Coke Live festival. At Coke Live, Coca-Cola act out mythologies of authenticity and engages with young people's meaning-making practices.

Even where young people set out to be unruly and rebellious, they reinforce the brand. The Coke Live festival began with red carpet arrivals. A music television host interviewed bands as they arrived at the festival. Audience members were invited to come onto the red carpet to meet the bands and ask questions. The red carpet arrivals were a staged spectacle where Coca-Cola gave its audience access to an exclusive cultural world to harness their meaning-making activity (Andrejevic, 2007a). As young music fans stepped onto the red carpet and directed the cultural action they added value to the Coke brand, articulating it with dispositions and attitudes that are more nuanced and reflexive than the pious manifestos of the advertisement. As young people stepped onto the red carpet and directed the cultural action,

they felt like active and empowered producers, who in articulating their own tastes and identity, added value to the Coke brand.

Most young people on the red carpet asked the bands questions like, 'What is your favorite breakfast cereal?' and 'Where did you go to school?' The questions were mostly innocent and inane and attracted playful responses from the bands. One young music fan broke through this code when he took the microphone and asked pop duo The Veronicas a question, 'Um, I've got a question for Jess and Lisa from The Veronicas.' 'Sure mate! What do you want to ask? Anything you like!' the effervescent host responded. 'Which one of you lost your virginity first?' There was a brief silence before the host exclaimed, 'You can't ask that!' The Veronicas giggled and offered, 'We both lost it at the same time.' Then the host intervened with, 'Next question please.'

Coca-Cola wanted Coke Live to be edgy and subversive. The young interlocutor took the Coke brand on an unscripted adventure. Although the moment appeared awkward and unsanctioned, he enlivened Coke's rock culture credentials. The red carpet arrivals event invited young music fans to direct the action and create an authentic cultural moment. When one of the young fans departed from the script by saying something the brand itself could never say, he enabled Coca-Cola to harness a subversive moment as a burden of proof of its own authenticity. Hypothetically, a young person could get up and culture-jam the brand, they could ask, 'Do you think Pepsi is better than Coke?' or 'Isn't Coke bad for your teeth?' Such an action would similarly reinforce the brand by demonstrating how reflexive, mobile, adaptable and self-deprecating it is. This brief moment illustrates how brands that are constructed in experiential brandscapes necessarily harness the energy of their would-be critics and cynics. The experiential brand is a shared social relation, not a zealously defended, closed object. It is most valuable when it opens its authenticity and meaning-making process up to its audience.

Advertisements are limited to linear proclamations of cultural values. At best, they can speak for the authentic values of popular music culture. Advertisements don't provide a material demonstration of how corporations actively support their claims. Savvy consumers are inherently skeptical about corporations claiming to support their cultural values (Holt, 2002). Corporations respond by engaging these savvy subjects in experiential brand-building. They need to live out their rhetorical claims. Coca-Cola, Virgin and other brands use advertising to demonstrate their intimate knowledge of popular music culture. To make their brands valuable within popular culture, however,

they need to put these claims to work. They can't have a manifesto without any action. Their audience is acutely conscious of being passive dupes.

The rehabilitation of Vanilla Ice

From Coca-Cola's 'music as it should be' and Virgin's Right Music Wrongs manifestos we can observe brands investing in the idea of live music as authentic. When audiences ironically or sincerely enjoy live performances, they are performing a specific ideology of authenticity (Auslander, 1999). Their meaning-making practices act as if some music is intrinsically authentic, while other music is not. In the afternoon at the Sydney V festival Vanilla Ice was declared innocent of crimes against music and took to the stage to perform his international mega-hit from the early 1990s *Ice Ice Baby* to the manic delight of the audience. It was difficult to distinguish sincerity from snarky cynical enjoyment. Was there a joke? Was the audience in on it? Was Vanilla Ice himself in on it? He pumped up the crowd for several minutes before the DJ dropped in the famous *Under Pressure* bass line. YouTube videos captured by the audience show the crowd going crazy and screaming along as he launched into the famous opening line, 'All right, stop, collaborate and listen / Ice is back with my brand new invention!'

Where Vanilla Ice appeared to be embraced with ironic delight, other live performances are taken to be sincerely authentic by the same audience members (in the following sections I will illustrate how audience members at the V festival revere bands like the Pixies, New York Dolls and Jesus and Mary Chain). A couple of months before Vanilla Ice performed at the V festival, I saw Fleet Foxes (a popular indie band) perform in my hometown. Fleet Foxes' performance offers a neat juxtaposition with Vanilla Ice that exhibits how the live performance is central to the construction of authenticity within popular music culture. A comparison between Vanilla Ice and Fleet Foxes helps to illustrate how discourses of live music and authenticity operate.

The Fleet Foxes performance embodies the values set out in Virgin's Right Music Wrongs manifesto. Even though Fleet Foxes didn't play the V festival, their performance is illustrative of the kind of popular music culture Virgin set out to defend. During the Fleet Foxes encore the performance took an unexpected twist. The lead singer-songwriter, Robin Pecknold, unplugged his acoustic guitar, stepped in

front of the microphone, and waited for the crowd to fall silent. Totally unplugged he played a version of the traditional ballad *Katie Cruel*. The crowd was totally silent, sensing the 'realness' or 'liveness' of the unplugged performance. No amplification, no mixing, just Robin Pecknold's voice, his guitar, and the lyrics of a traditional song handed down over generations. Over and over in my exploration of popular music the live performance is held out as real and authentic (by brands, musicians and music fans), moments where musicians demonstrate some 'essential' liveness to the audience intensify the sense of immediacy and authenticity. Bloggers and viewers on You-Tube testified to the unique immediacy and authenticity of the Fleet Foxes performance.

Vanilla Ice's performance, on the other hand, highlighted how contrived and constructed notions of real and authentic popular music are. In making distinctions between real and fake popular music performances audiences mobilize competing and contrasting frameworks of taste and distinction to craft 'exclusionary concepts of authenticity' (Auslander, 1999, p. 55). These exclusionary notions are mobile and reflexive. Vanilla Ice is routinely put forward as an example of crass commercial popular music, and yet, the V festival audience voted him innocent of crimes against music. Vanilla Ice's innocence might indicate that the audience cynically knows that notions of authenticity are themselves contrived. And so, to reflexively protect this contrivance they mockingly vote Vanilla Ice innocent. This cynical distance enables them to ironically enjoy popular music. Vanilla Ice might not be authentic, but reveling in his 'badness,' knowing that he is 'bad,' is enjoyable and enables the audience to articulate their cultural capital. The audience performs an ideology of authenticity that protects itself with its own cynicism. The ironic distance to Vanilla Ice and the sincere embrace of Fleet Foxes are two moments in one ideology of authenticity.

Virgin's Right Music Wrongs works on two levels: as a sincere manifesto that captures what audience members 'really' think authentic music is (for instance, it implicitly defends 'really live' performances like Fleet Foxes). At the same time it takes a cynical distance that recognizes how contrived these sincere notions of authenticity in popular culture are (for instance, by ironically embracing and enjoying Vanilla Ice). At the V festival both of these subject positions are deployed to craft the Virgin brand, audiences sincerely take the Pixies, New York Dolls and Jesus and Mary Chain to be authentic; they ironically enjoy and even mock Vanilla Ice (along with Duran Duran,

Pet Shop Boys and Smashing Pumpkins). Virgin is a contemporary brand *par excellence* because it actively embraces both sincerity and irony. It is a mobile and reflexive communicative object that, instead of offering a static set of sincere brand values, facilitates a lively meaning-making process. The brand is not valuable because of the particular meanings it stands for, but because of the way it makes meaning.

Essential claims are made about the authenticity or immediacy of live performance. Pecknold is perceived as more authentic and more real than other performers because he plays 'unplugged' from the apparatus of mediation, Vanilla Ice is rehabilitated (and his apology 'accepted') by performing live. Even though he was voted innocent, Vanilla Ice is treated with ironic distance because the audience perceives that his performance, even though live, is clearly mediated, not just in a technological sense but by the culture industry at large. In both cases, through the live performance the audience makes a direct judgment of the artist. Authenticity is taken to be some intrinsic quality that actually exists in the music. Only by performing live can musicians certify their authenticity (Auslander, 1999; Gracyk, 1996).

Despite this desire for immediacy, the popular music performance is constantly mediated. This mediation happens both at the level of the culture industry (that is, the social, economic and cultural context of the performance) and by individual music fans (with their cell phones, digital cameras and meaning-making practices on blogs and social networking sites. Shortly after the Fleet Foxes and Vanilla Ice performances, recordings appeared on YouTube, blogs and other content-sharing sites along with commentary on the authenticity of the artists).[4] One of the paradoxes of contemporary popular culture is that the way many audience members experience what they take to be the immediacy of authentic live music disavows the ways in which it is mediated. Even though audiences find live performances essentially and intrinsically meaningful, these notions of immediacy, realness and authenticity are constructed (Auslander, 1999; Gracyk, 1996; Klumpenhouwer, 2002). This doesn't mean that people who enjoy live music and find it authentic are simply dupes; we should not fall into the trap of dismissing popular culture as purely ideological content for capital. Following Zizek's (1989) ideology critique, popular music should not simply be dismissed as 'false' but rather taken as a significant part of social life that enables us to examine how capital structures and influences our social reality.

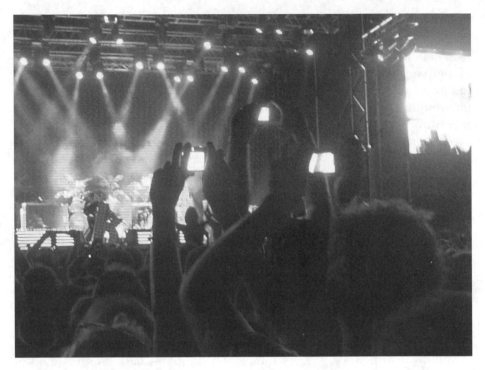

Audience members at the 2009 V festival use their digital cameras to mediate live performance of headline act, The Killers. Photo: Nicholas Carah.

In the rest of this chapter I draw on fieldwork at the V festival and Coke Live to illustrate how audience members engage with the live performance and the mythologies of authenticity that brands construct. Through their choice of bands Virgin cultivates discourses of savvy nostalgia on one hand and defining the contemporary moment on the other. Coca-Cola offers their audience a narrative of supporting live Australian music. In both cases these discourses are connected with the brand's values. The brands relate to the audience in a way that makes them feel as if they are valuable and skilled meaning makers.

The performances at the V festival take place on the neutrally named 'this,' 'that' and 'other' stage. At the V festival between 2007 and 2009 there were several discourses that music fans articulated around the live performances. These included a strong nostalgia for bands who defined particular moments in the history of popular music and an interest in 'it' bands who captured the essence of the present moment. In this section I draw on participant observation of live per-

formances at the V festival between 2007 and 2009 together with the perceptions of music fans who attended the 2008 festival.[5] I aim to illustrate the taste-making practices that unfold around the live performances at the V festival and theorize how this valorizes the Virgin brand. The taste-making practices music fans engage in articulate their own identities and communicate their symbolic capital around music culture. Music fans invest in branded social space with their identity-making practices.

This stage, that stage, other stage

Nostalgia is the bittersweet longing for a former time. Nostalgia is apparent at the V festival in two forms. The audience reveres bands that have influenced the development of popular culture they take to be authentic and meaningful. The Pixies, New York Dolls and Jesus and Mary Chain are all received with the utmost respect by the audience. Conversely, a savvy and ironic nostalgia comes in to play around bands such as the Pet Shop Boys and Duran Duran who embody the excess, perceived 'bad' taste and hyperreality of 80s and 90s synth-pop. In each case nostalgia serves to evoke notions of authentic and enjoyable music culture. Audiences deploy discourses of nostalgia to communicate their symbolic capital within their peer network. Being able to use nostalgia 'correctly' illustrates a person's understanding of the historical canon that shapes popular music. The presence of bands that evoke nostalgia at the V festival empowers peer leaders to validate the festival's claims to authenticity. The audience enjoys the musical performances at the V festival by mobilizing frameworks of taste and distinction.

The V festival routinely books bands that define a particular period of popular music history. The 2007 festival was headlined by the Pixies, who defined the indie art rock of the 1980s. The 2008 festival was jointly headlined by The Smashing Pumpkins, who defined the alternative rock of the 1990s, and Duran Duran, who defined the synth-pop of the 1980s. This reverence for era-defining bands is a distinct element of the V festival line-ups. 'I'm not sure why, but I love the way they do it, old school rocks,' one audience member told me in trying to express why nostalgia is such a powerful force. Regardless of whether bands perform well, audience members suggest that they enjoy seeing musicians evoke the romantic ideal of a lost and eminently more real and enjoyable musical past. Even when the performance at the V festival doesn't match their pre-conceived ideal, audience mem-

bers appear to fill the performance in with meaning anyway. One music fan explained to me that the older bands at the V festival, 'are really only seen due to hype...in their 'hey day' they would have been brilliant but now most people just see them because of who they are and not how they perform.'

The audience members actively reinterpret the performances. Some of these interpretations fill the performances with ironic inflections. One of them told me that '(Duran Duran were) so fantastically bad they were brilliant, it was just like living part of the 80s in an hour.' Another also went to see 'Duran Duran play *Hungry like the Wolf* because we were in the mood for a laugh.' These audience members enjoyed Duran Duran by deploying their cultural capital in ways that demonstrate a nuanced mastery of the canon of popular music. In distinction to these ironic views, older bands also evoked reverence and respect, V festival attendees that I spoke with unanimously 'loooooooooved the Pixies.' A festival goer who missed the 2007 V festival exclaimed, when I told him the New York Dolls had played, 'The New York Dolls came here? I can't believe I missed that. My God, I feel like an idiot.'

While bands like Duran Duran and the Pet Shop Boys are open to ironic enjoyment, other bands like the Pixies and New York Dolls evoke a period, politics and ideals that appear incorruptible within the brandscape of the V festival. At the 2007 V festival, the seminal 1970s punk band the New York Dolls took to the stage and appeared unaware, not only of what festival they were playing, but also what city they were in. 'Hello Sydney!' front man David Johansen shouted to the Gold Coast audience, prompting a hilarious exchange with audience members as he attempted to clarify what city he was in. The New York Dolls are untouchable. The audience saw them as if they were still in the space within which they first created their meaning. The audience didn't see them as a band playing a corporate-branded rock festival; instead, they saw them as if they were performing on stage at legendary punk club CBGB. They thought they were seeing an authentic piece of punk history. Their performance was a window back to the dawn of punk music. Playing the V festival wasn't 'selling out.' Their values weren't denigrated or changed by performing a corporate-branded rock festival. Instead, they effortlessly implanted their original and authentic punk rock shtick into the brandscape, and the audience enjoyed every moment. The audience deployed their cultural capital to revere these bands whose rich independent history correlates with their romantic and essentialist notions of authenticity.

The audience didn't appear to judge these performances in the present moment. Instead, they read them in relation to their 'creation myths.' While one fan thought that the Jesus and Mary Chain were 'disappointing' and 'lacked enthusiasm,' they were still 'in awe the entire time to hear some of (their) favorite psychocandy tunes live.' The same sentiment was expressed by another music fan who thought that the 'Jesus and Mary Chain looked like they were bored out of their brains, but it was still cool to hear Sidewalking' (the band's seminal psychocandy tune). The audience members I spoke with knew that the actual performance was contrived and half-hearted but still acted as if it were being played to them from some real historical place. Bands like the Jesus and Mary Chain implant an incorruptible notion of authenticity into the brandscape. While I recorded different perceptions as to whether these bands' 'heart was really in it any more,' and this impacted on how enjoyable the performances actually were, without exception audience members displayed reverence for what these bands 'mean' within the archive of popular music. Their meaning is so attached to a mythical musical past, that the V festival could have no effect on whether the interpretation of their music performance was authentic or not. In fact, even the bands themselves could have no impact on the interpretation of their performance. It was always-already authentic because the audience deployed the archive of popular music, rather than anything intrinsic in the performance itself, to say so. Even if these older bands show up and put on a poor performance, the audience still revels in the chance to see them 'live.'

Nostalgia comes from the audience's acquired cultural capital. It enables them to discern different notions of authenticity and enjoyment in relation to a variety of musical performances. A cultural outsider at the V festival would most likely not be able to tell if Duran Duran, the Pet Shop Boys, Jesus and Mary Chain or the Pixies should be treated with reverent or ironic enjoyment. The Jesus and Mary Chain, for instance, are reverently implanted into the present. Since they were featured in seminal scenes from Sophia Coppola's film *Lost in Translation* (2003), they have found a contemporary audience. Many of the new fans who are now nostalgic for psychocandy would not have been born when the Jesus and Mary Chain were creating their seminal records. Nostalgia is fickle and tethered to complex and constantly morphing frameworks of taste and distinction. The Jesus and Mary Chain were notorious for rioting and destroying venues in the 1980s. Their history of manic and anarchic energy makes them

authentic and burdens them with certain expectations from the audience. Crucially, this history is the symbolic capital Virgin purchases from them as content for their audience to convert into information commodities. While segments of the audience were underwhelmed because these now middle-aged rockers didn't destroy the stage, they still revered them for their history and raised their digital cameras and cell phones to capture images of them.

The audience members I spoke with could connect the V festival's interest in these bands to strategic imperatives. They suggested that the older bands performing at the festival 'give the snazzy cats a chance to see some of the cult bands which they wouldn't get to see otherwise.' The 'snazzy cats' are the opinion-leading, early adopters who shape opinions and tastes in their peer groups. Virgin acquires cultural capital simply by booking these bands. The audience thinks Virgin has a finely cultivated sense of taste. 'Perhaps Sir Richard is a fan?,' one of the audience members suggested when I asked why they thought these bands had been booked. The older bands are perceived to 'give (the festival) a sense of depth and more credibility than bands that are up and coming and having their "day in the sun."' This sense of depth and credibility draws an audience who are fundamentally interested in music. They invest in popular music with their identities, ethics and worldview. By going to the V festival they seek to 'experience something that so many people talked about in the past.' Bands which evoke these complex feelings form the incorruptible bedrock of the Virgin brand.

Many of the people I have attended the festival with have made cynical jokes about the branding of the festival site. They act as if they think the branding is a bit contrived and suggest that they wouldn't ordinarily go if it weren't for the never-to-be-repeated chance to see the Pixies, New York Dolls or Jesus and Mary Chain. When the beer lines were excessively long at the 2007 festival, they expected Virgin to 'sort it out.' When it rained at the 2008 festival they asked, 'Where is my free poncho?' Sure enough, within a few minutes of the rain arriving, the site was covered in people wearing Virgin branded ponchos. When it was hard to get mobile reception at the 2009 festival they mused, 'You would have thought that a festival run by a cell phone company would have good reception....' They distance themselves from the brand by expecting it to be at their service.

Authentic brands have a finely cultivated sense of taste. They both emulate and attract individuals who make finely tuned distinctions. While Virgin chooses bands that evoke strong feelings of nostal-

gia, they also book bands that capture the present moment. These bands contribute to the festival's allure as one which implicitly understands both the history of popular music, and its present moment. The Virgin brand has 'good' taste. Audience members recognize the V festival for securing bands from overseas that 'don't normally come to Australia.' Audience members note that 'The Pixies, Beck, Jarvis Cocker and Smashing Pumpkins are all very rare to tour here' (not to mention Robyn, Roisin Murphy, New York Dolls, Jesus and Mary Chain, Phoenix and Air). All of these bands either toured Australia for the first time or for the first time in many years with the V festival.

Some audience members linked the choice of bands to Virgin's brand values. One noted that Virgin

> definitely appeal(s) to the alternative crowd, I saw very few teeny boppers. Most companies appeal to the masses and go with what's popular. By holding this festival, Virgin attempts to crack the untapped alternative market.

Another audience member reinforced this distinction, 'Other festivals tend to market the more popular and upcoming bands' whereas, 'Virgin has good taste (and must) have someone really cool on their team.' The line-up holds symbolic capital by appealing to the audience's sense of distinction (to follow Bourdieu, 1984). Bourdieu's (1984) concepts of distinction and cultural capital are frequently invoked in the popular music literature (Auslander, 1999; Frith, 2007; Regev, 2002). The audience members I interviewed saw the line-up as a tool for shaping a particular audience that will then presumably shape brand values. They argue that Virgin picks the bands to 'market' to their 'target demographic.' For instance, one observed that, 'the late 80s and early 90s seem pretty fashionable right now, so it would make sense to choose popular bands from that era.' This choice of bands crafts live performances that enable the audience to articulate and perform ideologies of taste and authenticity.

Music festivals have often been associated with political movements and moments. Woodstock is attached to the political moment of the counter-culture. Lollapalooza is attached to the alternative politics of the 1990s. In Australia, the Big Day Out, through its Lilyworld and other installations, has maintained an affiliation with similar alternative politics. Performances at the V festival are distinctly apolitical. The V festival space is strategically formulated around enjoyment. Virgin cultivates symbolic capital from both the bands that perform and the audience's relation to those bands. Even bands

with a political history, like the New York Dolls, Pixies and Jesus and Mary Chain, while still referencing musical moments (punk, indie, etc.) defined by their politics, are in the context of the V festival completely depoliticized (Goldman and Papson, 1999).[6] These nostalgic bands don't perform to continue, or revive, the political projects that shaped their music in the 1970s and 1980s. Rather, they perform for the enjoyment of an audience who want to display their fine sense of taste and distinction by either reverently or ironically enjoying the performance. Where the Pixies, New York Dolls and Jesus and Mary Chain have a subversive, underground or fiercely independent history, they evoke this history as a lapsed (and therefore apolitical) authentic ideal. In contrast, the contemporary bands who play the festival do not come from a subversive, underground or independent background.[7]

The live performances at the V festival must add value to the Virgin brand. None of the performances at the festival can fundamentally disrupt, or seek to resist, the underlying strategic logic of the space. The performance of music that the audience takes to be authentic makes the whole event authentic. They can experience the music in ways which match their perceptions of authentic popular music culture (a band on stage, large video monitors and light shows, dancing, drinking, taking drugs, 'getting physical' and socializing), without the strategic mechanisms in the space disrupting them. Virgin carefully constructs the notion that these authentic music experiences make the brand real. Each of these discourses operates ideologically to suture over the strategic imperatives of the space. The audience interacts with these performances as a source of enjoyment. The audience also mediatizes these performances as information commodities that build brand value.

Going to Coke Live

Just like the V festival, audiences at Coke Live are attracted by the bands. And, they too develop discourses that account for their participation in branded social space, authenticate the live performance and valorize the brand. They are aware of the brand's strategic intent. Even though the brand claims a disinterested support of music culture via their manifesto, the young music fans see it as strategic and position themselves as the object of the brand's desire. Most of the audience members I spoke with at Coke Live had come to see one of the two headline bands: The Veronicas or Evermore.[8] The bands on the

bill enticed them to collect bottles of Coke and convert them into Coke Live rewards points online to secure tickets. I was given many serious, playful and cynical reasons why Coca-Cola ran Coke Live by the young music fans at the event. Many at the Coke Live event were acutely aware that Coke Live was a brand-building event. 'To get more money!,' they exclaimed, as if it were a given truth or a humorous joke. Their responses were slippery, ironic and playful. They were mostly excited to be seeing their favorite bands playing live. As they straight-forwardly explained why Coca-Cola ran Coke Live, they demonstrated that young music fans are adept at discerning Coca-Cola's strategic intent. These young music fans were not inert dupes; they were savvy consumers.

Coca-Cola supports live music because through live music young people have social experiences that are enjoyable, authentic and cool. I spent time before the festival with a boisterous group who were eager to see their favorite bands. 'Why do you think Coca-Cola supports popular music?,' I asked them. 'Coz it's hardcore and good!,' one of them exclaimed. 'Yeah,' another chimed in, 'instead of alcohol it's Coke,' at which they all laughed. Young music fans under the legal drinking age (18 in Australia) are mostly unable to go to live music events. Coke Live was one of the few opportunities for young Australians to see live music. Many alcohol brands support live music initiatives (Jagermeister, Jack Daniel's, Tooheys, Bacardi and Smirnoff ran programs in Australia in recent years). These programs, by law, have to exclude people under the legal drinking age. Most young people though are well apprised of these branding programs and, in the case of Coke Live, excited that a non-alcohol brand was providing for them.

I asked another group why they thought Coca-Cola ran Coke Live. One of the group replied, 'because Coke owns Pepsi.' Clearly, I was a bit of an oddity at a Coke Live event trying to figure out what Coke is up to. My questions were easily deflected in a number of directions. Everyone—the bands, the marketers and the young music fans—tries to avoid the question about strategic intent. If they acknowledged it seriously it would make the whole event look contrived. The young music fans claimed they were just there to see the bands, and didn't care about the strategic intent. The young audience members, mostly aware of Coke's intent, offered responses loaded with irony that ameliorated their own involvement. They savvily suggested that they 'knew' what was going on. They inferred that they were somehow exploiting Coca-Cola because they knew what was happening and they had figured out a way to enjoy themselves at Coca-Cola's expense.

What these savvy responses missed was the way that their enjoyment made the Coke brand valuable.

The young music fans attempted to invert the assumed power relationship between young people and corporations. 'Sure, I know why Coke put on Coke Live, it's because Coke wants to associate with me. I'm not associated with Coke (that would be seriously uncool).' Some of the young women in the audience mimic Paris Hilton, 'coz Coke are awesome (like der…).' Their responses obfuscate the material conditions of popular culture, while at the same time covertly acknowledging an understanding of these material conditions. These reflexive subjectivities only appear through extensive ethnographic fieldwork. Even though I was still fairly young when doing this fieldwork and had spent several years involved with young people and popular music culture in Australia, I still found myself scrambling to keep up with some of the dialogue.

Young people who went to the Coke Live concert were active participants in Coke Live. From this position their analysis was infused with irony, cynicism, subcultural and inter-textual references. They integrated Coke Live into their cultural world by ordering and presenting cultural discourse to make the event coherent and authentic. Within a particular context, which could be redefined at any given time, Coke Live was coded as 'cool.' Small groups of music fans created an acceptable reading of the Coke Live event and their role in it. They figured out ways of participating in Coke Live that were cool and acceptable.

Young people integrated Coke Live into their cultural discourse. The multiple interactions between young people in Coke Live's online and physical spaces translated into a mobile social construction of the Coke brand. Coca-Cola sought to direct this construction as much as possible through frameworks of control and surveillance. Young music fans produced a favorable decoding and encoding of Coke Live because their participation implicated them in the program. Any subversive decoding of the Coke brand would ultimately reinforce it and make it edgier and more authentic. The Coke brand was made authentic and valuable through its experiential social construction.

More often than not young music fans used the discourses supplied by Coca-Cola to authenticate their participation in the event. The young music fans told me that Coca-Cola ran Coke Live to 'give something back' to the Australian music scene. While they might have been aware of Coca-Cola's strategic intent, they chose to emphasize that Coke Live 'help(ed) Australian music.' This discourse was repeat-

edly reinforced by Coca-Cola. Coca-Cola offered 'support for Australian music' to young Australians and musicians as a discursive defense: 'if anyone asks you why we are doing this and why you are participating just say it is to help Australian music.' Supporting Australian music is a totally defensible action. There is no way that helping Australian music can be 'bad' or 'uncool' to the young participants or outsiders scrutinizing it.

Coca-Cola shaped and reinforced the audience members' perceptions of Australian music. Young people adopted these discursive logics, handed to them by Coca-Cola and conveyed them to anyone who enquired about their participation in the event. The young participants also extended the discourse in various ways. For example, they said that in addition to Coke Live helping Australian music it was good because Coca-Cola (unlike anyone else) gave young people the opportunity to experience live music. Coca-Cola used Australian music, I was told, because Australian music is 'awesome,' and 'we' should support it because it doesn't get as much support as it deserves.

My exchanges with music fans at the Coke Live event reflected the complexities and impenetrability of youth culture. The young audience members indicated that to some extent they made choices about their participation in Coke Live. They 'outwitted' the corporation in an attempt to get what they want. Their participation however, still involved work. Participants described getting tickets to Coke Live as a kind of project, they collected labels by buying Coke, collecting bottles off friends, and even grabbing Coke bottles from rubbish bins at school. Coke Live participants engaged with the event and program with different subjectivities, interpretations and practices. Young people don't see themselves as duped strategic pawns. Rather, they see themselves as an empowered and valuable part of the strategic action. Participants argued that they enlivened Coke Live with their agency, and so, they need to be given what they want if they are going to bring the Coke brand to life. While many of them take the event on cynically and subversively, ultimately their energetic enjoyment of the festival pays off for Coca-Cola.

Enjoying Virgin

Perhaps unsurprisingly, all of the V festival participants I interviewed knew that Virgin ran the V festival for strategic publicity, advertising and marketing reasons.[9] They were all aware that the V festival is constructed as a brand-building space for Virgin and its

partners. To them, Virgin runs the festival because, 'they get a lot of money out of it.' They recognized the festival as a strategic brandscape predominantly by referring to the visual elements of the space, 'I can't tell you how many times I saw Virgin merchandise being given out for free: blow-up Virgin chairs, Virgin drink holders, Virgin photo cards, Virgin advertisements and drinks.' Their recognition of these elements of the festival did not however, disrupt their enjoyment of the music.

On their post-festival survey each year Virgin asks punters if they would go to the festival before seeing the line-up announced. Virgin is trying to gauge the extent to which fans go because it's the V festival. The music fans I spoke with go to the V festival to see their favorite bands play, not to see Virgin. The V festival is a strategically valuable brandscape for as long as it appears authentic, ethical and 'disinterested' (Holt, 2002) by booking the right bands. V festival participants' comprehension of Virgin's strategic interests does not undermine their enjoyment of the event. The performance of music that the audience perceives as authentic makes the whole event authentic. They can experience the music in ways which match their perceptions of authentic popular music culture (bands on stage, large video screens and light shows, dancing, drinking, drugs, and boisterous crowds), without the strategic mechanisms in the space disrupting them. The music fans evoke Zizek's notion of 'decaffeinated empowerment' (Zizek, 2006, 2008). Savvy subjects crave what they perceive as authentic music culture, but they also want to have this authentic experience within a comfortable and enjoyable space. The V festival brandscape develops capital value because the fundamental element of an enjoyable experience of live music is in place. The stage, and the performance of live music, is a quilting point that sutures together the brandscape's incongruous parts (Auslander, 1999; Gracyk, 1996).[10]

While Arvidsson (2005) argues that the brandscape displaces experience to an 'artificial branded plateau,' audience members suggest that the festival is inherently real. The V festival, they propose, preserves and enhances popular music culture. The brandscape is a proselyte for authentic popular culture as one fan observes:

> I think it's great because it is the only way music festivals can keep going. If corporations like Virgin weren't running music festivals then there wouldn't be as much publicity, wouldn't be as much funding, so maybe this would result in there being not as many good acts.

From this perspective, without the brandscape's capacity and capital live music would disappear. Notions of what authentic popular music is are always-already embedded within capitalist relations of production (Auslander, 1999; Gracyk, 1996):

> I think it's a very cool way to reach out to the young people, and if big corporations like Virgin don't supply the mass levels of finance and organization to run a music festival, then who will?

Audience members who are 'enjoined to enjoy' (Dean, 2006), appear unfazed by Virgin's strategic intentions. In fact, some argue that the branded spaces and elements of the V festival enhance the experience. One participant explained that 'I don't mind as long as they keep the superb line-ups and supply more free blow-up chairs and ponchos next time.' Savvy subjects seek an enjoyable popular music experience. The performances at the V festival are enjoyable and apolitical. While audience members may still experience the politics of particular bands and musicians, the V festival brandscape is ultimately a space of apolitical enjoyment.

To cynical audience members 'all music experiences are commercialized anyway.' They are 'not too concerned':

> No matter what sort of event you go to these days, there is always a corporate motive behind it. I know that's why they do it, but at the end of the day, if there is something I really want to see there, I'm going to go.

Rather than explicitly defend romantic notions of pure and authentic music culture, V festival participants engage with music performances as if they are authentic. The brandscape functions effectively as long as it does not intervene in their enjoyment. On audience member told me that 'if they're providing good music for a decent price in a relatively safe environment, then it doesn't really matter who runs it in my opinion.' The brand, they claim, doesn't harness or co-opt their experience.

Contemporary music fans cultivate reflexive notions of authenticity and enjoyment within strategic spaces like brandscapes. Audience members offered a number of rationales for 'excusing' or 'explaining' their participation in branded music festivals. I was told that the V festival is more real, authentic, ethical and enjoyable than other festivals because of the selection of bands. Coke Live audience members told me that they had come to see the bands, and were evasive about Coca-Cola's involvement. The selection of bands displays a finely cul-

tivated sense of taste. In addition to this claim audience members also praised both the V festival and Coke Live for supporting live music. This discourse is carefully constructed by corporations that create live music brandscapes. Programs like Virgin's Garage2V and Coke Live's Unsigned support local live music scenes, and give emerging bands the opportunity to play at the festivals. In 2009 the V festival had a stage devoted to local and emerging bands at the festival, Coke Live had unsigned bands open the festival.

Corporations position this support as a socially responsible investment in live music culture. Audience members tend to agree with this narrative that without corporate support live music would 'disappear,' without considering the ways in which live music existed before or without corporate support. The corporate support really enables emerging bands to reach bigger audiences and commodify their music more effectively. Music fans often rhetorically ask 'if corporations don't support live music, then who will?' This rhetorical position assumes that live music is the authentic core of popular music culture and must be protected, regardless of its conditions of production. Audience members also shrug their shoulders and suggest that all music is commodified anyway. So, who cares if a corporation runs a festival that brings together branding and live music?

All of these stances express a way of embedding notions of authentic popular music within capitalist relations of production. This process 'ethically' embeds the corporation within social space. Capital is seen to support and protect authentic cultural experiences. Savvy subjects are aware of capital's strategic uses of social space but act as if these strategic actions have no real social consequences. Capital cultivates enjoyable experiences which audiences read as empowering, ethical and authentic. Participants don't go to the festival 'based on who is running it' but based on the authentic and enjoyable musical experiences they anticipate. The ideological trick is that we implicitly act 'as if' these experiences precede capital, when 'in reality' these notions are constructed by capital in the first instance (Frith, 2007; Zizek, 1989). Frith observes that, 'the industrialization of music can't be understood as something that happens to music but describes a process in which music itself is made, a process that fuses (confuses) capital, technical and music arguments' (Frith, 2007, p. 93). The audience's meaning-making work is central to the industrial production of culture in branded social space.

Music...as it should be

Contemporary brands embody flexible capital. Rather than being doctrinaire or pious, capital is most productive where it creates social spaces for consumers to engage in meaning-making activity. In this chapter I've presented the mythologies of authenticity that brands adopt and illustrated the way music fans engage with those claims. Music fans' authenticity-making practices, even where they are subversive, cynical and ironic, craft mobile and adaptable brands. Brands that can reflexively adapt to the nuances of popular culture by being embedded within taste-making practices are more valuable.

Where brands are too pious and sincere they get caught out trying to hide their commercial motivations (Holt, 2002, p. 87). Their disinterest looks contrived. Brands have to make a material contribution to the social world to give their manifestos substance (by booking the right bands, by supporting the live music scene, and by letting the audience in on the meaning-making action). This material contribution both evidences the brands claims (for instance, they appear to really support music culture) and opens the brand up to the innovative meaning-making practices of the audience. The purpose of this chapter has been to sketch out the ways brands adopt popular mythologies and connect these with the affective labor young people undertake in the social world. This interaction in the construction of popular culture forms the foundation for two key themes I take up in the rest of this book. In the next chapter I illustrate how this affective meaning-making labor gets channeled in media-making practices. Then, as the argument develops, I attempt to illustrate the impasses and limitations of the savvy skepticism young people bring to their participation in social life.

While savvy consumers might be skeptical of corporate brands, and see right through them, this skepticism seems to make brands more valuable and powerful. Skepticism is repetitive and tedious because no matter what consumers know about the conceit of corporate brands (for instance, that Coca-Cola doesn't really love live music or Virgin doesn't really care about righting music wrongs), they still persist as powerful cultural objects that are useful in articulating our identities within social life. Brands appear to feed off the unruly meaning-making practices of consumers. The market is fuelled by the 'constant production of difference' and so 'the most creative, unorthodox, singularizing consumer sovereignty practices are the most pro-

ductive for the system' (Holt, 2002, p. 88). Consumers are caught up in the same contradictions that brands are.

The emancipated reflexive subject, freely making meaning within commodified social life, is illusory (Zizek, 1999). Popular culture offers mythologies and fantasies that obfuscate a culture industry that produces capital as a social and political system. Branded social space engages cultural participants in the production of these mythologies of authenticity and empowerment. Young music fans are at first embedded within these meaning-making practices. Taking up the subjectivity of being a music fan means being able to adopt and perform the mythologies of authenticity attached to live music. These performances are enjoyable and translate into symbolic capital in social life (even where young people see them as contrived).

Chapter Three

'I Pushed My Way to the Front with Every Band I Saw': Mediating Live Music

Cameras and screens

Cell phones, digital cameras and web 2.0 are key devices through which young people experience and enjoy popular music culture. Young people create mediated texts that simultaneously textualize their experience of music festivals and construct brands as mobile media objects. In the previous chapter I examined how brands and young music fans create mythologies of authenticity around the performance of live music. I examined the affective meaning-making labor young people undertake in enjoying popular music. Their taste and meaning-making practices are harnessed and directed by brands. In this chapter I explore the media-making work that young people do as part of corporate brand-building. Young people perform brand-building labor at live music events and online. I organize this chapter around three media-making practices that brands foster: gathering data through young people's interaction with corporate branded websites, textualizing corporate brands and live music performances on social networking sites, and mediating live performances with mobile devices. I aim to explore how young music fans perceive their engagement with branded space and their relationship with corporate brands.

Creating an authentic branded self

The Coke Live website simulates a live music festival in a space where every communicative action can be recorded.[1] Young people participate in Coke Live by registering and building an avatar (a digital character) on the Coke Live website. The avatar is a branded self, a virtual person that can navigate around the branded online world. Participants pick gender, skin color and hair style before fashioning themselves as skaters, emos, surfers, rock chicks (and other cultural styles). They provide cultural, behavioral and demographic information by answering up to 100 questions, including 'Where do you hang out with friends?' and 'What bands do you listen to?'

The avatar is created from a series of possibilities intended to link participants to specific market segments. For instance, the purchase of a hoody, baggy jeans, trainers and large clock may correlate with a preference for urban music. Or, a participant may select skinny jeans, retro trainers, check shirt and a rock-on hand gesture, which may then correlate with a preference for indie rock music. Coca-Cola can make links between demographic, cultural and personality data, fashion preferences and behavior on the site by analyzing the content accessed and generated by particular users. As links are generated between personality, avatar and content information on the Coke Live site members are able to associate with other people with similar interests. Coca-Cola is then able to monitor these interactions and create 'complex tracking mechanisms' for understanding musical tastes and cultural values. Coca-Cola gathers information on the site's users, the content they access, and the conversations they have. For example, Coca-Cola is able to deduce that the participants who are into urban music also wear specific types of clothes, come from certain geographic regions, produce certain types of discourse when chatting on the site, and access certain content. Or, Coca-Cola may be able to ascertain that the largest segment of the site's audience is into rock music, which will influence the bands chosen for the Coke Live tour.

Having created a branded Coke Live self, participants enter the Coke Live site. The avatar is placed within a music festival site, surrounded by virtual stages and the avatars of other Coke Live participants. The site is a virtual online music festival that obfuscates Coca-Cola's strategic intent to monitor participants, collect information and build profitable brands. The young participants perform valuable work by ceding cultural information to Coca-Cola. Website participants use the resources of their authentic selves to fashion a branded self, a virtual person who can navigate around the branded online world. Coca-Cola engages the audience in a savvy interplay that strategically develops brand value by simulating authentic cultural spaces and experiences. The Coke Live website encloses participants within a space and set of practices that empowers capital accumulation. Participants in these spaces perform unpaid or free labor (Andrejevic, 2007a; Smythe, 1981; Terranova, 2000). The activity of cultural participants demonstrates how the discourse of empowerment is used strategically by corporations. On the Coke Live website Coca-Cola turns the experience of music culture into a sophisticated mechanism for collecting information from young people. The claims to supporting authentic music culture that they make through their advertise-

ments, and through the Coke Live tour, obfuscate these strategic actions. The Coke Live website marries the cultural action of individuals to an apparatus of surveillance and commodification. Experiential branding harnesses people's free action in ways that produce capital value (Arvidsson, 2006, p. 197).

Brands promise to support and enhance young people's popular culture. This promise suggests that the brandscape is an ethical space that defends authentic music culture. Corporations have a strategic interest in protecting the authentic cultural spaces they exploit for brand value. The promise of empowerment forms the basis of their claims to supporting and enhancing social life. The ideology of authenticity corporations construct and the promise of empowerment they make obscure the way in which the social spaces of experiential branding are mechanisms for accumulating capital. Notions of authenticity and empowerment are 'fantasies that structure our reality' (Zizek, 1989). The narratives of empowerment and authenticity corporations construct with our mutual participation enable us to misrecognise our social reality. Arvidsson (2005, p. 247) argues that 'as consumers become subjects brands become valuable.' Consumers will only become subjects of the brand if they perceive they are empowered to create and direct it. In this sense, consumers become subjects of their own fantasies of empowerment and authenticity. By making consumers subjects of brands, corporations can activate their claims to playing important and responsible roles in our social world.

Logging into Coke Live

The real Coke Live users are hidden from view. They are visible on the site only through their avatars and comments and are difficult to locate and representatively sample. Coca-Cola, of course, zealously guards all of the information they collect through the Coke Live program. For these reasons, I chose to engage a small group of young Australians to guide me through the Coke Live website during semi-structured interviews.[2] My interview respondents were qualified interpreters of Coke Live (they were in the target market, and engaged in popular music in a variety of ways), but they weren't dedicated participants on the website.

My intention wasn't to present the 'natural' use of Coke Live by young people. Rather I intended to record the perceptions of young people in Coke's target market about their branding strategy. Instead of attempting to determine the concrete effects of Coke Live like a

market research or media effects approach would, my aim was to understand how audience activity is 'articulated within and by social, political, cultural and economic forces' (Ang, 1996, p. 42). The audience is always embedded within ongoing cultural practices that cannot be isolated for objective empirical study. My approach is critical and reader oriented (Livingstone, 2003). I set out to uncover understandings of the Coke Live website by young people in a given social context. My aim is to examine the way interactive media texts like Coke Live 'mediate relations among people' (Livingstone, 2003, p. 353) and to explore how the audience is embedded within the sociocultural space (Nightingale, 2003) of the brandscape. I was interested in the ways in which participants form themselves as subjects (where subjectivity is a form of consciousness). Subjects use language to produce complex discourses that cannot be taken as simple realist representations of the social world (Seiter, 1999, p. 28). In using language to construct themselves in relation to popular culture, subjects may be unwittingly or consciously caught up in reinforcing the power structures of brands.

The young people who guided me through the Coke Live website were adept at articulating Coca-Cola's strategic intent. As they worked through the website, built an avatar and explored the pop music applications they shared their thoughts and perceptions. 'It's cunning,' one noted as they sifted through the array of sneakers they could choose for their avatar. He followed up by suggesting that Coca-Cola was setting out to build a personal relationship with a young audience through the website, and that by encouraging users to invest in creating a personal avatar as a communication tool, they were giving users 'status' or identity on the site.

The avatar design process involves constructing a visual representation in order to participate online. Coke Live users constructed an identity from a series of predetermined coordinates (hair styles, skin color, clothes and accessories). While this process intrigued participants, they were all especially critical of the personality-building process. They could see that by asking participants to 'build a personality' online, Coca-Cola collected information that would help them formulate their brand more effectively.

Despite Coca-Cola's assertion on the Coke Live site that building a personality helped you 'meet other like-minded people' online, my interview participants were media literate enough to be skeptical of this claim. They were all 17 or 18 years of age and were either in their final year of high school or first year of university, so I can't generalize

this skepticism to the entire Coke Live audience. One participant mused that 'most young people would not realize' the corporate intent. The extent to which young people can discern corporate intent in these programs is an important question and one which I cannot answer fully here. The young people I interviewed were in the target market for experiential branding programs or were active participants in those programs. Overwhelmingly, they expressed some perception of corporate intent, frequently couched in savvy, cynical and ironic terms. As the young people I spoke with (about Coke Live and other corporate programs) were all 17 or older, I can't offer insight on when and how these perceptions of intent and media literacy develop. Further research with younger audience and markets could offer insight into these questions.[3]

Coke Live appears enjoyable, fun and relatively harmless. 'Young people love to do personality quizzes' a participant told me as she thought about why young people participate on Coke Live regardless of whether or not they could discern the corporate intent. Coke Live does cater to what Botterill (2007) describes as the creative 'authentic project of the self.' Young people willingly engage in mediated identity projects (through interactive websites, television, magazines) as a process of creatively shaping and articulating their identity. Enjoyment and pleasure are derived by articulating oneself within the spaces of mediated popular culture. Within this context, young people can wonder, 'What exactly is the big deal about ceding information to Coca-Cola if it is just a bit of harmless fun?'

Participants enjoyed the avatar design process. They took time to select different dress options and play with hair color and fashion accessories. Some avatar items were free, whereas certain fashion items and accessories could only be purchased with Coke Live reward points. These points could be earned by answering more demographic and cultural questions. On Coke Live personal information is a commodity you can 'sell' to Coke for more rewards points. The participants enjoyed this process for what it was but could easily discern the underlying strategic intent. 'Why do you think Coke makes you pay for that haircut?,' I asked one of the participants as they were searching through different styles. The answer was clear, 'The majority of people have these sort of hair cuts (referring to the free ones), whereas these haircuts (referring to those haircuts which could only be purchased) are sort of 'out there.' These hair cuts, like, turn heads.' Coke Live members who want their avatar to 'look cool' have to spend Coke Live points on rarer styles and accessories.

The Coke Live website has the capacity to collect reams of valuable demographic and cultural information from its users. This capacity though is only realized if Coca-Cola can recruit an audience of dedicated users. Coca-Cola required Coke Live members to build up rewards points by answering up to 100 demographic and lifestyle questions or entering the barcodes of Coke bottle labels. The reward points could be used to purchase sponsored products, online content and tickets to Coke's all-ages music festival. 'I don't have the motivation or desire to drink Coke constantly for the single purpose of going to a concert,' observed one participant who had been to previous Coke Live concerts. To most of the interviewees the Coke Live site was too contrived. The idea of investing large amounts of time building avatars, and socializing with strangers online was unappealing. While they do use the web to communicate with their peer network and to access music culture content, the Coke Live site was far too complicated. The Coke Live site was unlikely to become a natural hub of their online social lives. MySpace, Facebook, YouTube, MSN and a plethora of other niche sites were already the spaces where this action was taking place.

This reluctance to participate in Coke Live as a social networking space corresponded with my own observations of the Coke Live site. Few young people appeared to be using the site in a dedicated fashion. The chat rooms continually stood empty and were eventually closed. The site 'populated' the music festival space with the avatars of people who were supposedly online; you could chat to these 'live' users or look at their profiles. There were never that many avatars online, and virtually no chatting took place. The only part of the site that ever appeared active was commenting on the exclusive music videos and interviews with bands and pop stars. This perception aligned with the thoughts of the interview participants who suggested that they would use Coke Live if there were content, prizes or concert tickets available which they wanted and which were reasonably accessible. To my interview participants at least, spending half an hour designing an avatar, answering up to 100 demographic questions, collecting Coke bottle labels, and participating in other online games to earn Coke Live reward points was largely too arduous to be worth the bother. Why work so hard for Coca-Cola when other global corporations and web 2.0 portals give it away for free?

Young people are adept at using corporate marketing programs to their own advantage or purpose. They may sample, adapt, and adopt elements of the program which suit their interests and needs, and re-

ject other elements. In the process they may provide deliberately misleading or false information in order to access the content, applications and prizes they are after. At least two of my interview participants took delight in entering false data and indicated that they always would enter false data for corporate sites like this. They just put in any information to get them to where they want to go.

The young people I spoke with all suggested that Coca-Cola ran Coke Live so that 'people buy more Coke.' Delving into their perceptions further helps to illustrate how these notions of corporate intent are deployed or diffused as part of their participation in popular culture. They articulated a variety of ways in which they think Coke Live translates into more Coke sales. They understood how marketing programs like Coke Live created capital value for Coca-Cola.

The young interview participants wryly observed that Coca-Cola targeted young people because they were the most important market to relate to. Older people who don't already drink Coke are unlikely to start. Coca-Cola is more likely to convince young Australians to begin drinking Coke. Coca-Cola has confirmed that their strategic objective is to relate to young people so that the Coke brand would be associated with formative 'coming of age' experiences. People will come back to the brand throughout their lives if it was an important part of their youth. Despite all of Coca-Cola's claims about their support for popular music culture, young people can see how supporting youth culture has its strategic payoffs.

The young participants made astute judgments about Coca-Cola's strategic intent. They saw Coke Live as an instrumentally constructed social space that enabled Coca-Cola to manage a relationship with, and collect information about, young people. They discerned how the information young people provide Coca-Cola enabled them to more sensitively develop their cultural credibility. The information young people provide helps to make Coca-Cola more adept at figuring out what styles of music, celebrities, and fashion are popular. Through the productive labor of young people on Coke Live, Coca-Cola becomes a savvy and reflexive coolhunter.

The Coke Live program focused exclusively on Australian music. Coca-Cola repeatedly claimed that they were making a significant investment in Australian music. Again, the interviewees could discern many strategic reasons for Coca-Cola's support of Australian music. Some participants suggested that Coca-Cola supported Australian music because it was 'edgier,' 'hipper,' 'more underground' and 'less mainstream,' which helped Coke appear cooler and more 'authentic.'

It would be too obvious for a large brand to support a large international pop star, but to support local Australian music demonstrated that Coke 'understood' or 'was down with' young Australians. Interviewees also suggested that Coca-Cola supported the Australian music scene. This action was seen as socially responsible, even though it did have strategic pay-offs. For instance, Australian musicians involved in Coke Live became advocates for the Coke Live tour and the Coke brand. While the Australian theme might resonate with young audiences and can be positioned as socially responsible, they could discern sound economic and strategic justifications.

The young people I interviewed about Coke Live savvily avoided being closed down in a subject position that dismissed Coca-Cola as purely exploitative of their cultural practices on one hand or embraced Coca-Cola's claims to supporting music culture as totally true on the other hand. They recognized both claims in play and saw them as a contradiction that is constantly working itself out within popular culture (similar to Holt's (2002) contradictions of postmodern brands). The existence of the Coke brand is purely strategic. If it were completely 'disinterested' and altruistic it wouldn't exist. The brand can only be strategically effective by obfuscating this intention. It must embed itself within, and play a part in producing, cultural spaces that audiences find meaningful and authentic. In the rest of this chapter I will illustrate how brand-building is most effective where brands engage with young people's 'ordinary' media-making spaces and practices. The limits of Coke Live's 'simulation' of live music are overcome where the brand engages directly in shaping and valorizing music fans' 'real' communicative practices.

The wider web of Coke Live

Similar to other live music events, in the weeks surrounding the Coke Live festival, online spaces like MySpace and YouTube were abuzz with Coke Live related content generated by young Australians.[4] The media-making activity on web 2.0 was far more lively and 'authentic' than on the Coke Live website. Comments, blogs, photos and videos were posted on personal and bands' social networking sites and message boards. One music fan posted an image of herself on stage on a band's MySpace page accompanied by the comment, 'i was at the sydney show! i was on stage woot! well fun!' Other fans expressed their jealousy at her onstage excursion, to which she replied:

its pretty good aye...ben came down to the edge of stage, put out his hand
and invited me up with him...he even got security to pull out of the mosh
and help me up there...then he sang me on his knee...ahhh so good lol.

Another message on a band's MySpace page read, 'I was at the
SYDNEY show and i got to say hi and get a pic with u...I love u After
The Fall...speshly u Ben!' The online content produced in the wake of
Coke Live illustrated concert goers creating culture which is a pas-
tiche of the styles and sounds Coca-Cola has given them to work with.
The promotional, celebratory and rebellious discourses of the red car-
pet event are repeated by young people online.

At the Coke Live music event (like other music events) devices
like cell phones and digital cameras were used to capture perfor-
mances. Following the event the content captured on these devices
was disseminated online (on social networking sites like YouTube,
Flickr and MySpace). These online practices are significant brand-
building activities. Music fans engage in the textual construction of
the brandscape. They construct multiple Coke Live related texts.
Commentary before, during and after the Coke Live tour on bands'
MySpace pages captured the role that young people played in mediat-
ing Coke Live and constructing the Coke brand outside of the space
created and controlled by Coca-Cola.

MySpace members responded positively to the news that the
bands were playing the Coke Live tour and then expressed excitement
when they got tickets. They also discussed performances and offered
their thoughts on the bands playing the tour. Nowhere on any blog
was Coca-Cola explicitly discussed or their involvement or motives in
running the tour raised. The young music fans created reams of con-
tent about the bands and the performances but nothing about the
marketing exercise itself. Following the tour young music fans viewed
bands' tour diaries and blogs and shared their own experiences, pho-
tos and video content with the bands and other fans. Several audience
members posted videos of Coke Live that they made with their cell
phones on YouTube. After The Fall, a band on the Coke Live tour,
linked to these videos from their MySpace blog, commenting that fans'
videos 'provide the best view.'

Coke Live is a successful catalyst for online discussion and textual
production. While Coke wasn't explicitly the topic of the discussion
(the bands and their performances were), Coke Live provided the un-
derlying framework. This implicit engagement in music culture, by
creating a brandscape within which cultural action unfolds, con-

structs more valuable brands than explicit marketing approaches that savvy music fans see right through.

Through Coke Live, Coca-Cola made itself an authentic part of the continual production of music culture by fans and bands. Coke became the space within which popular music comes to life. In response to the announcement that pop-duo The Veronicas were headlining the festival, posters to their MySpace exclaimed, 'if i go will i really get to see da veronicas on the red carpet? WOW omg omg omg omg omg!!!!! THAT IS SO AMAZING.' Despite the fact that The Veronicas live in the United States, one poster wrote:

> I've got my tickets for Brisbane! You know. I really admire you girls keeping true to your home <3 It's really great that you two do so many shows here unlike alot of aussie artists that spend all their free time and energy in the states. You rock. Hardcore.

The MySpace posters write in a language and deploy cultural capital that Coca-Cola could never authentically mimic. The posters use a language that is closed to Coca-Cola. Coke Live however, valorizes these meaning-making activities. Popular music is all about taste and distinction. It is made authentic through continual contests about taste. There is ample space both on MySpace and the Coke Live site for 'dissent.' One poster on MySpace lamented The Veronicas' inclusion on the tour:

> I feel so sorry for evermore, end of fashion, after the fall and the hot lies…I feel so sorry for the people that are going to go to watch them since they have to suffer with the droning of your sickening voices. why the fuck have you been added to this tour with these bands? like what the fuck are people thinking? shouldn't you be touring with… hmmm i don't know, ashlee oh well, i guess people can just go to throw hammers when you come on.

After the gig, another poster tagged The Veronicas on the Coke Live website with the comment, 'GO HOME VERONICAS THE DRINK BOTTLES WERE A HINT.' While some fans were dying to meet them, others were planning to throw drink bottles and hammers. That, after all, is the point. Through Coke Live, Coca-Cola captured all of this energy, these subjectivities and texts within a social space that converted all of this action into brand equity.

While these textual exchanges took place on MySpace and the Coke Live site between bands and fans, they all worked toward translating the Coke Live concert into an authentic and meaningful expe-

rience. Taste-making and media-making come together to create compelling narratives around which brands can articulate themselves. Music fans posted photos and stories about the event which authenticated Coke Live, the bands and the practices of mediating the live music event.

> I was at the SYDNEY show and i got to say hi and get a pic with u while u we're watching Evermore...i felt bad cuz u we're trying to enjoy Evermore..BUT I COULDN'T HELP MYSELF!!!!! I was the one who had to have many photos cuz my friend is a lame douche who doesn't know how to take a photo...but i enjoyed havin ur arm round me...mmm! And Shane was in the pic too!!! YAY! I'm sounding alot like a groupie but meh! Who cares! I love u AFter The Fall...speshly u Ben! P.S I LOVE the curly hair..can't wait to see u again! uz we're awesome! mwaaaahhhh!!!!

Their stories were an authentic record of the event that captured them enjoying the music, adoring the bands and making content.

> i met use as you can see in my picture! u are all very nice and u signed my shoe my top and my arms and u drew a loveheart with a arrow threw it and u told me to get it tatood on.

Coke Live successfully apprehended the myths of rock culture. In response to one of the bands' photo diary of the Coke Live tour, one fan opined, 'I'm so jelous! I want to live out of a suitcase, eat cheap but nice food and sleep in funky smelling hotel rooms. You were all great at Coke Live, Sydney. Keep rocking ur socks off!' It might seem naff to make a point of it, but at no point did any fan say that playing Coke Live was uncool. The only time Coca-Cola got an explicit mention was when some fans joked about how much Coke the bands had to drink on the tour. By mediating their identity and the Coke brand on MySpace, young people perform labor that creates brand value for Coca-Cola. They are both a commodified audience and a creative workforce for the Coke brand (Cote and Pybus, 2007). Arguably, this 'free' textual production outside of the Coke Live website produced more authentic and natural connections between the brand and popular music. In the next section I move to the V festival to illustrate how this textual production unfolds at live music events.

Leaping upon Thomas Mars

The Virgin brand is partly constructed through the social and meaning-making practices of young music fans. Their work in translating

their social world into information commodities constructs the Virgin brand as authentic, empowering and socially responsible. Many music fans experience the live performance via their mediation of it. At live music events the contemporary audiences get caught up in the compulsive mediation of social life.

In the early afternoon at the 2007 V festival the ultra-hip French band Phoenix took to stage. During their performance the lead singer Thomas Mars leapt off the stage and into the crowd. The crowd surged toward him. Historically, when a band member jumps into the crowd, people surge forward to physically touch the singer. In 2007 though, the crowd surged forward to photograph him, rapidly translating his performance into media commodities. The main stage screens displayed images of the Phoenix singer being photographed, and then these photographs were distributed to the screens by the audience.

The spectacle reflected celebrity media culture. Audience members used their devices to act like paparazzi, capturing images of celebrities and then distributing these images to online media spaces such as the V festival screens, V festival websites, and their own YouTube, Facebook, MySpace and Flickr pages. Experiencing live music is emblematic of broader shifts in popular culture toward a compulsive mediation of social life (Hearn, 2008). The audience uses devices to endlessly gaze on banal, everyday action happening 'as it really is.' Full immersion in the V festival is dependent not only on access to the physical site but also access to the devices and online spaces within which the audience, bands, and Virgin mediate the festival experience. Participants use their cell phones and digital cameras to stay in touch with friends, to network across the site, arrange meetings, and distribute content to friends of the action on the site. These processes do not immediately appear commodified, except when one considers the way these communication devices are embedded within capitalist modes and relations of production.

Live music performances serve as the central 'quilting point' around which music fans gather. The live performance is the central cultural object that audiences enjoy and mediate. The live performance authenticates both the musicians and the space within which they perform. The images and videos that music fans capture of these performances are translated into information commodities. These small texts become the content on web 2.0 spaces like YouTube, Facebook and MySpace. They work as value-generating information commodities in several ways: as audience-building content for web 2.0

spaces, as texts that ratify the social experiences that unfold in brandscapes, and as advertisements for Virgin. At the V festival, Virgin set out to construct a mediated social space that harnesses the enjoyment of live music and engages the audience in social practices that mediate that enjoyment.

Thomas Mars from Phoenix in the crowd at the 2007 V festival. This image is of the big screen at the festival capturing the moment live. Note the camera being held up to capture the moment. Photo: Nicholas Carah

Audience members use their digital cameras and cell phones to convert their authentic enjoyment into information commodities.

> I used my digital camera to take pictures of all the rock and roll icons and my friends rocking out in the mud. It was great to capture the festival atmosphere.

Capturing the festival atmosphere, and distributing it throughout web 2.0, focuses on capturing the bands, friends, fashion and voyeuristically gazing upon 'people with particularly strange behavior.' One audience member at the V festival explained to me that using digital

cameras and cell phones and gazing upon the big screens at the V fes-
tival revolved around people 'expressing how much fun they were hav-
ing.' Audience members emphasize how their cell phones and digital
cameras enable them to translate enjoyment into media texts. For in-
stance, one music fan recounted to me the experience of

> getting on my friend's shoulders at Splendour in the Grass while the
> Presets were playing and doing a 360 video recording of the crowd on my
> mobile, then showing it to other people to convey the group enjoyment of
> the crowd experiencing the festival.

Another live music fan told me that they had used their cell phone to
capture and send recordings of a Chemical Brothers performance at
one festival to a friend who was at another music festival in the same
city on the same day to 'show off that they were missing out on the
Chemical Brothers.' The lens and screen are a mechanism for captur-
ing and mediating enjoyment. Brands set out to commodify this en-
joyment (Arvidsson, 2005).

The audience are empowered to use devices, capture content and
actively participate in the performance. The avid enjoyment and par-
ticipation in the event create shared meanings and emotions attached
to the brand. This participation also creates a valuable surplus in the
media commodities generated and distributed as content to corporate
spaces like the festival screens, websites and content-sharing sites
like MySpace, Facebook and Flickr (Arvidsson, 2005; Moor, 2003). The
live performance is deployed as a reservoir of authenticity, a quilting
point that brings together the audience's participation with the tech-
nical apparatus of the brandscape. The live performance is a catalyst
for the production of information commodities. This apparatus both
extracts surplus value and constructs notions of authentic music cul-
ture valuable to the brand.

The use of devices to capture enjoyment is now embedded within
popular music culture. Contemporary audience members approach
cultural spaces with their devices in hand. Part of experiencing and
enjoying the space is gazing upon each other (Chesher, 2007; Gye,
2007). At a music festival, the stage and the bands provide the key
point of reference for this capturing of enjoyment. The stage is the site
the audience reference as the source of authentic enjoyment. And so,
it is toward the stage that they gaze

> I pushed my way to the front with every band I saw. I have a really effec-
> tive technique which basically involves me flailing around like I'm on ec-
> cys. Once I was at the front I grabbed some photos and a few videos.

While the audience appears empowered to use devices, capture con-
tent and participate in the performance, this performance is contin-
gent on them having access to these commercial spaces (Goggin, 2006;
Goggin and Gregg, 2007). Their participation in these spaces is har-
nessed as a form of labor for the production of information commodi-
ties (Arvidsson, 2005; Moor, 2003; Terranova, 2000).

Device use and screen culture are entwined with the development
of savvy identities. Audience members ironically refer to the narcissis-
tic culture of MySpace and Facebook photo practices like 'holding the
camera out and trying to get people into the frame.' Where Coca-Cola
took a concerted and regulated engagement with music fans over a
several-month period on the Coke Live website (music fans had to use
the site and enter significant personal information to secure tickets to
the all-ages music tour), Virgin harnesses young music fans media
production by letting the audience translate the festival into media
texts in their own web 2.0 networks. Coke Live demanded more di-
rected and comprehensively tracked labor, where Virgin cultivates
more reflexive and mobile forms of labor. At the V festival, Virgin
harnesses the audience's use of cell phones and digital cameras by
encouraging audience members to take photos and make videos of
themselves, the bands and the action on the site. They are encouraged
to place this content online in both their own web spaces or Virgin's
spaces (social networking sites like Facebook, MySpace and Flickr).
The audience are also encouraged to send content directly to the big
screens at the festival via Virgin's 'foto the fest' promotion.

Images on the big screens, mobile and digital camera screens, and
social networking sites capture and reflect the enjoyment being had in
the space. The audience gazes on itself, telling itself that it is having
fun. Voyeuristic images of selves, peers, musicians, and strange beha-
vior in the space capture this enjoyment. I asked audience members to
consider why they thought Virgin promoted the use of devices within
the festival site. One described how the use of cameras at the V fes-
tival constituted a form of advertising work:

> With the amount of advertising around the (festival site) that is sure to
> be captured in a number of photos. If those photos are then shared or
> loaded on MySpace it's like product placement advertising.

The audience member recognized the way their use of cell phones constitutes a form of media production like advertising. The practice of using a cell phone to capture their authentic personal enjoyment of the festival, when uploaded to social networking sites, takes on the properties of a strategic advertising text. The audience members I interviewed had uploaded content they captured at the V festival to their own social networking spaces. Through these activities they embedded the brand organically within their peer networks and within their mediated account of social life.

This image is of the big screen at the 2007 V festival. The image is of the 'foto the fest' promotion, where audience members sent images they had taken at the festival on their cell phones to the big screens. This image features an audience member drinking from a Red Bull cup. Photo: Nicholas Carah.

Audience members create images featuring their authentic enjoyment of the V festival. These images regularly capture the corporate brands and logos embedded in the space (Virgin wristbands, blow-up chairs, drink holders, glasses, stickers, badges, banners, screens, promotional staff and so on). The body functions as part of the brandscape (Moor, 2003). The brand drank, danced, took drugs,

wrestled in the mud, took photos of itself and distributed these photos online. These artifacts moved through the site, being carried by individuals, bounced across the audience and so on.

A Virgin branded beach ball is bounced across the crowd in front of a performance at the 2008 V festival. Photo: Nicholas Carah

While this created a visual effect on site, of seeing the brand logos moving throughout the space, the effect is also visible on YouTube, Flickr, MySpace and Facebook. The images they upload function as advertisements for the festival and for the brands embedded in the festival space. These images are arguably more authentic than advertisements. Rather than appearing to have been constructed as persuasive instrumental texts, they appear to capture natural and authentic enjoyment that just happens to be within branded space. Virgin's harnessing of 'natural' content-producing practices within web 2.0 spaces is more effective than attempting to explicitly brand or advertise within the space. The brand embeds and entwines itself with the popular culture experiences audiences take to be authentic.

Rockstars without guitars

Brand-building unfolds around the live performances. Virgin does not intervene in the performance of the music on the stage, which must be perceived as authentic. Bands are not involved in overtly promoting the Virgin brand as part of playing the festival because this would look contrived. Bands are only involved to offer a live performance that legitimizes the festival as an authentic cultural space. As I entered the V festival I received an SMS from Virgin, 'Rumor has it that Richard Branson is in town for V festival! Keep your eyes peeled.' One audience member I interviewed happened to be nearby when Branson appeared on site with a harem of promo-girls dressed in shiny red kitsch nurses' uniforms. She recalled that:

> Richard Branson came out handing out free ice-creams and a swarm of people mobbed him taking pictures, this gives Virgin even more promotion and money. Richard is not a silly man.

The bands aren't the only symbols and mythologies that get mediated. Branson is recognized as a celebrity for the brand, as an authentic embodiment of Virgin's luster, appeal and values.

The audience members I spoke with suggested that the V festival promoted user-generated content where most events discourage it. In doing so, they thought, the festival increases the 'feeling of being involved' for audience members at the same time those audience members 'take photos and videos (they) are likely to share with friends— which is free advertising for Virgin.' Engaging the audience in communicative practices where they create the brands' mediated artifacts makes the brand mobile and reflexive. Mobile and reflexive brands are more adept at molding themselves to constantly changing social contexts where traditional advertising texts are ineffectual. The V festival crafts the social space as a self-governing mechanism that constructs information commodities and brand equity. At the V festival the audience goes to work producing these reflexive and mobile advertisements. While they may recognize this practice as brand-building, they also see it as rooted within their authentic enjoyment of live music culture.

Audience members and musicians participate in these festivals because they perceive that corporations support live music culture. This support for authentic culture makes the brand inherently ethical and empowering to them as liberal subjects. They enjoy the music performance and shared experiences with friends and peers within

branded social space. The brand promotes forms of enjoyment which are framed as inherently ethical and empowering. From these experiences notions of corporations as responsible social citizens can be developed. The corporate brand not only sets out to enhance authentic culture, it also supports social and environmental causes. Embedding these claims within brand-building makes corporations' ethical activities appear natural, disinterested and authentic (Holt, 2002). This appearance of ethical, authentic and socially responsible actions obfuscates the underlying strategic intent of branding.

The brandscape is a strategic mechanism for producing brands that facilitate the sale of commodities. At a more fundamental level though, it is an apparatus for naturalizing capital as a socio-economic system. Through the brandscape capital brands itself. Discourses of globalization, cultural diversity, liberal multiculturalism, creativity and technological progress are repeatedly invoked in the construction of corporate brands. These discourses obscure the frictions of 'class, race, gender and global inequalities' inherent in capital (Goldman and Papson, 2006, p. 338). While on one level corporations seek to differentiate themselves from their competitors via branding strategies, at a more fundamental level, corporate branding as a discursive and social practice contributes to the shared project of naturalizing capital through the construction of branded social space.

Brands engage citizens and consumers in an 'immaterial production process' (Arvidsson, 2005, p. 238) that creates surplus value and capital. Immaterial labor produces both immaterial commodities and the social context of production. Music fans produce media texts and information commodities, but they also produce the social relations and mythologies of enjoyment and authenticity within which brands thrive. Brands engage us in forms of cultural labor and subject us to forms of surveillance, while 'deploying the promise' of real and authentic cultural experience. Cultural labor creates an 'ethical surplus— a social relation, a shared meaning, an emotional investment around a brand' (Arvidsson, 2005, p. 237). The brandscape is a mechanism for embedding brands within our way of life. In the brandscape consumers are simultaneously engaged in producing both corporate brands and their own identities. Meanings are shared between individual participants and between cultural participants and brands. This cultural production is valuable because it is not directly controlled by capital and so appears natural, free and authentic. While cultural practice is often enclosed within the strategic space of a brandscape, it continues to appear free and autonomous.

The contemporary brandscape embodies a key dialectic, or tension, within contemporary culture. The strategic intention of the marketer is to make the brandscape a closed and instrumental apparatus; at the same time cultural participants must feel that it is an open and free structure where they autonomously direct the action. It is precisely this paradox that makes the brandscape appear real and authentic; this sense of authenticity drives brand equity and capital accumulation. The tension between autonomous cultural participants and brand managers creates the 'diversity, ironic twists and unanticipated developments' (Arvidsson, 2005, p. 244) that make the brand an authentic 'open ended object' (Lury, 2004, p. 151). The brandscape is managed by steering innovation so that the brand evolves in specified directions. The brandscape is a mediated social structure where consumers perform brand-building labor.

Chapter Four

'We Are Not Here to Endorse Products; We Are Just Here to Play Music': Musicians in the Brandscape

Rock Gods in the brandscape

Wolfmother is an Australian retro-rock band who rose to fame in 2005. Throughout the summer of 2005 and 2006 they were the 'hottest band in Australia.' Their record was a hit; they headlined festivals, played sell-out tours, toured the USA, won a hard-rock Grammy award and of course endorsed many corporate brands. Wolfmother's retro-rock style dredged up the musical past of 1970s hard rock icons Led Zeppelin and Black Sabbath. They transplanted the sound, song structure, and performance style of these bands into a contemporary social context. They leveraged the perceived cultural capital from past rock music styles into their own musical commodity. On stage, Wolfmother played the style 'straight,' and their fans lapped it up with mock-sincere, ironic delight.

Not everyone liked Wolfmother. While it was no secret that Wolfmother's style was a pastiche of 1970s hard rock, many taste makers still deployed their cultural capital to reject them as 'inauthentic.' Mike Patton from the seminal alternative rock act Faith No More was one of those who sought to defend a notion of authentic rock music. Patton was interviewed backstage at the Lollapalooza festival where Wolfmother could be heard playing their hit song *Woman* in the background. Patton screwed up his face and said:

> Are you hearing this shit!? What year are we in? Forgive me, but, Wolfmother you suck! Help me! Am I fucking crazy? Can I get an Amen! My God, enough already, are people that stupid? I guess they are.

Patton's comments spread around social networking sites where fans took sides. Fans of Mike Patton defended their idea of authentic rock music, 'Patton is a musical genius. Wolfmother are derivative shite' one fan posted on a forum[1] while other fans ironically joked 'Wolfmother will save us all baby!' Despite many hard rock music fans hat-

ing Wolfmother, they were a valuable musical commodity because their music combined the sound of seminal 1970s hard rock with the stylistic sensibilities of contemporary pop music in ways that their record label and corporate brands could valorize. They became a promotional vehicle for the authentic; connecting up rock music's founding myths with the branded social world of the present.

Wolfmother became a symbolic vehicle through which corporate brands could access the mythology of Led Zeppelin, Black Sabbath and other 'real' rock gods. Wolfmother simultaneously produced popular music performances and recordings, multiple media texts and brand content. As they released their record, they also performed at music festivals such as Lollapalooza and the Big Day Out, they appeared on music television like MTV, Channel V and Video Hits, and their image and music were used in branding campaigns for Lee Jeans, Apple iPod, Sony Playstation, XBOX, Absolut Vodka, Coca-Cola and General Pants. Wolfmother became an intertextual commodity, where each of these symbolic appearances was mutually reinforcing. They rehabilitated a rock mythology to simultaneously promote their own commodified and mediated performances and corporate brands.

Wolfmother was a conduit for the discourses of rock music mythology corporations want to access. Their performance of an old style of rock music leveraged cultural capital and mythology developed by a generation of performers before them. These rock myths (pleasure, excess, individualism and hedonism) are still meaningful to the youth market, but the embodiment of these myths in old bands like Led Zeppelin and Black Sabbath is meaningless and inaccessible. Corporate brands needed a new symbolic vehicle for old myths. Wolfmother developed their sound and performance from an established archive of cultural knowledge and inserted it within a current cultural context. They performed the postmodern pop maneuver of taking what was old and making it new again. In doing so, they reinforced the canon of rock music mythology and mobilized it as a resource for the construction of valuable brands. Through Wolfmother corporations access the cultural mythology of these earlier forms of rock music.

Popular musicians are caught up in a branded and commodified social and cultural world. Images of musicians and their performances are used as content for advertisements. The myths and discourses they construct through popular music culture are deployed as structures of meaning for corporate advertisements and brands. Their music is used as a soundtrack for advertisements and for retail

environments. The bundle of myths, meanings and identities crafted through popular music is attached to corporate brands and spaces. Popular music is commodified in a myriad of ways beyond the performance and recording of music.

In this chapter I explore how musicians are embedded within an experiential brandscape. In carrying out this exploration I consider the interaction between musicians and marketers as they work to co-create experiential brands. Brands are the product of social relations. The social activity that musicians undertake to build brands is a form of 'immaterial labor' (Arvidsson, 2006; Terranova, 2000). The experiential brandscape relies on the avid participation of musicians. Rather than simply sell their records and performances to audiences and stand aside while these performances arc mediated as brand content, musicians are increasingly actively involved in the construction and mediation of brands. They traverse a line between being reservoirs or conduits for the audience's perception of authentic and meaningful popular culture, and being strategic vehicles for the construction of valuable corporate brands.

I sketch out a portrait of contemporary pop musicians and bands (like Wolfmother) interacting with marketers as strategic-authentic musicians. They perform at events that interweave live music performances with the construction of branded experiences and spaces. They assist corporations in the construction of mediated content that interweaves the brand with music. They license the mediation of their recordings and performances. They do backstage interviews as part of corporate promotions and they perform at branded music festivals. They also participate in a social context in which audiences mediate live performances with cell phones and digital cameras. They are the cultural object that audiences want to mediate and provide a focal point for this device use that translates into a myriad of networked information commodities for brands to leverage.

Backstage at Coke Live

The backstage at Coke Live appears like a 'normal' rock show. The bands hang around drinking and socializing and take to the stage to perform before an audience who appear like any other audience. Most of the overtly corporate aspects of the branding program are hidden from the musicians. Their job is to authenticate Coke Live as a popular music event, not to overtly endorse the Coke brand. Rather than

intervening in their performance, Coca-Cola embeds the bands within a space of branded installations and branded content.

To be given permission to interview a band playing Coke Live the band's management had to be assured that the tone would not be 'critical' of Coca-Cola. With these parameters in place before the interview began, I still sought to ask the band what they thought of people who might be critical of Coke Live. I encountered a discourse of 'conversion.' The band said that at first even they were skeptical of Coke Live (as any authentic rock musician would be), 'when I first heard about it I thought fucken Coke tour, fuck off!' Having participated in the tour however, they saw the program as a good thing for Australian music. The band justified their participation by pointing to other musical festivals and events which have been commodified (like the Big Day Out and Lollapalooza). If all spaces of popular music culture were commodified, then they saw little point in resisting this element of commodification, especially when, unlike others, it gave young music fans the opportunity to see live music. They reinforced this position by asserting that the audience weren't attracted to Coke, that they came to see the bands, and this 'opened their minds to different kinds of music.' The band offered three key rationales for participating in Coke Live–that Coke supported Australian music, that popular music is commodified anyway, and that the Coke Live tour provided a meaningful experience for young music fans. These rationales reflected the perceptions of V festival audience members discussed in the previous chapter.

The band reinforced their position by referring to the audience's positive reaction to the tour on MySpace pages and by noting that Coke Live was the largest all-ages tour of Australian music. As I delved further into these perceptions I encountered the strategic pragmatism of musicians who participate in brand-building programs like Coke Live. The band agreed that Coke Live was

> obviously a massive marketing thing for Coca-Cola, but at the same it is a massive marketing thing for us. It's better promotion than for our last record, they're doing a better job than our last record label. If someone is gonna get us on TV, then I don't have a problem with that, if someone is gonna help us, so be it.

Coke Live had provided a national tour in front of enormous crowds and large-scale mainstream media coverage, the best publicity they had ever had. They hadn't had any negative reaction from fans or

peers and were grateful for Coca-Cola's investment in them as a band and in the Australian music scene.

When pressed though, the band was keen to assert their authenticity as rock musicians, although the ambiguity in this position was apparent. As one band member said, 'We are not here to endorse Coke we are just here to play music, and that's it basically.' Another band member suggested, 'Well I guess in a way we are (here to endorse Coke).' To which the other replied, 'We are, (but) it's not like I walk around drinking Coke all day.' His band mate agreed, 'I don't drink it anyway.' Despite the fact that they were playing a festival devoted to the construction of the Coke brand, they separated themselves from the brand-building aspects of the festival by not drinking Coke. They were just there to play music and distanced themselves from the suggestion that it was their performance that really built the brand (rather than any overt endorsement of Coke). What this disavowal overlooks is that the more disinterested and natural their performance, the more it paid off for Coke because it appeared more authentic. Coke probably preferred musicians not to overtly walk around drinking Coke and endorsing Coke—that would look contrived. During the concert another band appeared to cynically over-endorse Coke, repeatedly encouraging the young audience to 'do the right thing' and pay Coke back by drinking heaps of it. This over-endorsement was downplayed by the host.

When I asked the band if they had reservations about the tour, they replied, 'you gotta weigh it up in terms of the best way to reach an audience.' This pragmatic 'business sense' of the musicians was further reinforced by a tour manager for several of the bands who have played Coke Live. The manager's job was to make the band profitable, yet he sensed a delicate balance when entering commercial branding arrangements. The tour manager scoffed at the notion that Coca-Cola ran Coke Live to support Australian music: 'They are trying to expand the marketing for Coca-Cola.' Consequently, he argued that bands could not be naïve when they entered into branding arrangements:

> You're taking corporate money to play in front of a bunch of little kids. The bands, if they endorse Coca-Cola, they have to look at themselves and say, 'we're encouraging kids to drink Coca-Cola.' Now if the bands acknowledge that this is because we want to grow our market and reinvent ourselves or this is a way of getting in front of 5000 kids that we just can't afford to do on our own tours, they accept it for what it is. And then if the market responds and the songs are great and the album does

well and that young edge or cutting edge of their youngest crowd is in-
creased and their sales pick up…then theoretically, there is another 5 or
10 years just from that tour alone that could stay with the band.

To the manager this was a strategic choice bands had to make, they
either joined in with the promotional culture of the popular music in-
dustry in order to make money, or they attempted to survive indepen-
dently. If you accept money from corporations, you accept what you
are doing and are up front about it; if you choose to be independent,
you acknowledge that it will be much harder to valorize your music.

As pragmatic as the manager appeared at first, he did then sup-
port Coca-Cola's 'investment in live music' but warned that Coca-Cola
needed to be careful not to 'take out the elements that bands do them-
selves.' The manager sensed that there was a fine balance in main-
taining the notion of authentic live music culture within the branded
social space of Coke Live. While he and the bands were keen to pro-
tect their live music culture, this was also very much in Coca-Cola's
interest. The authenticity of live music culture is the source of capital
value that Coca-Cola derived from the Coke Live project.

While some band managers argue that bands need to be 'upfront'
about their involvement in corporate branding programs, generally
speaking the bands were evasive and claimed not to overtly endorse
the corporation. Several bands I approached for an interview during
the course of this research declined because they, or their managers,
sensed that I might be 'critical' of their involvement. They were only
interested in the interview if I were going to promote the band and
the brand. It might be true that they sincerely think they aren't overt-
ly endorsing the brand. To make this claim however, they disavow
how their participation in the branding program is what constructs
the brand rather than their overt endorsement of the product. They
miss how their performance makes the brand a powerful social sym-
bol. Their endorsement of a festival like Coke Live as a social space is
much more powerful than an overt endorsement of the product. Their
participation in Coke Live legitimated Coca-Cola's intimate involve-
ment in popular music culture and endorsed Coca-Cola's claims to
supporting popular music culture. The band members were clearly
vexed about this. They knew it was not totally 'cool' to take corporate
money, that in some way it was 'selling out,' yet they did it anyway
and attempted to justify their involvement by referring to the corpo-
rate support of live music culture, or by claiming that they weren't
really endorsing the brand, they were just playing music. They acted
as if the bands and music fans were duping Coca-Cola by getting a

live concert tour for 'free.' This feeling of being a 'non-dupe' can be misleading.

One of the bands I spoke with about Coke Live was a younger emerging Australian band. They had been involved with Coca-Cola's competition to support bands and musicians who were unsigned. Through this program Coca-Cola claimed to make an investment in Australian music, and to assist younger bands to 'make it' in the industry. For the band I spoke with Coke Live was the largest gig they had played. Coke Live gave them an opportunity to play in front of a new audience and get radio, TV and internet exposure. The band members endorsed Coca-Cola's support for Australian music, 'Coke Live promotes Australian music, something that is suffering at the moment.' Australian music is often presented by bands and corporations as 'suffering' and 'under-exposed.' Corporations argue that there is a wealth of talent out there just waiting to be discovered and that they hope to assist in unearthing this music. The band members welcomed Coca-Cola's (or other corporations') involvement in the local music culture because, 'they have the money to actively promote a live scene in Australia.'

Experiential branding programs are presented as ethical and responsible interventions in social life. Rather than thinking about how these branding programs commodify popular music and social life in new ways, the brandscape steers bands and music fans toward being grateful for corporate support of cultural action. The rhetorical claims corporations make about the ethical and social responsibility of their branding activities obfuscate the ways in which experiential branding is an efficient and flexible tool for commodifying social life and accumulating capital. These discourses of ethics and social responsibility are persuasively mobilized to obscure the way that popular culture is embedded within industrial conditions of production.

While musicians argue that experiential branding programs offer mutual opportunities for bands and corporations to work together, they are reluctant to frame these partnerships in explicitly strategic terms. Rather than recognize the ways in which they too are commodified, bands tend to position themselves as authentic artists who are just trying to 'get out there,' to 'find an audience' and so on. They don't explicitly acknowledge how popular music is a form of cultural production always-already embedded in processes of commodification. They talk about finding the right balance when working with corporations to ensure that they maintain their credibility, because the corporations need the bands to remain credible if they are to build brand

value from the program. The ideology of 'authenticity' in popular music sutures over its industrial conditions of production (Auslander, 1999; Gracyk, 1996). Musicians and music fans are willing to go along with experiential branding programs because they are adept at finding the music itself somehow essentially authentic, without thinking about the social context within which it is produced.

If bands have initial reservations about working with a corporation on a branding program, after 'thinking about it and weighing it up' they often find that they stand to benefit significantly from commodifying themselves in an experiential brandscape in addition to just recording and touring. They can mobilize themselves as an intertextual media object. Their image, lifestyle and values are all aspects of being a pop band that they can valorize. The new 360 deals becoming popular in the music industry, especially through emerging popular music organizations like Live Nation, further illustrate this trend.[2] Interactive popular culture offers a host of mutually reinforcing possibilities. Bands no longer just produce records for sale; they produce a set of images, performances, styles and values that can be mobilized in a variety of ways. Their cultural content can be mobilized to animate brands and experiential branding spaces. Popular musicians fill brands with meaning and create social spaces where brands and social life are symbiotically produced. As the traditional record companies disappear, global corporations and their experiential branding programs take their place. To the bands, global corporations are a new kind of record company. If it is increasingly difficult to get a long-term record deal from a major label, it is increasingly common for bands to have a diversified income from a host of corporate partners. One musical recording can be commodified in many ways.

I talked with many musicians who were skeptical of corporate involvement in the music scene. They claimed that these new forms of branding 'take the artistry out of music.' They felt though that there would always be enough musicians who were willing to participate in experiential branding programs, and as more musicians do it, it becomes more and more acceptable. Musicians and venues who claimed, when I first began this research, that they would not become involved in these branding programs have since opened up their spaces or signed over their performances. Often, the musicians who claim some autonomist artistic status apart from the commercialization of popular music fail to recognize the ways in which they are already embedded within commercial contexts of production. Many musicians, whether it be playing in local clubs or at major music festivals, are

already a vital part of the elaborate structure of meaning within which brands are produced. They are a part of what Adorno called the 'almighty totality' of capitalism and so cannot avoid validating its 'monolithic control.' Even if I were a fiercely independent musician with anti-corporate (or whatever) values, as soon as I take those values and perform them through popular music, I am participating in constructing the structures of meaning that other bands and brands feed off. By articulating myself through popular music I can't avoid mediating and commodifying my performance. No matter how much Iggy Pop thought money and TV had destroyed rock music, he was still a vital cog in the performance and construction of the music festival as an experiential brandscape. At a more fundamental level, he was instrumental in developing the rock mythologies that brands feed off. In a thoroughly commodified popular culture, there isn't really some pure position from which musicians can avoid contributing to the capital value of brands. Of course, for popular musicians this has always been the case. For the most part, their relationships with the record industry were equally embedded within a process of capital production. Since the advent of popular music as we know it, it has been commodified (Auslander, 1999). I am not suggesting that there was once an authentic music culture; instead I am highlighting how central this mythology of authenticity is to branding just as it was central to the traditional record industry.

Getting drunk on brands

Through experiential branding programs corporations display knowledge of cultural frameworks of taste and value. Experiential branding, like much contemporary media work, is about acquiring and deploying cultural capital (Deuze, 2007; Louw, 2001). A valuable corporate brand must be able to use its accumulated cultural capital (held symbolically in the brand and by the meaning makers employed by the corporation) to sense the 'right areas to invest in' and 'the right moment to invest or disinvest, move into other fields, when the gains in distinction become too uncertain' (Bourdieu, 1984, p. 91). For a corporation, cultural capital and gains in distinction are a source of economic capital and surplus value. Corporations develop brandscapes in order to harness these flows of cultural capital. They engage culture and taste makers through the brandscapes they construct to accumulate cultural capital.

The brandscape is a structure that brings together the meaning-making process of the brand with the meaning process of popular culture. The brandscape is a framework for reproducing social structures of taste that empower capital accumulation. Bourdieu asserts that 'taste is thus the source of the system of distinctive features which cannot fail to be perceived as a systematic expression of a particular class of conditions of existence' (Bourdieu, 1984, p. 175). Taste-making practices order social life and reflect the order of social life. In this way, taste and meaning-making are central to the production of the uneven social structures that empower capital accumulation.

Alcohol brands successfully engage the taste-making practices of local music scenes to develop experiential branding programs. By drawing on the mythologies and values of the local scene they craft meaning-making processes that symbiotically produce brand and cultural meanings. The cultural experience within these live music brandscapes becomes an ethical, cultural and practical framework which music fans apply to their experience of music culture. In the repetitious production of popular culture, 'it is always forgotten that the universe of products offered by each field of production tends in fact to limit the universe of the forms of experience (aesthetic, ethical, and political) that are objectively possible at any given moment' (Bourdieu, 1984, p. 230). By directly engaging in the production of particular tastes within specific social contexts, brands set out to define and regulate a certain field of social production. They establish coordinates within which social life unfolds.

Tooheys Extra Dry is a popular Australian beer that has embedded its brand-building activities within popular music culture. Tooheys' Uncharted program directly attempts to harness the creativity of emerging musicians. Uncharted offers bands the chance to compete for a 'band development package' that includes a record contract, national tour, and media and production support. In late 2008, bands competed for the chance to win a spot on the national Big Day Out tour.

Uncharted articulated the authentic rock lifestyle. Bands chosen to compete in the final were featured in a reality TV style documentary for MTV. They were flown to Sydney, rehearsed their songs in hotel rooms, drank at local bars, got interviewed for television, and gained access to parts of the rock music industry closed to audiences and unsigned bands. The documentary narrative rehearsed the important myths and meanings of rock culture. The bands weave together the production of popular music and corporate brands. They embed the

brand within the frameworks of taste and habitus of the rock music lifestyle (Bourdieu, 1984; Regev, 2002). The musicians perform immaterial labor within a social context that produces brands and capital value. The brand produced as a result is a mobile symbolic object that moves within the spaces of popular music culture.

The MySpace blogs of the bands competing in Uncharted also reflected this symbiotic meaning-making process. In October 2008, Kate Bradley announced her involvement in the program on her band's MySpace page. On the blog she explained that Uncharted

> provides unsigned artists with a range of amazing possibilities. One particular possibility is that if you're the winner you and your band will play the Big Day Out festival. This is a really big deal for me. It would be a dream come true to play that festival and a real experience.

Kate and her band The Goodbye Horses ultimately won the competition and expressed their excitement and gratitude to Tooheys on their MySpace blog. Their fans responded with similar sentiments, emphasizing how great it was to see 'indie music getting the credit it deserves. The music industry isn't easy—so you have to enjoy every break that comes your way.'

Tooheys provided independent musicians with access to aspects of the music industry that are beyond their reach. In doing so they won the loyalty of independent musicians and their fans, and engaged them in developing a narrative where the corporation plays a vital role in the music scene. The band members and other gatekeepers of taste on the MTV documentary constructed the brand and notions of popular music. Interviews with industry panelists during the program savvily engaged the band members in offering their opinion of the Tooheys program. Colin Blake from MTV suggested to one of the bands that, 'You could have a lot of acts look at you and think you are cutting corners by entering a (corporate branded) contest like this.' To which the band replied, 'If they bag this then I don't think they are really being true to their profession.' Another band member added, 'It's so tough you really do have to try everything,...if you look at our gig list we really do work our arses off.' Through these exchanges industry insiders and musicians offer a reflexive defense of the program. On the Uncharted website Colin Blake from MTV said:

> The competition is a highly coveted and respected competition that exposes a diverse variety of musical styles...I love that big business and respected brands see the value in supporting local talent that are still

looking for their break. It is refreshing that this kind of marketing ener-
gy can help out those who deserve it and not just the obvious big names
that already have made a success of themselves.

Blake's assessment of the program demonstrated the way he and oth-
er gatekeepers of taste emphasize the contribution that Tooheys
makes to independent music but not the immaterial work performed
and value added to the Tooheys brand by the bands. Experiential
branding programs offer a reflexive discursive defense of their own
motives and carefully construct ethical and socially responsible
frameworks to situate themselves within.

The bands that play corporate programs like Tooheys Uncharted
aren't desperate for fame and money. It would be a mistake to dismiss
them as desperados searching for their 15 minutes of fame. Un-
charted has several hundred bands on their site. The musicians in
these bands self-finance the recording of albums, publicity, advertis-
ing and touring. They devote large amounts of their time and money
to their band. In many cases they invest large amounts over a period
of years without making much income. This has always been the na-
ture of local independent music making, and many musicians in these
scenes never expect to 'make a living' off their music (Frith, 2007;
Hesmondhalgh, 2002; Rogers, 2008). Like most people who play mu-
sic, their desire to be in a band began in their teenage years when
they first began listening to music and playing an instrument. They
began to write music and follow in the aesthetic footsteps of their
musical influences. Playing music is a meaningful practice for band
members in articulating their identity and their social world. They
believe strongly in the social and cultural value of music and local
spaces for musical performance. In constructing a local cultural milieu
around writing, recording and performing they get caught up in the
duality that all pop music finds itself: being both a commodity and a
meaningful aesthetic object. These local scenes inadvertently create
social spaces and relations that are a valuable brand-building re-
source for corporations because they are rich with cultural capital.
They are incubators for the mythologies and meanings that are cen-
tral to social life. Through experiential branding programs corpora-
tions offer bands money, access to industry insiders, tours, publicity
and recording opportunities. In return, the bands offer significant cul-
tural resources. Bands and brands each have sources of value that the
other wants.

Corporations make contact with bands through appropriate chan-
nels and pitch their programs as significant and respectable opportun-

ities. Bands are assured that they won't have to 'sell out' and vigorously endorse products if they are involved in the program. The bands are enticed into participating in the brand-building programs by the opportunities that aren't available anywhere else. The bands use these opportunities to get revenue to support their touring and recording. Musicians frequently told me that to survive in this flexible and fragmented music industry 'you have to take whatever opportunities come your way.' As these programs become more popular musicians are getting involved because influential peers have. They have seen how valuable the experience has been for their peers in terms of meeting influential people in the industry and securing gigs and publicity. Programs like Uncharted offer bands access to tours, media and record companies that otherwise do not exist. Tooheys Uncharted uses representatives from MTV, Sony, MySpace and radio to act as mentors on the program. This participation by producers, musicians, record company executives, media and publicity agents makes the program credible and embeds the program within an authentic cultural milieu.

Once selected for the Uncharted finals bands go to work promoting the program through their social networking sites, websites, local media and personal networks. The bands encourage their friends and fans to check out the Uncharted website content and vote for them. These promotional activities build salient niche-targeted publicity for Tooheys. Tooheys provide the bands with branded promotional material for their websites that weave the Tooheys brand into the local media and social networks of the bands. The bands also upload content on their MySpace site from their Uncharted experience. Videos and images of the bands at the Uncharted gig, backstage, shooting music videos and so on promote both the band and the Tooheys brand. Images of meaningful music production are interwoven with the brand. The brand is positioned as instrumental in the production of popular music culture.

The Uncharted finalists met the movers and shakers in the industry, got the chance to play in a great venue, and had a photo shoot with a famous rock photographer. This experience confirmed for the bands that Uncharted isn't just a promotional activity for Tooheys, it is also a meaningful contribution to the Australian music scene. The band members I spoke with were keen to emphasize that, even though it was a branding exercise and there was plenty of Tooheys beer available, 'Tooheys weren't pushy about drinking Tooheys. I didn't find that they were 'Tooheys Tooheys Tooheys' and thought that was

pretty good.' In fact, the bands tended to think that they had a re-
sponsibility to do some promotional work for the brand, 'I did respect
the fact that we'd gone in this competition very well knowing that, OK
we're in this competition sponsored by Tooheys so there will be some-
thing for Tooheys. This works two ways.' They found however, that
the brand never wanted them to overtly endorse the product. Tooheys
didn't want the bands to do anything besides what they normally and
authentically do as independent local musicians.

Tooheys provides the bands with the 'full rock star treatment.'
They are put up in fancy hotels, get hired cars, publicity and media
personnel, and backstage riders. Uncharted immerses them in an in-
dustrial milieu as much as it also gives them an opportunity to play
live to large audiences and record albums. The opportunity to play the
Big Day Out tour or record an album for Sony works 'wonders for
promoting the band.' The bands' exposure increases; it's easier for
them to get gigs, book media spots, and the traffic and plays on their
social networking sites like MySpace go up.

Traditionally, the industrial side of popular music making was
carried out by record companies. The relationship between band and
record company was mediated by the A&R representative. The A&R
representative had to make the relationship between the commercial
imperatives of the record company and the aesthetic sensibilities of
the band a productive one. This traditional record business is being
replaced by fluid and fragmented networks between bands and emerg-
ing sectors of the creative industries. As part of these changes bands
are being led toward new revenue streams and new modes of commo-
difying their art. Peer Group Media, who developed Uncharted, sug-
gest that the multi-million dollar program responds to the

> changing structure and dynamic in the distribution of entertainment, the
> evolution of advertising and media and how consumers are digesting
> brands. Instead of hijacking an entertainment vehicle and interrupting
> people with a brand message, we're creating our own entertainment that
> represents the core values of the brand.... Uncharted is contributing to
> the culture, rather than just sitting there as a brand.

Experiential brand makers argue that brands support and facilitate
cultural production rather than feed off it.

Media agencies like Peer Group Media are adept at managing the
relationship between the bands who want exposure and the corpora-
tions who want brand value. For the most part the media agency
doesn't want to bother the band with what the corporation wants. The

bands are not told anything about Tooheys or what Tooheys wants. Instead the media agency focuses on making the experience as 'natural' as possible. One band member recalled, 'I never got told to mention Uncharted or Tooheys on stage, I did out of courtesy coz I think y'know, well, this has all been paid for.' Another musician who played Uncharted said the only time they were counseled about brand values was during a stressful performance, when equipment failed and they said on camera that they intended to get 'shit-faced (drunk) tonight.' Even though it was a joke, they were told they couldn't say that sort of thing on camera because the company needed to be careful to appear socially responsible when promoting alcohol. Other than that though, the corporation never intervened in the musical production. The bands play, wear and say what they want and are generally surprised to find that the company is not overly protective and 'very liberal in their approach.'

The bands arrive at Uncharted expecting that they will have to promote the brand and are surprised and relieved to find that they aren't forced to make any overt endorsements. One band member said that anything they had to do was discreet, 'in some interviews we had to hold a beer, that sort of thing, which for us wasn't that hard.' There was always plenty of Tooheys beer around, and to this band, that was a great thing. The media agency that ran Uncharted never 'emphasized saying 'Extra Dry' they handled that side of it themselves.' The bands left the Uncharted experience feeling like they didn't have to promote the brand at all.

Bands and musicians approach programs like Uncharted with a strategic frame of mind. They know they will have to contribute some labor via their musical recordings, performances and image, but they also hope to achieve some strategic objectives of their own. Uncharted offers bands the opportunity to get out there, it has a 'life-cycle' and the band needs to capitalize on it. 'It won't ultimately put you in the spotlight and make you number one, but if you got what it takes it gives you a chance to go forward,' one band member told me. While none of the band members attempted to dispute that Uncharted was clearly a 'marketing thing,' they were keen to emphasize the contribution that Tooheys makes to the music scene, and downplay their own role in constructing the Tooheys brand or in helping to embed Tooheys within local music culture. One musician suggested that:

> I don't think it's right to say that it's blatantly about marketing because there is a genuine outcome for the band, you do get that opportunity and

when you do it's really good. So they are committed to what they are putting out there.

Experiential branding programs win the support of the local stakeholders they are attempting to engage when they appear to be making a material investment in the community. The key to experiential branding is that it is couched within the social relations it is attempting to derive value from. The musicians suggest that Uncharted has both strategic payoffs for Tooheys and benefits for the community. To the musicians involved, Tooheys reaches their target market and builds brand value but also gets to say 'we've helped an artist here; we're putting back into the community.' What they downplay is the role they play in constructing the Tooheys brand and the ways in which Tooheys' 'investment in the community' is a salient brand-building tool. Uncharted sets out to act in the community in ways that make it appear socially responsible.

The bands and industry figures who participate in Uncharted suggest that experiential branding programs offer bands opportunities that didn't previously exist or that have disappeared. The competitions broaden the scope of opportunities available to bands. Popular culture has changed, and musicians are finding that they have to adapt to the new features of the culture industry if they are to reach an audience. Even if they have some concerns about the program or the brand, the benefits might override these concerns. One musician involved in Uncharted reflected:

> I did (have some reservations) a little bit, because it's my own ethics. I did think at first maybe I'm compromising my own ethical ideas about things: about marketing, about brands, about beer companies and things like that because I think this country has a big problem with alcohol.

These reservations were overridden by the opportunity for the band and the way the corporation presents the program. Peer Group Media and Tooheys deliberately ensure that the brand logo and product are subtle parts of the social action, naturally embedded within and supportive of music culture. Ultimately, this apparent 'disinterest' on the part of the brand creates more brand value than overt branding. To the bands, 'it's not selling out. Music is a business. There is an art and there is a business. If you didn't want to sell out at all you'd never leave your bedroom or harass your friends to go to a gig.' While musicians might not write music with instrumental goals, they are prepared to work strategically to find an audience for their music. In

doing so, they inevitably end up straddling the dualities of being strategic and authentic musicians. Of course, some bands have no reservations promoting corporations if it helps get gigs and exposure. One band told me that they were more than happy to drink Tooheys and promote the brand:

> We're all pretty good drinkers, and all excited about the fact that the band's name would be on the bottle. It didn't bother us. Obviously it's in your mind that it's an event to promote a product, but we still looked at it that we could get something.

Uncharted works for Tooheys because they take great care to appear disinterested in overtly building their brand by emphasizing their interest in the music scene. They share the same tastes and values as musicians and music fans. The brand appears to live out the same values as the culture. Rather than just make rhetorical claims through advertising, Tooheys makes a tangible investment in popular music culture. The musicians point to these real investments in cultural space as evidence that the corporate claims are sincere, even if everyone knows that they also have strategic aims. Any ethical concerns musicians might have, about the social impacts of promoting alcohol, or about endorsing brands, are ameliorated by the material investment the corporation makes in cultural life.

Tooheys reinforces many of the musicians' thoughts about Uncharted. They emphasize their contribution to Australian music culture through the program. They suggest that the relationship between the corporation and musicians is mutually beneficial. Uncharted supports bands at the same time that it builds brand value. Tooheys claims that through Uncharted they are building a 'home for budding unsigned local Aussie bands to speak with, and reach, the wider Aussie public.' Uncharted is pitched as an A&R program that does what the record industry used to do. The difference is that along the way it generates brand value for Tooheys. Tooheys decided to use an experiential brand-building approach because it enabled them to be 'wherever their target market are.' Tooheys management told me that:

> Music is a key interest of this demographic; having our brand closely aligned with this interest is key to driving increased awareness and purchase of Tooheys amongst this important consumer group. Uncharted provides something of worth for musicians and music lovers alike. It enables us to speak to our target market in their language, really engage them in a conversation, as well as providing value to their lives in addition to the product they know and love.

Tooheys constructs experiential brand-building as a mutual exchange of knowledge and value between corporation, musicians and consumers. The rhetorical ethical claims built into experiential branding programs obfuscate the ways in which these forms of brand-building rely on an asymmetrical exchange of value. Tooheys' research demonstrates that 'Tooheys' association with music has quadrupled' and sales have been boosted. Uncharted increases the capital value of the Tooheys brand through the labor of bands, fans and other music industry stakeholders. The payment these bands receive for their work in Uncharted is increased exposure, tours and recordings. In exchange they make Uncharted a successful program by giving it access to their frameworks of taste and cultural capital.

Scenesters

The inner-city venues that form the nucleus of the local music scene attract a crowd of musicians, influential adopters, trend setters and peer leaders. People who hang out in music scenes often talk of the bars, bands and people that make them authentic (Rogers, 2008). In my hometown, like many cities undergoing the process of connecting to the networked, mediated, global world, the spaces of the local music scene are being subsumed into an intensely regulated and highly profitable entertainment precinct. 'The Valley' was once a typical inner-city area with a mix of working class, industrial and manufacturing spaces. It was disconnected from the mainstream cultural life of the city and became the place where the city's underbelly and alternative music thrived. As Rogers (2008) and Stafford (2004) have noted, the music scene of this era was a product of the city's oppressive political regime and cultural isolation. 'The Valley' of today, however, is networked into the rapidly evolving media city (McQuire, 2008). Music scenes have become part of government policies to economically develop, and corporate strategies to commodify, the 'creative life' of the city (Brennan, 2007; Florida, 2002). It is within this context that local music scenes are integrated into the experiential branding programs of global corporations.

A hallmark of a media city is the growing prevalence of creative precincts where creative folk, creative and media-dense industry and public social space interconnect. These spaces retain a depth of cultural capital as the location where the live music scene 'happens' and where musicians and other creative types 'hang out.' The relationship between the social spaces in these creative precincts (like music ve-

nues) and their patrons (bands, scenesters, creative folk) is symbiotic. These spaces are created through the interaction of people, media and social space. Club owners derive a profit from having a cool club. A cool club is dependent on attracting a legitimate and credible live music scene and its media and meaning makers. It is this creative culture which authenticates these inner-city spaces and makes them the kind of spaces that corporate brand builders want to access. The owners of music venues and other social spaces are in a position to commodify and exploit their highly valuable niche audiences. I don't want to diminish the role these spaces play in enriching the life of the city. I do want to argue for a more thorough understanding of how these music scenes and other creative precincts in the media city are embedded within a specific political economic context. They are part of the convergence of media, capital and creativity unfolding in contemporary urban life.

Accounts of the local music scene in my hometown emphasize the local and interconnected webs of cultural capital and taste-making that organize the scene (Rogers, 2008). There are significant local spaces which creative folk invest with their meaning and identities. These local processes unfold however, within the context of these scenes being plugged into the infrastructure of the media city (McQuire, 2008). As the entertainment precinct of the city develops, these spaces become embedded in the mediation and commodification of urban life. I want to contend that, in this context, they aren't as 'political' as they take themselves to be (this observation is reflected by Arvidsson (2007), Muggleton and Weinzierl (2003) and McRobbie (2002)). They are consumed by stylistic and taste-making practices and tend to ignore the material conditions of production. The meaning attributed to participation in these scenes acts as an ideological fantasy that obfuscates how they increasingly function as sites of meaning-making for corporate brands and for a thoroughly commodified social world (Bauman, 2000; Beck, 2002; Zizek, 2006).

During 2005 and 2006 Jagermeister developed an experiential branding program embedded within the local music scene. The program was connected to local venues, bands and media. In her work on branding Celia Lury argues that 'the brand is a key locus for reconfiguring the contemporary processes of production' (Lury, 2004; Moor, 2003). Here I want to examine Jagermeister's Jager Uprising as an example of an experiential branding strategy that engaged the local music scene as a site of brand production. In addition to producing local music, and their own identities, the participants in the scene al-

so produced the Jagermeister brand and a social context within which the brand could thrive and continue to valorize social life.

The Jager Uprising program gave independent bands the opportunity to perform in local clubs and win recording time in a local studio. The program was an adaptation of Jagermeister's branding activities in the US. The aim of the program was to position Jagermeister within local music scenes populated by trend-setting peer leaders. Jager Uprising involved performance nights at local music clubs, an interactive website where local musicians networked with industry insiders, and a 'presents' deal with local street press. Jagermeister purchased a mixture of advertising and editorial space in the street press with guaranteed positive editorial coverage for the brand and the program. Reviews of branded music festivals and programs like Coke Live, Nokia's Terminal 9 and Jagermeister's Jager Uprising in the street press are uniformly positive. Corporations negotiate 'presents' deals with local street press, where in return for advertising revenue the street press provide positive editorial coverage of corporate programs and events.

The Jager Uprising website stated that the bands were not paid in cash for performing in the program; however they were supplied with sound technicians, press promotion, Jagermeister and a positive review of the show in the street press. Australian rock music historian Clinton Walker observes the transition in local street press. Where once they were a space for the development of a critical local music scene, they are now just a 'collection of press releases.'[3] The editors of street press 'happily admit' that their content is entirely motivated by record company publicity departments and tour managers (Brennan, 2007). Virgin's Garage2V competition also struck a similar deal with musicians. On their FAQ for the competition Virgin stated that musicians wouldn't be paid, but

> there is a whole lot of promotion that you'll benefit from...the heats and final gigs will be profiled heavily on FasterLouder.com.au and Garage2V.com.au. Plus, we'll be running a series of street based marketing around the heats and finals. Your band will be featured and the exposure you receive from being selected by our judges to play the heats will lead you to much more opportunity for paid work in the future!! Promise.

These partnerships between street press and experiential branding programs not only give voice to the corporation's sense of social responsibility, they also take over the editorial space where other venues and gigs get promoted. One local promoter I spoke with who ran

local club nights for indie bands told me that both the local street press and one of the leading national music websites told him they couldn't showcase his gig or cover his efforts to promote local music because they had signed an exclusive deal with Jack Daniel's to promote their JD Set. Not only do corporations want to construct the narrative that they support local Australian music, they also strategically buy advertising (and editorial) space in the street and online press to prevent other organizations and promoters from showcasing their support for local music. In the case of the JD Set, the local promoter was disappointed that the street press would so heavily promote the JD Set and endorse their support for local music when they put on one gig per year while ignoring his efforts to stage a gig every month. He felt that the claims being made by Jack Daniel's in their (paid for) street press editorial were contrived.

Jagermeister expected bands to promote the program through their local networks. They relied on local musicians to undertake word-of-mouth promotion of the event and to distribute fliers in local clubs and cafes. The musicians promoted the brand in exchange for the chance to perform in a reputable venue and have positive press coverage. The band members served as highly credible cultural elite who promoted and endorsed the brand.

Jagermeister ran several advertisements in the local street press and national music press for the Jager Uprising initiatives. The advertisements recruited indie bands to participate in the program and audiences to come to the shows. Jagermeister positioned the program within a local cultural milieu. The advertisements emphasized the local, independent and emerging vibe of the program. The editorial items in local street press encouraged young bands to join the Jager Uprising program and encouraged young fans to get along to the gigs. On the website, pitched at the local musicians involved in the program, Jagermeister asserted that their intention was to provide

> promotion and publicity infrastructure to a grass roots development program, guarantee positive editorials by buying advertising space in local street press, facilitate cultural networking, enable the culture to function effectively and efficiently, and link new artists with the music business.

In my hometown, Jager Uprising was held fortnightly in a popular local indie club. The event attracted the local indie-music or 'scenester' crowd. Most of the people in the audience were friends of the bands performing or part of the local indie music scene. Many of the crowd members were aware that the night was 'sponsored' by Jager-

meister but didn't seem to care except perhaps to make fun of it. As young people engaged in the creative milieu of the city (in terms of fashion, music, art and media), they were an incubator for cultural trends. The crowd at the local indie music venue was an adopter-elite. Young people who play in bands form the nucleus of these creative spaces. The bands that played the Jager Uprising were given free Jagermeister, and Jagermeister was one of the 'specials' at the bar. The venue had Jagermeister items such as bar mats, lanyards, badges and stickers, and a Jagermeister representative walked around with a tray of free Jagermeister shots. Jagermeister, like other alcohol brands (Jack Daniel's, McKenna Bourbon, Hennessy Cognac) has cultural capital in rock and popular music culture. Jagermeister's brand is integrated in the hard rock music culture of the USA but in Australia only had small brand penetration. The purpose of the Jager Uprising events was to build the cultural capital of the brand within local music scenes. Brands like Jagermeister contract communications agencies to get them access to these local cultural spaces.

The most popular band to play the Jager Uprising was a local indie rock band I Heart Hiroshima, a band with post-punk jagged guitar lines and shouted vocals. The I Heart Hiroshima set ended with an ironic 'thanks Jagermeister!' from the drummer. Bands like I Heart Hiroshima drew large crowds to the Jager Uprising events. Their name on the bill and the word-of-mouth in their local networks drew people to the event. The indie bands that played the Jager Uprising approached it with a degree of savvy cynicism. They took the authenticity of their performance and the local scene as incorruptible by the brand. They acted as if the authenticity of their art, and the venue they were playing in, could not be corrupted by their association with Jagermeister. All of their fans realized that they were only associated with the brand for the opportunity to play live. In this regard, brands like Jagermeister are simultaneously ignored and embraced by local subcultures. Jagermeister is present as an ambient effect in the local venue, woven into the local cultural practices. Corporations are able to construct themselves as culturally responsible by associating themselves with, or even providing, live music experiences. By doing so they are seen to be supporting the actual and real production of popular music culture even though their motives for doing so are strategic.

I interviewed a couple of the bands who played the Jager Uprising program and found that they had a range of opinions about the program. Their experience was echoed by other bands I interviewed who had participated in Tooheys Uncharted and Coke Live.[4] The bands

spoke of increased exposure, better access to gigs and media and ex-
perience playing in front of big crowds as benefits they derived from
playing the programs. They were not concerned about not being paid
for their performances; the in-kind benefits were more than enough.
For one band, Jager Uprising was their first performance at one of the
sought-after inner-city music venues. The gig got them good expe-
rience and exposure, which led to more gigs in local venues. As a
young band starting out the program offered a performance space not
normally open to them. They were grateful for the opportunity the
program provided and quite aware of what Jagermeister wanted in
return. The band members knew that Jagermeister was after their
cultural capital: 'It's good for their image to be seen in music...they
could also be going by the theory that people in bands wield social in-
fluence.' The band believed the corporation deliberately targeted un-
derground independent bands with a broad appeal rather than the
aggressive 'guy-rock thing which alcohol companies usually do.' They
thought that the program delivered a positive message about the
brand to local musicians:

> The band who won the program, they're going really well. They won
> some money from Jagermeister and that got put towards the recording
> that they did and that's really helped them. You see the Jagermeister
> name and you think of small time decent music because of the program.

The band realized that they had a certain unique cultural capital,
connected to the frameworks of taste and meaning-making of the local
music scene.

Many band members were cynical about corporations' professed
motivations for supporting the music scene. One of the musicians I
interviewed about the program they were involved in said it didn't
appear very credible even though it was one of their first big gigs and
got them their first dedicated editorial in the street press. I asked the
band members if they agreed with the corporation's claims that the
program was beneficial to the local music scene:

> Not really. Bands and punters don't want to go and see a competition be-
> tween bands. Sure it helped one band do something. It's not really an as-
> piration to play a corporate program. It's not like South by Southwest;
> there is no air of importance. (The program was) like sport, come and
> drink and see who 'wins.'

The band members could see that the corporation ran the program to

bring more attention to their brand through a young, hip, arty crowd to appeal to young rockers and get a cool image going, like rock equals rad product stuff. It's not a real regular drink, so they are trying to thrust it into the limelight.

Regardless of the sincerity of corporate claims, I wanted to know what they thought about corporations being involved in the music scene. Most band members shrugged their shoulders and said they didn't really care; they didn't particularly like it, but they weren't going to get aggravated about it. One band member initially told me she 'felt fine about it' before pausing and saying 'what she really thought':

It's so dumb. I don't feel very good about it. It takes the artistry out of music. Nuh, it's all crap. If you're in a band and asked to do a corporate gig you'd do it if you needed the gig. If you do it you're a sell out, you're becoming a product yourself. The money thing comes into it; you'd do the gig for the money if you had to. If you want to become a professional musician then that's what you have to do. This is one reason why I withdrew from the band. It was turning into a business, becoming focussed on the scene, being a big band, rather than playing great music for friends. It's good for bands who want to become a business. In Australia you're either in or you're out. And if you decide to be out then you aren't making any money.

She captured the tension of being a popular musician in constantly negotiating authentic ideals and strategic imperatives. For most musicians who participate in branded programs or who find themselves performing at events that brands are involved in it's 'not cool to be "difficult"' or to contest the role of corporations in the local scene (McRobbie, 2002, p. 523).

Jager Uprising was one of many competitions for unsigned bands corporations have run during the last five years. Jack Daniel's, Tooheys, Coca-Cola, Virgin, Nokia, Starburst, General Pants, Victoria Bitter and V energy drink (just to name a selection) have all run programs similar to Jagermeister's Jager Uprising. Bands and their managers decide to enter into experiential branding programs for the chance to get media exposure, play in front of new audiences and secure lucrative prizes. Experiential branding programs are becoming a more legitimate avenue for emerging bands, and being involved in them can have real strategic benefits. Bands will enter the programs for strategic reasons even though they think they are totally contrived and lame. While enticed by the strategic benefits, participation in the programs can leave bands with mixed feelings. Reflecting on a corpo-

rate branding program they were involved in, one musician told me that their 'management enters us in a whole bunch of shit,' including branded programs because of the opportunity for getting prizes and exposure. At first the band and their management were not concerned that the experiential branding programs might have a negative impact on the band's image. They initially thought that they stood to profit in media exposure, gigs, access to industry insiders and other prizes by participating. After participating in one experiential branding program to win a spot on a national music tour, they changed their mind. One of the band members recounted to me:

> (It was) bizarre...there was this fucking crazy guy in a red jump suit. Before they announced the winner we had to do an interview backstage and then look into the camera and say 'we're going to (the rock festival)!' The competition was a pile of shit. I guess management enters us because it looks good on the press release. To say 'hand-picked by industry judges' is a good angle or some crap like that. The whole nature of the business now is about fan base and that shit, people will like you if you have some kind of glittery golden badge that says you won some crappy (competition). If you are endorsed by a big brand, or record company, people go, 'oh you must be good.'

While many bands say they would enter competitions again if the opportunities were good and if they felt it would benefit the band, members of this band felt that the competition harmed the scene and the band: 'no way, first time and last time, I'm not going to be judged by a bunch of b-grade booking agents, A&R representatives and industry hacks!'

After participating in experiential branding programs, band members are often vexed about their participation and their role as brand builders. They enter the competition motivated by what the program can do for them and don't always consider what it is that the corporation wants. Reflecting after their participation though, they can articulate what they contributed to the brand:

> If I had to speculate I'd probably say it somehow makes their brand seem part of the music industry, seem part of the actual creative development of artists rather than a faceless corporation that dumps cash into a festival and gets to have their symbol everywhere. It gives people a human interaction with the brand; they were at the festival; they voted for their band.

Regardless of whether they supported or disliked the program they participated in, musicians are generally reluctant to say they personally endorsed the brand:

> I've been thinking about it that way (that I did endorse them). We're just starting out. All the bands were starting out. In order to feel like I was endorsing the brand I'd have to feel like my band had equal weight to the brand, which it doesn't. I'd say definitely not, I wouldn't have thought that it'd be them stamping us, not us stamping them. They stamp us to make them cool, to promote their shit in the street press, get across what the fuck the brand is. No one knew what they were doing there; it was super contrived. Artificial hype really stinks; you can smell it. You can feel the old people trying to be cool. It feels orchestrated, arranged, elaborate, mutton dressed as lamb.

Older musicians on the scene are also skeptical of corporate involvement but unsure of what exactly to say about it. It's not as simple as saying bands who participate 'sold out' or defending some contrived authentic ideal that was the norm 'when they were playing on the scene.' A respected older rocker I spoke with reflected:

> I'm not gonna say they sold out, selling out is when you have an alternative and don't take it. I don't think they have the education any more because there is not a vibrant political system. What are the ethics and morals here? And that's where the debate stops. It's not because kids don't have ethics and morals, it's because they don't have an education in my opinion in applied ethics and morality in business.

Bands are increasingly caught up within thoroughly commodifed social spaces. Where once recording was seen as the domain of commodification and live performance in local clubs thrived as a removed cultural underground, there was a clear line between bands who 'went commercial' and those who stayed 'independent.' The contemporary music scene though is increasingly incorporated within the capital-producing logic of the creative industries. While this gives local bands and scenes a sense of legitimacy on one hand, on the other it fundamentally changes the practices and ethos that make up these spaces. Another established musician suggested to me that:

> These days it's very hard to tell the difference between advertising and culture. That's the way advertisers want it to be. The corporations invest in culture because that's the easiest way to sell their products. I think the most important thing is that you are thinking about it. If people are aware that they are being sold to, and whenever they see these logos

around if they think about what this company did to get their images and their ideas, their ideology, into those spaces.

Ultimately more bands participate because they are caught up in a thoroughly commodified popular culture where branding programs offer them the most salient opportunities to build an audience. Bands also participate because they find themselves in music scenes that are increasingly interwoven with experiential branding programs because they are embedded in the creative industries of the media city. The music scene itself is a vital part of brand-building. Musicians negotiate between the ideology of authenticity and the demands of corporate brands who want to profit from that ideology.

The intensified engagement between brands and bands reconstructs the mythologies and ideologies of authenticity, subjectivity of musicians and brands simultaneously. Bands that maintain a pure sense of authenticity miss the always-already commodified nature of popular culture. Bands who claim to be totally commercially driven disavow their myth-making roles. The commodified and branded social world produces both brands and bands. Branding and commodity production are inscribed into the fabric of social space. This is made clear by the counter-intuitive realization that the more independent, alternative and resistant culture makers in the culture industry set out to be, the more valuable the meanings and myths they construct are to capital (Bradshaw et al., 2006a; Holt, 2002). Escaping from the market through myths, ideology and resistant practices is imagined, it is never really an escape at all (Kozinets, 2002). Narratives and mythologies of authenticity, artistry and resistant life-politics are the content of branded social life (Heath and Potter, 2005; Thompson and Coskuner-Balli, 2007). Thompson and Coskuner-Balli (2007) argue that accounts of commodified popular culture get caught up either arguing that culture is co-opted or that it is always-already commodified. They call for

> more nuanced analyses...to advance understanding of the structural relations, dialectical tensions, and ideological disjunctures...within the global circuits of corporate capitalism.

Capital accumulates geographic and social space, it constructs a social world which regulates relations between people. This social world has a radically contingent character (never completely open and never completely closed). Capital may be a totality, but this totality is characterized by internal contradictions and antagonisms. A dialectic

conception of this social world attempts to come to terms with the way capital, rather than being crippled by its contradictions and antagonisms, is dependent on them for its growth and innovation. The imagined social world that brands and bands co-construct is a political formation that creates the space within which branding and the extraction of surplus value take place. At the political level it needs myths of responsible consumption. Partnerships between culture makers and brand builders take place within socio-political spaces, contexts and institutions that are the product of a struggle over what society should be like. These spaces are never finished and static; they are contingent and contradictory. The extraction of surplus value though points to an asymmetrical sharing of power. Brands accrue value off the labor of cultural participants. The myth-making of musicians produces a popular culture that evades its contradictions.

Chapter Five

'Enjoy Responsibly!': Young People as Brand Co-creators

Young people and the work of brand building

Social brand-building activities raise an important question about the apparent paradox of mediated youth experience. At the same time branded social space promises romantic notions of empowerment, self-expression and authenticity, these spaces also instrumentally exploit this promise in order to engage young people in processes of commodification and surveillance. Young people have been objects of social, cultural and marketing thought since they were constructed as a distinct and powerful cultural group and market segment post-World War II. Youth culture (as we know it) and the youth market emerged simultaneously.

Rob Latham (2002) in his inventive analysis of consumption in youth culture argues that:

> Youth culture can be profitably studied in terms of a dialectical exploitation and empowerment rooted in youth's practices of consumption, practices that are enabled by and contained within specific technologies. (Latham, 2002, p. 4)

Similar to Latham's (2002) dialectical concept of youth in capitalist society, I too argue that young people are seen as a disruptive and problematic social group (they drink and take drugs, listen to loud music, have endless 'free' time, transgress social boundaries and disrupt public space) at the same time they are desired (popular culture is obsessed with youth). And, they are seen as both marginalized (they have no real access to the political and economic power of institutions and processes that impact on their lives) and preyed upon (corporations coolhunt their every move, seek to capture them as attentive audiences and valuable customers). The experience of young people is a product of contradictory forces. Being young is defined by the heady mix of feeling totally free and powerful at the same time that you feel fatally flawed and thwarted. Studies of young people and youth culture can all too easily romanticize, patronize, and exploit young

people and their social world. Studying young people and youth culture in the west is embedded within a lengthy tradition emanating from both the UK and the USA.[1] My purpose here isn't to rehearse the history of youth studies. It is to contribute to the wider field of youth studies by mapping out the vision for youth that brands construct.

I use the work young people undertake in building brands as a framework for thinking about youth culture. This work is an objectified form of unpaid social labor through which young people commodify their social experience, but at the same time they enjoy it and find it empowering. Terranova (2000, p. 34) describes the provision of 'free labor' as a 'trait of the cultural economy at large' that is 'simultaneously enjoyed and exploited.' Youth experience in a capitalist society is always-already commodified and therefore is always a form of value-creating labor (regardless of whatever other emotions, feelings and perceptions might be attributed to it).

Young people, from the moment they take up the social role of being a young person in a liberal democratic capitalist society, are value-generating subjects in a commodified culture. Smythe (1983) established how the audience is a commodity produced and sold by media organizations. Jhally (1990) takes up this concept by examining young people as a value-generating labor commodity—a commodity that freely gifts its labor and produces more value than it costs to produce. In *The Codes of Advertising* (1990, p. 121) Jhally argues that in the process of using media 'consciousness becomes valorized':

> There is this partial truth in the label which writers such as Smythe affix to the modern mass media—'consciousness industry'—except that they have so far conceptualised it 'upside down'; it is not characterised primarily by what it puts into you (messages) but by what it takes out (value).

Jhally illustrates why it is important not just to think about the 'effects' the media have on young people (e.g. how they influence what young people think, construct who they are, etc.), but to really get to the heart of the matter—the work they put in, the value they create, and how they are socially constructed into value-creating roles. In branded social space this value-creation is harnessed as brand-building activity. Corporations set out to apprehend the productive capacity of young people (not just to put meanings in their heads).

While the literature offers many frames for constructing and understanding the experience of young people, I take three reference

points in capitalist society: youth culture is always-already commodified; young people are continually caught up in the performance of value-creating labor, and, these forms of labor are often mediated. Youth experience is constructed in the dialectical and contradictory structure of capitalist production. Young people are 'exploited' by it; they create surplus value for corporations; at the same time they invest in the culture with their identity and desires and extract enjoyment from it. They are 'free' only to alienate their cultural labor in the pursuit of enjoyment. Youth culture is filled with enjoyable freedoms that mask a lack of real freedom (Zizek, 1989), which makes it an ideal site for examining the 'cultural logic of late capitalism' (Jameson, 1991, 1998).

Music goes live

Young people produce the cultural content of brands. Alison Hearn (2006, 2008) in her analysis of the branded self describes the reflexive project of the self as a form of labor and source of value in the current mode of capitalist production. I begin here by examining the work young people do in branding themselves as part of HP's Go Live branding program. The branded self is central to capital accumulation because it 'effectively circulates cultural meanings' (Hearn, 2008, p. 198). Young people, through their identity and culture-making practices, are 'global value subjects' (Hearn, 2008, p. 205). Constructing yourself as a value-creating subject by acquiring the right cultural capital and embodying brand value is key to feeling 'empowered' in the flexible capitalist economy. Work on the self is a kind of primitive accumulation that leads to further value-creating opportunities in the branded social world. In this social world subjectivity is productive:

> The practices of self branding are clear evidence of the increasing cultural value, and potential surplus value, that is now extracted from the production of affect, desire, attention and image...subjectivity is central to the current mode of production. (Hearn, 2008, p. 215).

In the past five years corporations have engaged young people in content production by giving them access to the exclusive backstage of cultural production. Coca-Cola took young people backstage at Coke Live to interview bands. Nokia gave young people mobiles and sent them backstage at gigs to capture the atmosphere and chat with bands. They also sent them backstage at the ARIAs (Australian Grammy Awards) to interview bands and put the exclusive content

online. Multiple corporate partners have used their branding agreements with the Big Day Out to send young people backstage to interview bands and create content.

Corporations present these initiatives as socially responsible because they give young people the opportunity to develop content- making skills and expose cultural producers. These narratives of social responsibility obscure how the content young people produce is harnessed as valuable brand content that both gives the brand cultural substance and attracts an audience to branded websites.

For device manufacturers like Motorola, Nokia and HP these initiatives are also culturally instructive. The programs showcase the use of the cell phone (or mobile device) in everyday life. The experience and enjoyment of popular culture are naturally entwined with the production of brand content. The content produced serves as an educative workshop in the 'democratization' of media production. Mobile devices like cell phones make it possible for 'anyone to be a reporter' provided of course that the corporation gives you the device, a backstage pass, and a media manager to get access to the bands. The young reporters both create brand content and the mythologies of being an empowered meaning maker within which contemporary brands thrive. The fun-filled experience of being a backstage reporter builds brand value and obscures the forms of immaterial labor everyday citizens perform in constructing corporate brands through their mediation of social life.

At the 2009 Big Day Out festival computer manufacturer HP set out to engage young people in the production of web 2.0 content.[2] They ran an experiential branding program that set out to find a young music fan to be the official backstage reporter at the Big Day Out music festival. To enter, contestants had to make a video review of their favorite band and post it on YouTube. The immaterial value the Go Live contestants brought to their entries was their taste. The Go Live entries demonstrated how music fans produce themselves as commentating subjects, who take popular music as creative and authentic art. In their entries, the contestants take the album seriously as a piece of art (rather than a commodity) and in doing so, structure popular music as authentic and meaningful. Eventual winner David Murray reviewed Birds of Tokyo by relating it to its genre and deducing its radio friendliness. Other contestants followed a similar logic. They offered their own intimate knowledge of the band and genre and skillfully placed the album in a web of meaning. They displayed their prowess with the accepted canon of popular music culture. They dep-

loyed cultural reference points (the band's milieu, personal life, previous work, other significant bands in the genre) to provide a rationale for it as either good or bad taste. They performed labor in busily critiquing the produce of the culture industry as it is already critiqued for them (Adorno and Horkheimer, 1997). They judged the album from within the structure of the culture industry and offered this critical judgment and taste-making practice as brand content for HP.

The culture industry, more than ever, relies on the 'avid participation' of citizens and consumers. This avid participation is conventional and banal. It fits within pre-established frameworks of taste. The traditional hallmarks of the ideology of authenticity in the culture industry were repeatedly deployed by the reviewers. For instance reviewers remarked that, 'they have clearly progressed as a band,' 'proved many wrong by showing they are not a one album phenomenon' and 'every album needs a ballad.' Songs were described as 'lush and majestic,' songwriters as 'amazing,' 'talented' and 'intense.' For many of the bands 'big things' were coming. The reviewers gave their interpretations extra weight via discourses of conversion, 'I wasn't a fan at first, but now it's endearing' one reviewer reflected. Older musicians, like Neil Young, are portrayed as authentic 'godfathers' who are the 'real deal' because they influenced the canon of popular music. The video reviews are texts within which ideologies of taste, creativity and authenticity are constructed by audience members. The reviews are appropriated by HP as brand content. The first step to becoming a brand builder for HP is successfully branding your own self with cultural capital that HP wants to acquire. Acquiring and articulating musical taste is a kind of cultural labor that contestants perform in branding themselves as knowing subjects capable of transferring that knowledge to the corporate brand (Hearn, 2008).

Popular music and the culture industry are resilient because they manage to perform a duality that does not obliterate the ability of the commodity to generate value, on one hand, and the ability of the commodity to be taken as an authentic and meaningful object, on the other hand. Brands set out to perform this duality, of being both a strategic value-creating object and an authentic cultural resource.

HP wants to make a profit by building brand equity, and the young music fans want pleasure and satisfaction by being able to mediate music culture from within the exclusive backstage of a music festival. Branded social space is media-dense. It is a mediascape (Appadurai, 1990) fuelled by both the 'desire for profit and the desire for consumer pleasure and satisfaction' (Kenway and Bullen, 2008, p. 19).

Kenway and Bullen (2008) describe the mediascape as a libidinal economy that 'consists of social and market structures and dispositions that release, channel, and exploit desires and feelings.' Young people participate in popular music and brand-building in the pursuit of pleasure and enjoyment. In doing so, they make brands alluring, seductive and valuable.

The media-making practices of life lived in a branded and mediated social world are products of, and dependent on, the infrastructures of the media city (McQuire, 2008). The desire to build brands for pleasure, enjoyment and self-fulfillment is a product of life lived in a media-dense society. Young people who engage in the mediation of social life and popular music culture as part of Go Live and at the Big Day Out are engaged in pleasure-seeking and identity-making practices that simultaneously build brand value. They are flaneurs in the Benjaminian sense (Andrejevic, 2007a; Kenway and Bullen, 2008; McQuire, 2008), constructing their identity via their interaction with urban mediated space.

Harnessing unruly music fans

The brandscape is a productive space for brand-building partly because of its creative and unruly subjects. Music festival fans can deliver brand value, but they can also be fickle if the branded space is not smoothly integrated into their enjoyment of popular music. At the Big Day Out festival HP installed a Go Live pavilion with the headline 'Let Your Creativity Go Live.' The Go Live pavilion consisted of several computer terminals where people could upload content from cell phones and digital cameras to the web and social networking sites. Signs in the space encouraged music fans to 'upload photos and clips from today or shoot your friends a quick update on all the action here at the Big Day Out.' The Go Live installation attempted to harness the media-making practices of young music fans.

HP attempted to capture the creativity and unruliness of fans at the Big Day Out and direct them toward activities that build brand value. The promise of interactivity doesn't always pay off. Taking time out of the Big Day Out to blog about it and upload photos of your experience impedes immediate enjoyment. Blogging and uploading photos happen once the festival is over. It is increasingly common for music fans to use cell phones to capture and immediately upload content from the music festival. This practice seamlessly fits with the immediate enjoyment of the festival because audience members can

do it with a mobile device in their hand. Festival goers aren't going to take time out of the festival to upload content to the web, they will only do it as part of their seamless experience of the festival.

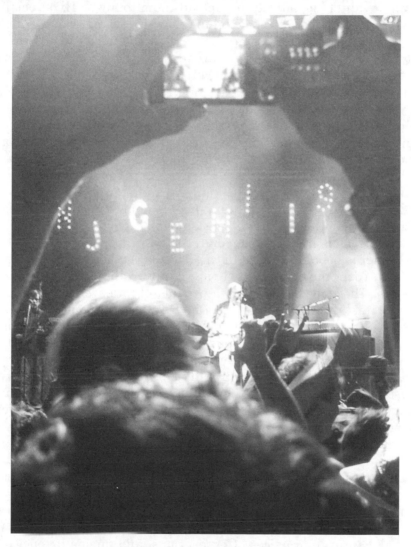

An audience member uses a cell phone to capture an image of Neil Young perform-ing live at the 2009 Big Day Out. Photo: Nicholas Carah.

Inside the HP Go Live installation a young guy, after entering all his personal details to register with HP, asked the promotional staff,

'OK, so I've given you my info now what do you give me?' The promotional staff member laughed and tried to play it cool. One of the staff showed me how to download my photos from my camera onto the HP system to edit, crop, adjust and upload them to my or HP's social networking sites. As he was showing me how the system worked, he was distracted by two people using the gear in the next pod. It was only early in the day but they were already pretty drunk and had a few beers with them. As they were mucking around with the PCs, it began to look like they would spill beer all over the gear, so he had to leap away from me and gently move them away from the computers. It was a comical image of immediate enjoyment and corporate attempts to harness that enjoyment clashing. Harnessing enjoyment as brand value can be difficult.

Through the Go Live installation HP attempted to capitalize on young people's enjoyment of live music events. Music events are media-dense social spaces, and young people enjoy music events via the continual mediation of them. The enjoyable gaze between audience and performer is frequently mediated by a cell phone or digital camera. Cameras bobbing around in the crowd are a key feature of the Big Day Out. After the event these images appear all over social networking sites. These media texts are a product of immaterial labor that in the first instance constructs the Big Day Out as a meaningful mediated cultural text and then helps to construct it as a mediated brandscape that connects the musical performance with the mediated social spaces of web 2.0. To capitalize on these media-making practices HP needed to construct a branding program that worked within this social context. Inviting the audience to take 'time out' from the music festival to mediate it missed the crucial aspect of mediation at live popular music events: it must be *live* and must be interwoven with the immediate enjoyment of the pop music performance. Rather than set up a separate pavilion HP would have been better off putting devices in the hands of young music fans and getting them to stream content live to the web.

The HP installation demonstrated how obvious and clunky brands can look when they 'poke out.' They work best when embedded within 'natural' cultural practices. Corporations and media agencies frequently claim that their brandscapes are 'authentic' whereas their competitors overdo it, smother the audience and so on.[3] Experiential branding experts caution that brands need to find authentic experiential relations with music festival audiences. They espouse this as a fundamental creed of experiential branding. In selling their message

to their corporate clients though, they appear to miss the ways in which their branded installations really do stick out; everyone can see them, and everyone knows what they are doing. Few young people would sincerely agree with experiential marketers that their corporate clients' brands really do love popular music. I would argue that what brands are really doing is reconstructing notions of authentic music culture within branded social space. Branded installations recreate ideas about what enjoyable popular music culture is. Whether they realize it or not, branding programs are strategically effective not because the audience takes them to be authentic, but because they construct the audience's enjoyment of music culture in the first instance.

Going backstage

In addition to the installation at the Big Day Out festival HP sent a 'citizen reporter' backstage. David Murray joined the Big Day Out in every city of the tour. He was sent out to 'interview bands and artists at the festival using his new HP HDX Premium Notebook PC and HP iPAQ912 Series Business Messenger.' In the press, David, like the other entrants in Go Live, expressed a hope that winning the prize would be a 'great boost to what I really hope is going to be my career.'[4] Go Live was an opportunity to 'get a foot in the door of an industry which can be pretty hard to break into.' David's first blog from the Gold Coast Big Day Out captured his excitement at being a backstage reporter:

> Wow! What a day and its not even over yet! Met and interviewed Fuzzy from Video Hits this morning. She was absolutely awesome and gave me a bunch of pointers on my presenting...Man, was I nervous before (my interview with Sneaky Sound System) but it all went great! The whole band was heaps funny and kept talking over each other.

His reports, blogs, tweets on Twitter, and YouTube videos were uploaded on HP's Go Live website. Through the Go Live website Big Day Out audiences could log on to view videos David shot backstage at the Big Day Out, see how they could also use these devices in their own cultural practice, and view HP products and promotional material.

David mobilized the HP brand. As he moved about backstage at the Big Day Out and interviewed bands he took the brand places that advertising executives and marketing managers can't access. He brought his cultural capital, knowing cool from uncool, and his reper-

toire for describing popular culture, to the HP brand. For instance, on the blog he said, 'for those of you who don't know (and seriously if this is the case you'd have to have been buried in a snow drift somewhere in Antarctica for the last 3 years), Sneaky Sound System are a dance-pop....' Most of the HP executives and shareholders wouldn't know who Sneaky Sound System are. Go Live built brand equity off the fact that David knew. He undertook valuable immaterial labor for HP.

David is emblematic of much of the media production that takes place on web 2.0. Participants perform immaterial labor and create brand content by commentating popular music, by offering their knowledge and cultural discourse to the brand. HP wants young music fans to 'let their creativity go live.' Being creative is part of the ideology of the authentic self (Botterill, 2007). The brand sets out to capture these projects of the authentic self and transform them into capital value.

For Go Live to be an effective branding program, it needed to deliver on the creative promise of interactivity. David needed to tweet from mosh-pits, send live photos from the side of the stage, upload blogs each day and deliver short, snappy videos straight after each Big Day Out stop. Unfortunately for HP, the content was slow to arrive on the Go Live site. David tweeted and blogged infrequently, and the videos were hampered by poor sound and vision. In the week following the Big Day Out David's interviews attracted between 50 and 100 views on YouTube. This isn't a significant number of views when compared with other fan-generated media from the Big Day Out. A poor-quality video filmed on a cell phone of the Pendulum circle pit (a group of people who run and dance wildly in a fast-moving circle, frequently pushing people in and out of the circle) scored over 10,000 hits in the same time frame. One of the Go Live contestants who frequently uploaded content she made at live music events to YouTube told me that, 'after I go to gigs I love going onto YouTube and checking them out later on. Just for the memories. I just upload (my videos) for other people.' David's videos were most successful when they captured the raw energy of a young music fan and least successful when they attempted to be real professional videos. The audience for online media texts searches out the real and raw mediation of the music festival.

One of the challenges of critically examining experiential branding is that there is little publicly available empirical research that compares it to other brand-building practices. The corporations I spoke with commonly attest that experiential branding programs increase

the target market's brand awareness, association of the brand with popular music and sales in key segments. A program like Go Live appeared contrived to both musicians and music fans because the mediated content it generated and practices it fostered were not seamlessly integrated into cultural practice. The program didn't harness the ways in which young music fans mediate their enjoyment of pop music events. While user-generated content from the Big Day Out appeared all over social networking sites following the festival, HP didn't effectively manage to embed itself within these media-making practices.

Brands can look hopelessly immobile when they aren't reflexively integrated into cultural practice. When David asked Children Collide whose idea it was to have a scratch-it on the front cover of their album one of the band members replied, 'It was actually me, I'm a marketing genius, so if HP needs to flog any ink jets or dot matrixes, let me know.' The band members poked fun at the brand, and just like the physical Go Live installation, again the brand was caught 'sticking out.' The execution of the Go Live program demonstrated how the brand's dependence on the 'autonomous' cultural action of cultural participants is a fraught process. While HP relies on their natural cultural actions to construct the brand, these actions can drive the brand in unspecified directions.[5]

Brands accrue value from popular culture by appearing 'disinterested' (Holt, 2002). To appear disinterested they have to turn aspects of brand production over to cultural agents who might not always have the brand's strategic interests at heart. Experiential branding is most strategically effective when it carefully constructs the spaces within which the cultural action will unfold in order to integrate with cultural practices. Despite its claims to successfully 'coolhunting' styles and trends and naturally partnering with musicians and young people as peer leaders, experiential branding is really most successful when it constructs and facilitates the social spaces within which brand-building activity happens. Experiential brand-building isn't about benignly, authentically and ethically partnering with social life 'as it is,' but is about constructing social spaces and forms of social life that are inherently about brand-building.

A brand-building branded self

Like most of the Go Live entrants David hoped that it would prove to be his 'big break' into the industry.[6] To many of the entrants being a

reporter backstage at a music festival was a key signifier of the authentic self. The backstage is the exclusive 'real' space of cultural production. One of the contestants told me:

> I wanted the shot at the major prize because I thought hey if I'm in the VIP section, I'd maybe have a chance at meeting the inside people as in maybe people who actually work for the labels or the bands and artists, or maybe meeting promoters or publicists...and yeah I'm hoping to make it in the music industry, maybe working for a marketing company or being a PR for some record label.

The commentating subjects of web 2.0 form themselves under a commercial logic. Go Live takes this idea of the authentic self and embeds it within the brandscape. David introduced himself on the HP Go Live blog by stating how 'unbelievably stoked' he is to win Go Live because 'over the last few years I've been working pretty hard to break into television as a presenter and this may be the foot in the door I need.'

The contestants didn't offer their creativity and knowledge of popular culture to HP just for the fun of it. They entered Go Live for strategic reasons. They expressed a desire to work in the media and music industry. Several were already involved in some way in their own media and musical projects. For instance, they were in bands, studying media, working in community media, or ran their own YouTube channels. They were media makers, musicians, citizen journalists, and bloggers. HP attempted to tap into the media practice of adopter-elite in order to harness their creative energy as brand content. The contestants had strategic motives of their own; they hoped that by entering the HP contest it would give them a break into the media industry. These aspirational audience members dreamt of jobs making media content. The global culture industry is increasingly built on flexible and unpaid labor that produces content, while the paid jobs within the culture industry are to facilitate social space (Deuze, 2007; Louw, 2001). As informally networked audiences produce the content, the professionals increasingly produce the social spaces that harness and valorize that content.

The contestants saw Go Live as an opportunity to develop a portfolio and perhaps to 'make it' in the creative industries. Go Live looked like a way of 'getting into' the TV and music industries. One contestant told me that:

Competitions like HP Go Live are a great way of getting experience in a pretty difficult industry to break into. I entered because I'm working to become a presenter and anything that helps me achieve that is worthwhile.

Contestants networked with friends who had skills in cinematography and production to develop their entries and mostly spent a day or so planning, shooting and editing the video. They impressed on me that the reasons for entering Go Live were for the real career opportunity (a deep and authentic reason), not for a flippant desire for fifteen minutes of fame:

I think it is a brilliant opportunity for people, good on them for giving us that chance to get our faces on TV. But that's just it, the majority of the population just want their 15 minutes of fame and that's it. I mean it's all about being famous these days, and I am a total hypocrite now because I used to be like that, but now I want television and radio to be my career, I want to be known by people but not be famous.

The entrants recognized that HP ran Go Live for strategic reasons. And so they positioned their relationship with HP as a strategic partnership. One contestant said that HP ran Go Live to

promote their business and reach out to the people so they can voice their passion about music. The universal language of today is music and so it's a clever strategy to use the Big Day Out concerts to attract mass audiences.

While another added that:

HP wouldn't just start this competition simply for the greater good, it has to give them something as well...The Big Day Out is a massive national tour which sells out every year. It is the perfect opportunity for a massive corporation to flog its latest line of products to the intoxicated and impressionable youth of the country.

With these strategic goals clearly in focus, the contestants were happy to participate and keen to demonstrate how they could be of strategic value to HP.

Of course, this strategic mindset was also deployed in cynical critiques of the brand. One contestant suggested that corporate sponsorship and the Big Day Out fitted together because the festival was a mainstream commercial venture. The Big Day Out didn't book bands that attracted audiences who were 'angry people who hate popular

culture and that kind of corporate bullying.' This contestant just entered the competition because he had bought a HP phone which was 'absolutely terrible' and he hoped to 'get something back from them.' He suggested that the eventual winner was innately conservative and selected because the corporation could tell he would support the brand values and wouldn't try to do anything subversive. The experiential branding program ultimately has to be filled in with banal pedestrian content; otherwise it could take on a political life of its own (like other public spaces). Corporations search for the right cultural capital in terms of knowledge of popular culture as well as the right political disposition.

Branded selves are frequently cynical because participants implicitly realize their identity work is an exercise in value creation. We are 'global value subjects' conditioned by global flexible capital (Hearn, 2008, p. 214). Disenchantment and cynicism are products of flexible accumulation. As we constantly adapt and change, we start to feel that there are 'no longer any identity systems worth believing in' (Hearn, 2008, p. 214).

David's final Go Live post was a tutorial on how to interview bands and upload the content to the web. He offered tips on doing research, writing questions and editing interviews. Throughout his tutorial he emphasized a do-it-yourself, citizen-driven, enthusiasm for media-making. He also took the opportunity to integrate HP into his media-making practice. When doing research the first thing he did was, 'jump on his brand spanking new HP laptop,' he said with a wink to the camera. And then he transferred his questions onto his

> HP iPAC that the guys at HP gave me...it's really really cool because I can tap around on this and all my questions come up...and I don't have to carry around a piece of paper. Great stuff!

He finished the video by saying, 'Upload it to the net, share it with the world and wait for the job offers to come in. Speaking of job offers...any minute now...hasn't Channel V got back to me yet?' It was a joke. But, it was one of those jokes that pointed directly to a prickly truth. David and his fellow Go Live contestants really do want a 'real' job in music television, and even though they dare to dream it might come true, they 'know' it probably won't. HP builds their brand off this desire. The young contestants who want a media career so badly are prepared to labor for free for the brand in the hope of 'making it big.'

The young people and musicians who engage in experiential branding programs and get the opportunity to go backstage, go on tour, make a record or be a reporter relish getting the 'rock star treatment.' One of the young music fans who won the opportunity to be a backstage reporter reflected:

> In a lot of ways the whole 'backstage reporter' experience exceeded my expectations. It was completely surreal and not just because I got to interview some great bands. I kinda approached that side of it as work–really cool work, but still work. It was all the other stuff that went on around the interviewing and reporting that made the whole experience so special. One of the best parts was running into bands I had met outside of the festival–at the airport or at the hotel–and being able to interact with them in a way that wasn't them as rock star and me as the fan.

This reflection neatly captures how many of the young music fans and independent bands who participate in these programs seek access to a closed cultural milieu. They want to work in the culture industry and so happily devote their time, energy and immaterial labor to these brand-building programs.

The work they perform is unpaid (in the sense that they don't get a wage), but they feel that they are paid in the immaterial benefits from the experience. These immaterial benefits include meeting their favorite musicians, getting exposure for their band, or getting experience in interviewing and making media. The chance to tour with a big festival, record an album or be a reporter is an 'intensive internship' where they are thrust into the 'real' world of cultural production. One participant said, 'I was given some real responsibilities and in the process was able to refine my skills.' The perceived pay-offs for the participants obscure the ways in which this work is invaluable in creating mobile, reflexive brands that appear ethical and socially responsible. Participants easily integrate these brand-building activities into their social practices and cultural milieu. Following their experiences on these programs they often speak positively about it to their peers (encouraging them to participate in future programs). Their incremental participation makes these programs a more natural part of popular music culture. Following his Go Live experience David set out to start his own blog because he realized that you don't need 'heaps of money or gear to produce content, all you need is access to a computer and something to say.'

David expresses a common romantic notion about web 2.0 and citizen media makers. The social and political power implied in the as-

sertion that 'anybody' can produce content for the web needs to be considered with regard to the political economy of the web. Matthew Hindman (2009) in *The Myth of Digital Democracy* offers a defining empirical study of the structure, traffic flows and audiences on the web. He raises two key issues that are paramount when thinking about how empowered citizen meaning makers are relative to the global culture industry. First, the infrastructure of the web is such that major portals shape traffic flows through their link and search structure. And second, owing to this structure there is a profound difference between 'speaking and being heard.' Elites and their messages are still the prevalent authoritative voices.

While the web might be full of 'ordinary' meaning makers, they are fundamentally making meaning within a spatial architecture owned and controlled by elite interests. In the case of HP's Go Live David was given space within which he had to build the HP brand. Those who own and control these spaces strategically shape them toward their political and economic ends. Whatever creativity that might transpire online, we must remind ourselves that it transpires within a context where powerful groups, means of communication and messages are closely interrelated (Deuze, 2007; Hindman, 2009; Louw, 2001).

Experiential branding is a symptom of this reshaping of the culture industry, replete with its narratives and mythologies of empowerment. Meaning makers in experiential branding programs might have a computer and something to say; however, whatever they say is said in the context of building the corporate brand. And their audience and impact are relative to their position within this communicative architecture. There is a profound difference between 'speaking and being heard' (Hindman, 2009). That difference is shaped first and foremost by the architecture of the culture industry and its social spaces like web 2.0.

The experience of 'going backstage' into the 'real world' of cultural production makes these participants want to get more involved. The effort they put into brand-building is of no real concern. They don't see these activities as commodifying or changing popular music culture. They see the brands as making a positive investment in the culture at large and in helping them out as individuals to achieve their dreams of being an integral part of cultural production. When I asked one participant if they felt they played a role in building the brand they replied, 'I hope so. If I didn't I didn't really achieve what I was there for.' The brand-building labor is an unquestioned part of the

deal. It is something they have to do to get access to the cultural backstage. The communication agencies that run the experiential branding programs and liaise with musicians and young music fans never emphasize the brand-building strategy behind the program. While the participants recognize that they are contributing to brand-building, they are often pleasantly surprised when they realize that they don't have to overtly engage in endorsing the brand.

Manufacturing authenticity

The work of people in the cultural industries–musicians, media makers and music fans–is intrinsic to the development of brands that people take to be authentic. Marketers and the participants in their branding programs assert that corporations enable and empower people to actualize their desires and dreams by investing in cultural space and opening up spaces of cultural production previously only available to the elite. Marketers claim that enabling 'natural' cultural production leads to the development of inherently ethical brands. Most participants recognize that these corporate programs are ultimately about building valuable brands and that their role is to contribute to brand value. The more apparent their role in brand-building, the more concerned they are about the social consequences of these programs and the merit of the rhetorical ethical claims corporations make. The brand-building programs often reflexively respond to these queries. The brandscape offers discursive space within which these concerns can be raised and neutralized. Within the brandscape participants are free to criticize brands as long as they don't criticize branding. Criticism is always directed at a particular brand rather than the universal logic of branding. As such, the brandscape appears free, open and autonomous.

Culture industry practitioners play a key role in shifting marketing from being a 'distinct business activity' to an 'embedded cultural practice' (Firat and Dholakia, 2006, p. 126). An embedded cultural practice of marketing is collaborative, diffused and complex compared to the traditional centralized and ordered management approach. Contemporary marketers hold the perception that the practice of co-production in marketing empowers consumers. Marketers argue that marketing is moving from a 'consumer satisfaction' to a 'consumer empowerment' oriented practice (Firat and Dholakia, 2006; Vargo and Lusch, 2004). A repositioning of marketing language is taking place, moving from the tactical post-war language of marketing manage-

ment (target, segment, action, and tactics (Kitchen, 2003)) to inclusive and ethically sensitive language. Words like participation, empower-ment, mutual, experience, creativity, and responsibility attempt to signal that the consumer is not being 'actioned' by marketers but ra-ther is an integral part of the 'action.' This discourse signals a new populism, where inclusive and participatory language obscures the power structures inherent in capitalist society and culture.

Marketing theorists adapt cultural, postmodern, and critical cul-tural theories eclectically. The intent appears in part to distance mar-keting from 'modernism' and re-embed it in a savvy contemporary space where it can be rendered more 'ethical' and 'socially responsi-ble.' Firat and Venkatesh (1995, p. 240) demonstrate these contempo-rary discourses in marketing theory:

> Modernism has failed in its quest for an ethically ordered, rationally con-structed, technologically oriented, seemingly progressive and relentlessly unifying social order.... The modernist project has rendered the consum-er a reluctant participant in a rational economic system that affords no emotional, symbolic, or spiritual relief to the consumer (Angus, 1989). In essence, modernism has marginalized the 'lifeworld' (Habermas, 1984). The postmodernist question therefore is to 'reenchant human life' and to liberate the consumer from a repressive rational/technological scheme.

Firat and Venkatesh position themselves as 'liberatory postmodern-ists,' a perspective where individuals can be 'liberated' and 'empo-wered' within (and due to) the capitalist system by being consumers (Arvidsson, 2005; Holt, 2002). Not all (in fact, very few) marketers are self-declared 'postmodernists,' but many espouse different versions of this 'empowerment' rhetoric.

These discourses can be observed in the culture industry partici-pants who legitimize their involvement in the production of strategic brandscapes by deploying the contemporary ethical discourses of cor-porations. Marketing theorists assert that these partnerships between corporations, cultural industry practitioners and consumers create forms of communication which actualize the 'mutual construction of symbolic meanings, a process of partnership between marketers and the consumer' (Firat and Dholakia, 2006, p. 146). Contrary to the claims of marketing theorists, media theorists like Deuze (2007) and Louw (2001) articulate how the construction of symbolic meaning takes place within social space facilitated by marketers and the cul-ture industry. Marketers shape social spaces that serve their strategic aims. A critical response to marketers is to examine the way these

partnerships embody what Goldman and Papson (2006) describe as the process of capital branding itself. They echo Adorno's (1991, p. 81) argument that mass culture is a 'system of signals, signalling itself.' Marketers create a new ethical language in partnership with culture makers like musicians. As they do this, discussions about the role of corporations in cultural life are framed in ways conducive to brand-building. For instance, those that we might intuitively assume would critique or question brands and the role of corporations in social space (for instance, the authentic 'artists' (Botterill, 2007)) learn to speak a language that reinforces marketing. Bands, instead of speaking out about the broader social impact of alcohol brands or soft drink brands in musical festivals, venues and the industry, praise their 'investment' in local culture. The discourses they use to authenticate and legitimize their own cultural subjectivity, by necessity, also reinforce capital.

Musicians and music fans are engaged in forms of cultural action which appear to encompass both autonomous and authentic identity work alongside the production of cultural spaces with capital value. They provide the unpaid labor and cultural capital to make these programs authentic and successful. Using Bourdieu (1984), Regev (2002, p. 252) examines popular music in the context of late modernity, where collective cultural participants struggle for status and legitimacy. In this analysis popular music is a 'cultural tool, used by these rising collective entities and identities, to define their sense of cultural uniqueness and difference.' Popular music culture is a process through which cultural capital is established or acquired, and forms of distinction are enacted through cultural practice (see also Lury, 1996). The participants I interviewed advocate for the corporate investment in local cultural spaces and claim to recognize that capital value is being created through these programs. In all except a few instances, however, they do not perceive that the strategic interest of the corporation may reconfigure the cultural space. To the participants, the cultural space retains its autonomy and 'authenticity.'

Chapter Six

'I'm Here to Party...': The Social Narratives of Brands

From brands to branding

Throughout this book I have detailed how brands develop ironic and reflexive persona, embed themselves in cultural milieu, create origin myths and stealthily influence meaning-making processes (Holt, 2002). In addition to these practices, contemporary brands also weave in narratives of ethical substance and social responsibility. Marketing and corporate communications literature traditionally maintains an ambiguous separation between branding strategies and social responsibility initiatives. Kotler and Lee (2005, p. 2) define corporate social responsibility as 'a commitment to improve community well-being through business practices and contributions of corporate resources.' This definition appears benign. Their explanation of how to put corporate social responsibility into practice details how socially responsible initiatives should have a good strategic fit with the values, goals and markets of the business. This includes building brand identity. Corporate social responsibility, initiatives and marketing all fundamentally tie together ethical narratives with brand values in ways that are strategically beneficial for the corporation.

The contrived theoretical separation of corporate social responsibility from branding obscures how corporate conceptions of social responsibility are necessarily limited by the strategic imperatives of the corporation. Marketing strategies with social objectives contribute to constructing an ethico-political framework within which brands operate. The conceptual apparatus of the brandscape is useful in articulating the links between brand-building activities and the production of branding as a social, ethical and political logic. Brand-building is not just about individual brands but about 'coloniz(ing) the lived experience of consumers in the interests of capital accumulation' (Hearn, 2008, p. 201). In this regard, experiential branding is politically limiting because it involves selling just the 'image of autonomous subjectivity' (Hearn, 2008, p. 207).

In the previous chapter I examined young people as direct participants in experiential brand-building. They built particular brands. Through these activities young people also participate in the construc-

tion of a branded social world. Just by being a young person in a liberal democratic capitalist society they are already bound up in brandscapes of capital (Goldman and Papson, 2006). Experiential branding and the production of brandscapes make a significant impact on the lifeworld of young people, not just as a mechanism that appropriates their labor (Arvidsson, 2005; Terranova, 2000) but also as a cultural model they live, think and feel through (Thompson and Arsel, 2004). Branded social space is framed by the political and ethical coordinates of corporate marketing strategies. Brands make rhetorical claims about the social world. These claims construct subjects for whom the brand is an influential ethical and political framework. The intersection between corporate branding activities and their social and ethical claims needs to be examined.

In this chapter I examine instances in which branding is a prism through which the social, cultural and political world of young people is organized. In addition to constructing particular brands that have specific value for their corporate owners (the HP brand, the Tooheys brand, the Virgin brand and so on), young people produce the social spaces in which brands are animated and made valuable.

Capital produces and regulates social space (Harvey, 2000; Lefebvre, 1991). Experiential branding is a strategy to accumulate social space and deploy it as a value-creating mechanism (Holt, 2002). Social space is a more efficient mode of valorization when its ethico-political coordinates are aligned with the interests of corporate brands. To this end, corporations have an interest in promoting ethical, social and political causes that validate brands and branding. Branding is a limited prism for thinking about the social world, and so, corporate attempts to be socially responsible get caught up in complicated paradoxes. In this chapter, I examine two of these paradoxes at the V festival.

In his critical theory of brands Arvidsson (2005, pp. 244-5) argues that the mobility of brands must be

> controlled and kept within the boundaries of the intended brand identity. This necessity to balance between innovation and conservation means that brand management contains two sets of techniques: those that aim at the selective appropriation of consumer innovation, and those that aim to make consumers' use of branded goods serve to reproduce forms of life that the brand embodies.

Branding is not disciplinary, rather, 'brand management works by enabling or empowering the freedom of consumers so that it is likely

to evolve in particular directions.' Brands 'empower' consumers by recognizing their autonomy. Following Zizek (1999), Arvidsson (2005) argues that brands say 'you may!,' not 'you must!' To create value by empowering autonomous consumers, brand managers move from constructing brands as particular meanings and move toward constructing and facilitating the social and political contexts within which brands are made. As such, Zizek (1989, 1999) would argue that this fantasy of liberal freedom (where I can freely perform brand meaning and appropriate the brand to whatever meanings I choose) provides the subject relief from the demands of real freedom. Brands' discourses give contemporary subjects a framework through which they can feel that their participation in commodified and branded social spaces is ethical and enjoyable (Arvidsson, 2005; Dean, 2006; Zizek, 1989).

The social, ethical and political discourses brands construct relieve us of the duty to think so that we can continue to enjoy (Dean, 2006). Brands provide ready-made answers to social, environmental and ethical problems that don't disrupt our participation in the consumer society (Goldman and Papson, 1996, p. 214). We are subjects of our notions of freedom and empowerment. The social world brands set out to construct is a regulated economy of enjoyment that directs us away from the 'antagonisms of the social' (Dean, 2006, p. 104). Rather than directly confront the role capital plays in creating the social and environmental problems it claims to fix, we develop a notion of ourselves as socially, politically and economically, empowered by capital.[1]

A music festival like the Virgin V festival is a specific articulation of this branded social space within which participants are enjoined to enjoy.[2] I examine two elements of the V festival space where particular social, ethical and political discourses are deployed in ways that contribute to the reflexive and mobile value of the Virgin brand. The first space is a socially responsible partnership between Virgin and One Punch Can Kill, a government funded initiative to curb alcohol-fuelled violence among young people. The second is a stealthy branding of cigarettes at the festival. I'm not interested in the strategic 'effectiveness' of these spaces in the way a media effects analysis would be. And, while I agree that these spaces and practices may have some discreet 'positive' or 'negative' social effects, this isn't my interest in analyzing them. My interest is in examining the way these social and political practices are put to work by brands to empower their efforts to interweave with social space and to appear authentic and ethical in the process of accumulating capital. By examining these particular

meaning-making spaces within the V festival we can illuminate some of the paradoxes of contemporary brands.

One Punch Can Kill

Authentic brands have a moral code. Audiences and consumers can identify and relate to an authentic brand's 'values' (Arvidsson, 2005; Lury, 2004; Holt, 2006; Botterill, 2007). Richard Branson and his Virgin branding machine evoke the essence of liberal freedom (liberty, equality and enjoyment). The Virgin brand is hip, cool, relaxed and inclusive. Partnering with social, cultural and environmental causes within the brandscape offers a way for Virgin to map out its ethical stance. Virgin incorporates socially, politically and environmentally responsible discourses into the V festival such as carbon neutral, climate change and social justice initiatives. In addition to these causes, the V festival also partnered with One Punch Can Kill (by giving them space at the festival to interact with the audience), a government- and police-funded campaign to convince young people that alcohol-fuelled violence is uncool, unenjoyable and unethical. One Punch Can Kill fits the ethical landscape of the Virgin brand. Crucially, in One Punch Can Kill and other anti-violence campaigns, violence isn't just immoral, it is also unenjoyable.

The One Punch Can Kill campaign aimed to 'prevent senseless violence among young people.' The campaign targeted Generation Y by using 'modern media technology' to send a 'positive message that empowers young people to consider the consequences of their decisions.'[3] One Punch Can Kill takes on a liberal logic aimed at individual choices and actions rather than the structure of social space. The campaign aims to make violence uncool by having young, attractive women speak to young men (via advertisements, interactive websites, social networking sites, and installations at events like the V festival). This approach is based on research that found 'that young males are highly influenced by the women who surround them.' One Punch Can Kill follows a media effects logic. It aims to empirically define and strategically deploy an effective way of convincing young men not to be violent.

The One Punch Can Kill campaign was visible to festival patrons as they entered the V festival. Promotional models hosted a game of social soccer in a large inflatable installation, while other promotional staff in and around the installation distributed One Punch Can Kill wristbands and badges. Virgin appears to support an important public

initiative by 'lending' their audience (which they spent significant amounts of capital to cultivate) to One Punch Can Kill. One Punch Can Kill may or may not have measurable effects on curbing drunken violence, my interest here is how it lends its value to Virgin. Socially responsible initiatives like One Punch Can Kill are central to the construction of authentic and ethical brands. Other installations at the V festival (such as the Jagermeister bar, McKenna Bourbon Urban bar, Eclipse Mints Cool Room and so on) are nakedly and instrumentally promotional for profit. In contrast, One Punch Can Kill appears to be there for social reasons. The One Punch Can Kill installation gives the impression that the V festival is not just a commercial brand-building space, but also a public space where social issues are discussed and valued. In fashioning itself as a public space, the V festival pushes its overarching strategic imperatives into the background.

Within the V festival there are several installations persuasively and seductively promoting the consumption of alcohol. Many are within sight of the One Punch Can Kill installation. Targeting social change via strategic and instrumental communications campaigns often does not address the underlying systemic causes of the perceived social problem. One Punch Can Kill, in the context of the V festival, doesn't necessarily aim to reduce alcohol consumption, but to stop alcohol-related violence. In this context, it appears to ignore the fact that violence is an inevitable by-product of alcohol consumption. To reduce alcohol related violence we don't need drunken people to be less violent, we need people to be less drunk. Virgin appears to support the One Punch Can Kill message when 'in reality' the very structure of the V festival is geared towards excessive enjoyment fuelled by music, alcohol and drugs. Virgin needs to create music culture experiences which their audience finds authentic. Alcohol and drug consumption are interwoven with authentic music culture experiences. Virgin partners with several alcohol corporations that persuasively link their brands to live music culture. The engagement with One Punch Can Kill must not undermine these alcohol-branding activities or appear that Virgin is attempting to police or thwart the audience's authentic enjoyment of live music (which involves alcohol and drug use).

Audience members implicitly recognized the tension between Virgin's strategic imperatives and their promotion of One Punch Can Kill's messages. One audience member explained that the V festival facilitated the pursuit of pleasure and enjoyment, 'I don't know how successful (One Punch Can Kill) would be, as most people I saw at the

music festival were enjoying themselves perhaps a little too much.' Another audience member contended that drugs and alcohol were so entwined with live music that One Punch Can Kill was unlikely to prevent violence. While Virgin attempts to harness the raw and authentic energy of music culture, this music culture in part speaks to excessive forms of enjoyment. Ingesting alcohol and drugs while listening to music that heightens emotions and feelings, encourages wild dancing or moshing, and invites the audience into fantasies of hedonism, pleasure and indulgence is a fundamental part of an authentic music festival. These forms of enjoyment can (and do) erupt in alcohol- and drug-fuelled violence. One V festival punter told me, 'I know from personal experience that being in a mosh pit with a couple of massive moronic males who start pushing and shoving around is not a pleasant experience.' At the V festival, 'a lot of people were drinking, smoking weed and forever running into each other. That's a bad mix when it comes to fights.' Brands do need to regulate the economy of enjoyment. The excessive enjoyment of some can reduce brand value by disrupting the smooth functioning of brand-building social spaces.

Consumption of alcohol and drugs at the V festival dialectically contributes to, and detracts from, Virgin's brand equity. In response to this paradoxical tension in the brandscape, One Punch Can Kill attempts to regulate enjoyment by encouraging subjects to form the opinion that violence isn't enjoyable. The brand is not disciplinary; it doesn't deny enjoyment, rather it is sensitive to the individual subjectivity of liberal freedom—it co-constructs the audience's idea of enjoyment. The brand guides subjects towards specified discourses and outcomes.

One Punch Can Kill, doesn't target the architecture of the V festival brandscape as a space which seductively links live music to alcohol consumption, instead it focuses on individual choices within branded social space. To this logic, social problems are more individual than structural. One Punch Can Kill needs to be examined as a discourse enacted within the branded social space of the V festival. Through One Punch Can Kill, Virgin cultivates a self-policing attitude. The V festival wants audiences to get drunk and enjoy themselves if that is what corresponds with their notion of authentic music culture. They also though, need to 'brand' the violence and anti-social behavior that are a natural excess of this culture as 'uncool' and detached from their brand. One Punch Can Kill implicitly cultivates audience practices that reinforce Virgin's brand values.

One Punch Can Kill is viewed skeptically by V festival patrons. The audience members I spoke with thought the intentions of One Punch Can Kill were honorable but questioned the effectiveness of the campaign. I was told that it probably wouldn't work. Despite this dismissal of One Punch Can Kill's effectiveness, audience members did acclaim the V festival for promoting socially responsible attitudes. Audience members presented me with their strategic analysis of the campaign:

> The campaign is obviously a good idea, but it feels weak. The yellow face image is uninteresting and isn't likely to make someone pause and think before getting involved in a fight. It also seems as if the major push of the campaign is simply 'don't' instead of 'here's how not to.' I think it would be more effective if it was aimed at the reasons people fight, rather than the fight itself.

This audience member reflects the opinion of other audience members. The distance they take toward the campaign arises from their implicit realization that the consumption of alcohol and drugs is interwoven with the experience of what they perceive as authentic live music. No one supports violence, but savvy audience members recognize that violence is a symptom of the types of enjoyment the V festival encourages:

> Anyone who goes to festivals knows that by 10pm many of the punters have had their fair share of Mary Jane and high cost, low quality beer... it's common that one of these types will end up on the receiving end of a fist.

The audience members I spoke with were not only skeptical of the campaign's effectiveness they were also cynical about the festival promoting the campaign. Virgin should know that it won't work, so what might be their 'other' motivations in promoting it? One audience member suggested that while they were 'probably trying to curb violence,' Virgin really partnered with the campaign because it 'gives the festival a better image.' They perceived that One Punch Can Kill built brand equity for Virgin regardless of its social effects. Other audience members suggested that One Punch Can Kill enabled Virgin to demonstrate that they were attempting to keep the audience safe. I was told they were attempting to keep themselves 'lawsuit free' and only addressing social problems for strategic reasons. In response to the social soccer game One Punch Can Kill organized at the festival, an audience member facetiously asked, 'Is it an anger release alterna-

tive?' Another remarked, 'When I first saw the One Punch Can Kill tent I thought 'what the fuck? How do they link that with soccer? Random.'

This cynicism is also inflected with a dark sense of humor. In response to my question, 'What do you think of One Punch Can Kill?' an audience member replied, 'It usually takes my friend Colin two (punches to kill),' before arguing that:

> All government advertising for things like that is crap. You can pick an Australian Government ad in two seconds: low budget, bad acting, boring content, over-doing stereotypes. That ad doesn't relate to me in any possible way.

The audience member didn't really critique the relationship between Virgin and One Punch Can Kill, instead they suggested that One Punch Can Kill doesn't effectively compete in a branded social world. It isn't as seductive or compelling as the other brands being promoted. Jagermeister's injunction to enjoy drinking and dancing to music is more compelling than One Punch Can Kill. The V festival is full of incongruous messages. Jagermeister, Coopers, and McKenna say 'drink alcohol! Party hard!' while One Punch Can Kill says, 'don't drink alcohol excessively!' The response of punters (in the words of one audience member I spoke with) is, 'I'm here to party!'

Here we strike the cynical distance of young people in branded social space. They agree with the values expressed in campaigns like One Punch Can Kill but are cynical about its effectiveness and the 'real' reasons for why Virgin partners with them. They take the cynical position of 'Yes, I support it even though I know it won't work.' They are non-believers (they can 'see right through' One Punch Can Kill), yet the system of belief still functions (the brands still make claims and young people see the merit of those claims). This cynical attitude is a product of a social world where people intuitively maintain the symbolic fictions that support their reality, even if they know them to be false, because their subjectivity and enjoyment are dependent on those very fictions.

I was told by audience members that most people 'go to festivals to drink, dance and have fun with their mates.' The V festival builds brand value by reflecting and supporting these notions of authentic enjoyment. Within this context One Punch Can Kill is reduced to the pseudo-activity of 'putting the message out there' and 'getting people to talk about the issues.' One Punch Can Kill adds value to the Virgin brand by connecting it to socially responsible discourse. It is hard to

see how it has any impact on the systemic causes of alcohol-related violence among young people. Virgin, for one, couldn't partner with One Punch Can Kill if the campaign attempted to seriously disrupt or counter the branding activities of their alcohol partners or if the campaign attempted to change alcohol consumption at the festival. At the first V festival in 2007 the lines at the bar were long and slow and audience members had to drink in fenced-off areas. This was one of the major criticisms of the festival made by the audience. In the promotional material for the second V festival Virgin promised that alcohol service would be quicker and that patrons would be able to drink alcohol while watching their favorite bands. The audience, for the most part, wants to be able to get drunk. They want alcohol to be a part of their festival experience.

One of the young female celebrities who endorsed One Punch Can Kill contended that the V festival was all about enjoyment. The challenge for One Punch Can Kill is to be effective in a space where the injunction is to enjoy, and attempts to curb enjoyment will be derided. Placing One Punch Can Kill within the overall context of the V festival, she argued that V festival audience members, 'are only interested in three things: music, booze, and getting physical, figuratively speaking.' One Punch Can Kill competes with

> all the visual and aural stimulation provided by the advertisers, who have much larger, savvier and sophisticated weapons of influence at their profit motivated disposal, as well as the message encouraged by the musicians, record companies and fun-fuelled festival organizers.

Consequently, audience members 'wouldn't bother with a deconstructive analysis of the messages for or against getting smashed (drunk).' Initiatives like One Punch Can Kill are faced with the difficulty of making a virtue or socially responsible behavior 'cool' within a space in which vices or irresponsible behavior are 'cool':

> It's very difficult to make a virtue, if you will, rather than a vice 'cool'; youths who spend most of their time wondering how they can be cooler than they perceive themselves to be are twice as critical of contrived coolness because they're more attuned to it. Festivals are cool because you're allowed to lose control—get loose man, Yeew! And when you've got a campaign that smells, ever so slightly of police and government affiliation advocating control, it begins to look a little ludicrous.

There is a tension at work here. Virgin supports One Punch Can Kill to look socially responsible, and that builds brand value by reinforcing

the notion that Virgin is a responsible corporate citizen. But, at the same time Virgin builds brand value from the very cultural practices One Punch Can Kill is attempting to change.

One Punch Can Kill attempts to respond to the challenge of competing with the seductive fantasies of brands by appealing to desires and fantasies of its own. The program, through advertisements and promotional models, communicates through the sexual politics of the relations between young men and young women. To reduce violence in social settings that are geared towards the production of violence, One Punch Can Kill effectively says to young men, 'Girls won't want you if you fight, and you want girls, so don't fight.' This injunction fits the logic of the V festival and the Virgin brand; love, attraction, and seduction are more desirable than aggression, hatred or violence. The eradication of subjective violence (violent individuals) sutures over the systemic causes of violence woven into a brandscape like the V festival. Corporations are compelled by their sharcholders to use the brandscape to increase capital value, not solve social problems.

Initiatives like One Punch Can Kill are 'good PR, public opinion *is* against violent and excessive drinking.' The problem for audience members is that dedication to these progressive and positive social causes 'tends to weaken with several shots of Jager (liqueur) coursing through your veins,' as one participant told me. The Virgin brand wants to embody the peaceful and socially responsible discourse of One Punch Can Kill, at the same time it creates spaces which promote the causes of those very social problems. One Punch Can Kill's social context thwarts it from effecting social change. If One Punch Can Kill actually did stop people from drinking (assuming that alcohol-related violence is the inevitable product of alcohol consumption), then Virgin would not partner with them (Jagermeister, Coopers and McKenna pay them very much more money). Programs like One Punch Can Kill are barred from achieving the change they speak for, where that change would impact on the capital value of the branded social space within which they operate.

'The best thing about One Punch Can Kill is that whether people agree or disagree on the effectiveness of the campaign, they're still discussing the issue, putting it on the agenda and calling for action,' one of the participants told me. Consuming alcohol is woven into our cultural relations, into the way young people listen to music and socialize. Virgin cannot risk disrupting these relations when it is so coolly trying to align with these very cultural practices in its effort to build brand equity. One Punch Can Kill doesn't have the resources to

shift 'Australia's cultural "identity," so it is reduced to 'addressing a particular aspect of the issue.' The campaign puts the issue on the agenda, but ultimately, it is swamped, distorted, constantly contradicted by the 'world we live in,' by a branded social space that thwarts all attempts to impinge on individual freedom to consume and enjoy. If brands are really going to engage social causes in social space, then they need to aim at holistically acknowledging and unpacking (with their audiences and markets) the paradoxes and contradictions that simplistic notions of corporate citizenship produce.

The crisis of brand integrity, where corporations need to be seen as positively and authentically engaged in the social spaces they valorize, has led Virgin (and other global corporations) to narratives of social responsibility as new sources of capital value. Virgin's engagement with socially responsible causes is reflected in the brand-building activities of other global brands. Muller et al. (2008, p. 27) illustrate how Nike uses attitudes to racism in soccer as a source of capital value by using the brand as a vehicle for social change. In the Muller et al. (2008) survey of Dutch soccer fans and my exchanges with V festival audience members, there is a similar perception that the brand has no impact on the social problem and its systemic causes. Corporate social responsibility ensures the brand's integrity and equity rather than contributing to social change. Consumers and audience members agree with the sentiment of the brand but can't see it effecting any real change.

In the case of Nike, the brand's intervention in the social world doesn't aim at the structure of social relations but at educating the 'ignorant few':

> The notion of the 'ignorant few' with intolerable 'views' is identical to the image of the 'racist hooligan' described earlier. By taking up this discourse, the campaign thus obscures the possibility that soccer culture as a whole may be implicated in the reproduction of racism. (Muller et al., 2008, p. 34)

The brand is more concerned with appearing to speak for an authentic ideal than enacting any real social change. Rather than recognize social issues like violence, racism, alcohol and drug use as intractably tied up with the way people live in, construct their identities and enjoy the social worlds brands attempt to commodify, brands' narratives of social responsibility create a mythologized representation of social life without its real paradoxes and antagonisms.

Corporate discourses of social responsibility can divert attention from real problems and consequently from real solutions. The brand enables citizens to excuse themselves from the ways in which they are implicated in the reproduction of social life. Narratives of social responsibility in branding programs are indicative of the potential corporations have to be agents of social change. That potential often isn't realized because corporations are more compelled to use social space to accrue capital value than solve social problems (Muller et al., 2008, p. 36). For instance, Nike's 'Just Do It' empowerment sutures over the social and economic structures (like class, race, gender, social status, geography) that impact on whether or not someone is 'empowered' (Goldman and Papson, 1999). If the brand's 'philosophy' is divorced from its systemic reality, then any social issue that is brought within the logic of the brand will also be thwarted in the same way.

Smokescreen: (Peter Stuyvesant's) dance tent

The V festival is made up of multiple brand-building components. Throughout this book I have illustrated how brands are built through young people's labor with cell phones, cameras and social networking sites, in branded spaces like the Virgin Louder Lounge and through partnerships with socially responsible causes like One Punch Can Kill. In this section I examine a brand-building space that might be characterized as 'stealth branding' (Holt, 2002, p. 85). Holt defines stealth branding as seeking out the 'allegiance of tastemakers who will use their influence to diffuse the idea that the firm's brand has cultural value (i.e., is cool).' Stealth branding creates an ambiguous relationship between the brand and social space. At the V festival each year there is an all-white dance tent with an electronic band at one end on a small stage and a stall where 'promo-girls' (promotional models) sell Peter Stuyvesant cigarettes. The edges of the tent are ringed with molded seating. The tent is filled with audience members drinking, dancing, and, of course, smoking. Audience members dance, drink and smoke while standing on the plastic seats and tables and even on the cigarette counter. In the dance tent the Peter Stuyvesant (and Virgin) brands are created experientially. The brand is created as a social experience rather than an inert visual logo. The dance tent is a strategically constructed space that entwines popular music culture with the production of branded commodities.

The dance tent at the V festival illustrates how the brandscape can effectively obfuscate the branding of cigarettes and how the spa-

tial architecture of the brandscape is fundamental to the construction of the Virgin and Peter Stuyvesant brands. Brands are built as social relations not just as visual texts of pre-packed meaning. The audience's festival experience creates brand value. As they enter the tent, dance, drink, smoke and take photos they construct a social milieu for the brand. The mediation of social life that unfolds at music festivals embeds brands within everyday cultural practices and webs of meaning. Audience members' photos of the dance tent become authentic advertisements for cigarettes and Peter Stuyvesant both at the festival and within web 2.0.

The all-white dance tent at the 2008 V festival. This image shows the stage and speakers at one end, while inside the tent cigarettes are sold and audience members dance and socialize. Photo: Nicholas Carah.

Experiential branding involves the production and regulation of space. In a counter-intuitive way the cacophony of seductive visual lures in the V festival brandscape can be a veneer that diverts our attention from its spatial architecture. The all-white dance tent is a space which, by law, cannot clothe itself in brand logos. The brand appears invisible. This whiteness though demonstrates how the spatial architecture of the brandscape produces value. In the dance tent,

music culture is being deployed as brand value 'as it really is.' Popular music isn't the soundtrack to an advertisement; instead the commodity is embedded in a web of music culture experiences the audience perceives as authentic.

The all-white cigarette tent at the 2009 festival. The installation had a 'resort' theme with a dance band playing at one end (left hand side of image) and cigarettes for sale at the other (right hand side of image). Photo: Nicholas Carah

Advertising cigarettes is illegal in Australia. This legislation though doesn't prevent the branding of cigarettes.[4] Cigarette packets still retain brand logos and cigarettes are embedded within popular culture. In the dance tent there is no 'advertising,' the tent is entirely white. Instead, Peter Stuyvesant places the sale of cigarettes within the context of a dance music venue. The crowd of festival goers who dance and party in the tent all day and night arguably don't 'see' the branding taking place. Consequently, they miss the ways in which branding structures social space. The distance subjects employ to filter out explicit branding obscures the social relations forming around music culture and commodification. Cynical distance is this assumption that because we think we can 'see' branding take place, it has no impact on us. The brandscape accommodates us as free and savvy subjects who disavow our own perceptions of commodification.

The dance tent strategically aligns the enjoyment of live music with the branding of cigarettes.[5] The white cigarette dance tent first emerged in 2003 at Australia's Big Day Out. It was pioneered by Peer Group Media. Speaking in the Australian media at the time, Peer Group Media denied a relationship between the agency and cigarette companies at the level of branding. They told the media that, 'it would be illegal for Peter Stuyvesant to sponsor an event like the Big Day Out or for it to make merchandise which promoted cigarettes.' The dance tent absolutely fits the laws concerning the sale and marketing of cigarettes.[6]

Recently, Britain went a step further than Australia by not only banning cigarette advertising but by banning any kind of branding on cigarette packets. Cigarette packets, like the dance tent at the V festival, will be all white. This action was matched by calls from Australian lobby groups to do the same. What these lobbyists' calls for legislative responses demonstrate is an ineffective logic in responding to a perceived social problem. Contrary to their popular opinion, making commodities 'all-white' will not prevent them from being branded as seductive, desirable and cool. Brand value extends beyond the logo. In fact, given young people's cynical distance toward branding and advertising in general, forcing commodities into an all-white package will force brands to build value and meaning via social relations that young people find authentic. All-white cigarette packets would be mobile communicative objects whose meaning is constructed reflexively in social space. Cigarettes are not made seductive by the monolithic, linear, brand messages on their packets but by the social relations that embed them within popular culture.

Distinct from traditional views of branding as a visual and mediated process, in the Peter Stuyvesant dance tent we can observe experiential branding in practice. The brand is constructed 'invisibly' through cultural experience. If the 'public' (in Australia, through the Federal government) were serious about preventing the promotion and branding of cigarettes, then they would need to somehow prohibit them from the social spaces where they are made desirable, seductive and cool. Making cigarettes uncool would involve expunging them from the webs of meaning in which they are made cool. Simply denying cigarette brands the right to instrumentally package their product with particular meanings misses how popular culture and cigarettes are entwined. Capital and its brands are much more mobile than the regulatory frameworks which attempt to contain their meanings and impel them to behave in an ethical and socially responsible manner.

The instances of capital behaving in a socially responsible manner I have encountered uniformly empower capital accumulation. I've not encountered an instance where capital finds itself as part of the problem it is trying to solve.

Brands' ideas of social responsibility are constructed around a vision of society that empowers capital accumulation. Brands fetishize social values and ethics. Even though the marketing literature resists or obfuscates this idea, corporate social initiatives are primarily a mode of capital accumulation. Virgin's brand equity is cultivated around supporting socially responsible values which 'in reality' the architecture of the brandscape disavows or works against. The narratives of social responsibility embedded in experiential branding programs set out to construct a pact between society and corporations, craft particular notions of politics and public life, and construct social space in ways that empower capital accumulation.

Ingesting enjoyment (responsibly)

Alcohol and cigarettes, like popular music, are bound up with seduction, desire and fantasy. Each is a commodity that we indulge in against our rational judgment. We indulge in them in the pursuit of pleasure, disengagement with rational life, the search for enjoyment and the production of identities with cultural capital. Sobel (1978) in his history of cigarettes in American life demonstrates how, as the anti-smoking lobby from the 1950s onwards attempted to make cigarettes uncool, Big Tobacco responded by keeping cigarettes connected to the right circuits of cultural capital. This embedded cigarettes deeply within social life and in many cases ended up being cheaper than paying for advertising space. Alcohol and cigarettes are central to the authentic experiences of live music culture, which Virgin seeks to create in order to accumulate capital. In the case of cigarettes and alcohol, both of these commodities add value to the brand by making the cultural space more authentic (for many folks authentic live music experiences are about drinking and smoking). At the same time the brand also wants to appear socially responsible by promoting certain attitudes toward the consumption of cigarettes and alcohol. A common injunction on Australian alcohol products and advertising is to 'enjoy responsibly.' This phrase is significantly different from the warning on cigarette packets, 'smoking—a leading cause of death' and so on. Advertising in the alcohol industry is largely self-regulated in Australia (unlike cigarette advertising which is heavily regulated).

The notion of 'responsible enjoyment' evokes the apolitical governmentality of branded social space. By apolitical governmentality, I mean the liberal attitude of caring for oneself and thinking about individual rights and responsibilities, in ways that ignore the systemic context within which individuals live their lives and conceive of their agency. Even though people may be cognizant of the social, cultural and political impacts brands have on their world, they disavow them. That is, 'I know Virgin runs the V festival in order to make more money, and that the music culture I find authentic is commodified, but I continue to act as if this is the not the case.' One way of theorizing why people adopt this position is that cynical and savvy subjects buy into apolitical enjoyment in order to be 'relieved of the duty to think' (Dean, 2006). To continue from the statement above, 'I'm just trying to produce a sense of self that feels good, I'm just trying to *enjoy* myself, interrogating the ethical consequences and disavowals of this sense of self doesn't help!' The concept of corporate social responsibility sits at the tense interface between marketing and society. Corporations craft an economy of 'responsible enjoyment,' which always avoids considering the larger political economy that structures social relations.

Virgin makes direct and vigorous claims to social responsibility. Richard Branson argues that global capitalism does face enormous epoch-defining challenges: endemic poverty, the digital divide, global warming. To Branson these challenges can only be overcome by an entrepreneurial spirit (Branson, 2008). Rojek (2008) suggests that Branson is emblematic of 'neat capitalism.' In neat capitalism making a profit is the foundation of ethical activity in the world. Big profits are not emblematic of more exploitative extraction of surplus value but instead offer more chance of 'doing good' in the world. To Rojek (2008), the brand has a social conscience. Capitalism repairs a crisis in its legitimacy as an ethico-political system by actively 'solving' social problems.[7] Branding constructs capital as a socio-political system (Goldman and Papson, 2006).

The work of weaving together brand-building and socio-political life constructs notions of society, ethics and citizenship bound up in the imperatives of capital. Young people perform labor that constructs individual brands and forms of social labor that build branding as a series of social relations. Margaret Scammel (2000, p. 353) argues that this has led to a 'politicization of consumption.' Like Rojek's neat capitalism, this is an ambiguous idea. At first glance, one might argue that consumers have become 'politicized.' For instance, they demand

that corporations be socially and ecologically responsible; they are generally aware that corporate behavior has social consequences. The idea of politicized consumption does, however, also signal an aestheticization of public life and politics and an incorporation of political subjectivity within branded social space. Corporate brands now appeal to us:

> As cool citizens, people who were not green purists, who want the choice and pleasures of consumer society but do not want to support the bully over the little guy, trample over human rights, pollute the planet, and treat animals to wanton cruelty. (Scammel, 2000, p. 353)

These appeals construct us, and our conception of our role in society, within the parameters of branding.

Corporations strategically respond to us as concerned citizens, and we interpellate (or put) ourselves into this position by responding with concern and performing the necessary social labor that integrates the logic of branding and our conception of politics. Who we are and how we might act politically become bound up in the same social spaces and processes that create brands. Notions of consumer citizenship are tethered to, and are products of, the narratives of corporate citizenship that are embedded in contemporary brands. Corporate brands reflexively incorporate political narratives, including resistant ones. Socially responsible brands offer us solutions to problems where we don't have to directly confront the risks of life in a global capitalist world, where we can disavow the way our consumer citizenship is embedded in a system of global capital with its social and ecological consequences. Narratives of social responsibility enable us to continue to 'bask in the politically correct glow of favored brands' (Thompson and Coskuner-Balli, 2007; Heath and Potter, 2005).

Chapter Seven

Brand Builders

Professional brand builders

The flexible relationships between corporations, marketers and cultural participants reflect the mobile nature of contemporary brands. The cultural industries are a dynamic and fragmented network of contractors, agencies and people providing content and labor. In this chapter I examine the work of brand-building by marketers and other professionals in the culture industry. Marketers who craft experiential brands aim to empower consumers by letting them drive the brand-building action at the same time they aim to accumulate capital by strategically exploiting their labor. Marketers and their cultural industry partners derive a sense of legitimacy and authenticity about their work from the assumption that the corporations they work for are socially responsible (Deuze, 2007). Marketers construct the narrative that the marketing programs they develop are ethical and socially responsible because they 'empower' cultural participants in the process of empowering themselves and the corporations they work for. They also treat their work as instrumental and strategic and meaningful when it generates capital value for the corporation they work for.

Experiential brands are the product of a decentralized network of production. The decentralized nature of this cultural workforce is both economically efficient and decreases the likelihood of public discussions about the role of corporations in social life. McRobbie (2002, p. 519) argues that 'there is little time, few existing mechanisms for organization, and anyway, no workplace for a workplace politics to develop' in the flexible, 'speeded up,' constantly changing spaces of cultural and brand production. Both economic and socio-political relationships are decentralized. The cultural industries contractors involved in designing and implementing experiential branding programs are reluctant to speak about the corporations they are contracted to. Marketers are unable to talk seriously about the social impacts of their programs beyond trumpeting brand values and mantras. Bands that are cynical about branding programs are reluctant to speak out about programs because they know that it could cur-

tail future opportunities in the rapidly changing music industry. Bands participating in branding programs are only willing to participate in interviews that promote their cultural input and the brand. In my experience as a researcher trying to engage with these networks of production, most musicians and marketers asked for a list of agreed questions or sought assurance that I wouldn't discuss anything 'critical' prior to agreeing to an interview. Corporations protect their strategic interests first and foremost. Despite their experiential programs making claims to an inclusive and empowering politics, those claims themselves are not open to debate and discussion. Marketing might be moving toward managing social space; while that makes the brand appear more open, the same can't necessarily be said for the social space that marketers facilitate.

I sought to interview the marketers and cultural industry workers involved in the experiential branding programs I describe in this book in order to record the dominant themes and narratives they use to articulate their brands and branding programs and their role in them. Owing to confidentiality I don't attribute these themes to specific corporations and campaigns; what emerges though is a clear narrative about experiential branding that provides a useful starting point for thinking about how marketers and marketing constructs itself as a socially responsible and ethical activity in contemporary society. These themes help us move toward thinking of experiential branding as a holistic political logic.[1]

Marketers

The marketers I spoke with commonly indicated that changes in communication technology had made interactive brand-building relationships with young people possible. Experiential branding enabled them to build a 'brand story' in conjunction with core opinion leaders and adopters in their target market. The key difference between experiential branding and traditional branding approaches is the strategic intention to develop a mechanism for engaging young people in authentic, enduring and interactive brand-building relationships. The success of this approach relies on young people feeling that the corporation supports rather than structures their cultural world. Experiential branding is effective when young people feel that they are the empowered directors of the brand-building action. Such a strategy has to take a long term relationship-building approach. Popular culture is a key conduit to connect with young people; it marks out a social space within which young people and corporations can meaningfully

relate to each other. One marketer at a global corporation described their experiential branding program as focused on three components:

> Connecting teens with music, rewarding brand loyalty and creating amazing brand experiences through live music. These three elements tap into insights about teens and music, and are not new. The brand has been tapping into these insights for the last couple of decades; this program is just a way of bringing them alive in a new and unique way. Changes in technology, however, have changed how we bring these components to life. (We can now) create amazing experiences for the product that strengthen their relationship with the brand.

Experiential branding enables marketers to develop a 'vehicle to tell the brand story' and to get consumers 'excited about the story behind brands.' These programs frequently articulate the brand into cultural narratives. Experiential brands understand the culture they work in; they develop a 'brand community.' The brand community is a product of the experiential social spaces within which the brands are built and embedded within popular culture by the joint efforts of marketers and the market (Muniz and O'Guinn, 2001). The brand community refers to both the relationships customers form with the brand and the relationships they form with each other around the brand (Veloustsou, 2009). Valuable brand communities are culturally influential. Effective brands court their top-tier exclusive adopter markets and use them as conduits that 'filter brand information to the market.' These relationships can be developed by offering musicians and peer leaders access to exclusive zones of cultural production.

The brand community is also underpinned by mechanisms to gather data and insight about the brand and its social and cultural context. Marketers normally measure effectiveness through instrumental techniques such as behavioral data analysis, market research, sales tracking and monitoring of online activity. Within a corporation these are the most effective ways of articulating value to management. Moor (2003) argues that traditionally marketers and managers have focused on assessing the direct impacts of 'above the line' marketing activities. For instance, marketers have reported to management the impact specific advertising campaigns have had on sales volume in key target markets. This mode of evaluating brand-building overlooked how 'below the line' meaning-making activities also accrue significant brand value. In her interviews with marketing professionals, Moor (2003) notes a renewed interest in engaging and understanding the impact that 'below the line' experiential brand-building

practices have on brand value. Marketers are moving to think of brand value being constructed 'wherever' the brand is (Moor, 2003, p. 42).

The marketers I interviewed indicated that the effectiveness of experiential brand-building is gauged through more intangible measures than just instrumental data analysis. They attempted to discern the cultural impact of the programs because this was imperative for relationship building between the brand and market over the long term. Evaluating experiential brand-building often requires a long-term view of value creation (Moor, 2003), and so marketers need to convince management that the 'effects' of experiential brand-building may not be immediately discernable. One marketing manager described the process as being engaged with young people at a formative stage in their lives and integrating the brand into their cultural heritage:

> The program, through its live events, creates experiences that teens would probably not have otherwise. You are more likely to remember an unforgettable experience in your life and the person that allowed you to have it versus a traditional advertising campaign. So by the brand creating these experiences it creates a long term bond with teens by being a part of their teenage years. We assess the viability of the program by how teens bond with the brand over the long term measured through complex tracking studies.

While corporations do use instrumental and traditional marketing research and sales data tracking tools to evaluate the effectiveness of experiential brand-building in creating brand value, they also argue that it is difficult to reduce experiential marketing to finite sales or statistical data. One corporation describes the process as complex methods of tracking 'brand health.' Another outlines how they 'track cultural initiatives against sales data' but the program is 'more positional and relationship building and so not purely assessed in terms of sales.' Corporations use a combination of methods to determine brand health. While they use traditional methods such as surveys and focus groups they also 'look in online forums, track online communication about the program and content downloads, and gauge participation in online initiatives' through downloads and hits.

In 2009 media agency Peer Group Media launched a service called PeerIn in conjunction with Sentiment Metrics. PeerIn aims to

> enable brands to identify their current market position in terms of music equity, develop unique creative solutions together with the appropriate

mix of up to 12 key music-specific media channels, including digital, experiential and above-the-line media.[2]

Sentiment Metrics is a UK-based market research firm that specializes in tracking brand conversations on web 2.0's social media. Sentiment Metrics claims to provide accurate portrayals of media-making activity related to particular brands, popular culture, and political issues in web 2.0 (Trendrr is another of the emerging market leaders, and this sector is rapidly expanding). Beyond just recording hits and quantity of communication, Sentiment Metrics claims to provide automated analysis of the substance of conversations. They can deduce the specific textures of the meaning-making and align these meanings with geographic, demographic, cultural, and behavioral data. Experiential marketers want to be able to map how particular demographic groups in specific geographic locations use particular products, have particular tastes, hold particular political views, and use social media. Experiential marketers don't just build brands, they also build social spaces where participants compulsively mediate everyday life and where these practices of mediation are logged and gathered by corporations as part of the social action. These initiatives aim to evaluate and enhance the 'social equity' of brands.

The activity that unfolds around brands in web 2.0 lends itself to tracking and surveillance of the 'texts' consumers produce around particular brands. Much of the innovation in marketing research to come in the next few years will be in tracking the textual meaning-making undertaken by the market. Corporations want to understand what their audiences do with their brands when they mediate them online. The audience not only performs labor by embedding the brands as mediated texts within their online social networks, they also construct these social networks in web spaces that are a valuable information commodity that documents their online meaning-making activities. Their online activity constructs an enormous textual focus group (Andrejevic, 2007a). As part of constructing the social spaces that facilitate experiential branding, marketers are also retooling their market research activities to understand and track action in these spaces.

Experiential brand-building relies on corporations fostering relationships with key players in the cultural and creative industries. The relationship between corporation and cultural industries is different from traditional relationships between corporations and advertising agencies. To build brands experientially corporations engage a

breadth of media and culture workers. Corporations manage a diverse mix of 'website people, content people negotiating with bands, music industry people, and traditional media agencies.' Marketers at corporations need to employ the right cultural capital to engage with and facilitate their brand-building social spaces.

Experiential brands are built in diverse networks of creativity and social action. This includes large record companies, media producers, local venues and musicians, street press and independent online media organizations. Through media agencies many creative industries' workers are contracted on a flexible basis to deliver particular program components. Some corporations take great care to acquire cultural capital by employing 'from the culture' and recruiting and training staff from the 'shop floor' into the creative and brand production roles of the firm. One of the corporations I spoke with employed young people who fit the youth culture values of their market. Recruits from these youth cultures gradually transitioned their knowledge of youth culture into brand value throughout their 20s. The 'shop floor' staff were actively engaged in developing aspects of the 'brand personality.' At one level their shop floor service is a form of 'aesthetic labor' (Pettinger, 2004), but they are also a valuable resource in the ongoing construction of the brand. They don't just 'perform' the brand on the shop floor, they also innovate it by linking up their identity and cultural world with the brand's continuous flexible development.

The marketing manager at this corporation observed that young people loved to get involved in experiential brand-building because no one else was funding grass roots culture, and this was the best way for young people to express themselves. The corporation gave employees and their top-tier customers outlets to make and showcase their music, films, fashion and art. The manager said that because employees and top-tier customers 'live and breathe the culture, we will always be in front (of competitors), you can't copy that.' Several other corporations had tried to copy their approach, but because they weren't closely interlinked with youth culture and had relied on advertising and marketing agencies to produce the content, their attempts had looked contrived and failed to build real brand value. His experiential branding strategy had been successful because he had leveraged the intimate cultural knowledge of his employees and top-tier market in the production of a brand community and capital value. The brand community was presented as supportive of young cultural producers.

Brand communities court particular young creative producers. The young people and youth cultures that corporations partner with must contribute to the strategic aims of the brand. Their creativity needs to be uniformly apolitical and non-threatening to the brand. Corporations don't partner with creative cultures from poor and disadvantaged groups or parts of the city. Experiential brand-building is positioned by marketers as a socially responsible investment in the social world of young people. One marketing manager told me that their brand was

> about creating local connections not just global ones. We believe that the local music scene has a wealth of talent but sometimes teens don't get as much exposure to this as the big international acts, so what's better than giving the local guys a hand in reaching this audience?

Corporations position themselves as facilitators and defenders of important social spaces. These claims form the foundation of their claims to being socially responsible and ethical brand personalities. Through experiential branding, corporations 'like to support local talent in areas that get less attention, focus on grassroots (production) and... develop relationships with cultural producers and communities.' These producers and communities are always interconnected with the brand's target market. Of course, this is no surprise, but it is significant to make this point in contextualizing their claims to social responsibility. Their vision for society equates with their conceptualization of a target market.

Keep it on the ground

I interviewed people involved at several levels of experiential branding programs: from marketing managers at the global corporations to the local cultural industry workers who implement programs. My experience has been that marketing management at corporations is prepared to outline the brand intentions and values and emphasize their contribution to local culture at the same time they build more dynamic brands. Often, the local level implementers who run the programs in local cultural spaces, or whose venues serve as the sites of these programs, are willing to talk and have a good sense of how the strategic objectives of the corporations play out in the local scene. The local managers understand the audience that corporations are attempting to engage with. One local manager told me:

It's a savvy audience. They want to be in control of their label associations, they want to be in control of their media. Individuals want to set trends instead of following them. The marketing people know this. So rather than saying, 'hey this is going to make you look cool' they say, 'we think you're cool so we are going to support what you are doing.' And of course the person has to turn around and go, 'oh thanks, cool' and there is some loyalty developed there.

Local managers understand how the brand operates at the local cultural level in a nuanced and localized way, whereas marketing managers tend to only understand these interactions through abstract data and reporting mechanisms.

One local manager of an independent band competition understood why the corporation was engaging in the program but was able, from the unique position of being involved in both the local culture and the strategic planning, to discern the gaps between the corporation's aims and the local cultural reality. She explained the distance between the strategic intentions and the conflicting concerns of each of the stakeholders (local venues, local bands, media agencies and the brand). She articulated the differing objectives that need to be balanced in delivering an experiential branding program:

> The program was delivered by a marketing agency who was employed by the national distributor who was distributing the product for the international manufacturer. The marketing agency was asked to deliver a program similar to the one delivered in the US. The distributors were getting worried because they didn't see the drink sales translating. The major problem was that most of the venues we were working with know that nobody was paying to get in the door, so they weren't getting a cut off the door, so they didn't want to give a Friday or Saturday. But the distributor and marketing agency wanted Friday and Saturday night because that's a drinking night—we were talking about a spirit here, it can't be lightly consumed. So there was that clash from the beginning.

The local manager got the best available night, but venues weren't going to give away a weekend night, because that is when they get bigger bands and audiences who drink more. The aim was to sell alcohol, but the audience wasn't drinking because it was a weeknight, and they were mostly a young student crowd out to support their friends' bands. The brand values and the cultural values aren't always completely mutual.

> So there was that polarity between what (night) the venues could give because of the very nature of the program. You are specifying your au-

dience when you choose your bands and when you choose unknown quantities you have to accept the audience you get with that–that's the very nature of the program. But the distributor and managers of the program didn't quite get it. They were choosing unknown quantities... they couldn't understand why you couldn't get big drink sales. In effect, that's why the corporate manager decided to try something different and that's why the marketing dollars were moved.

Brands can overestimate how important 'supporting local music' is as a common cause for local music fans. They see local music all the time, so they often don't see what the big deal is of a global brand coming to town for a few weeks to support it. The brands want both the large sales and brand impact that come from large mainstream audiences; at the same time they want to cultivate the brand with a young adopter audience that follows emerging music. Experiential branding needs to be adaptive to the social spaces it is trying to engage with or facilitate. According to the local manager, the new marketing campaign for the brand floundered because it reverted back to the traditional alcohol marketing strategy of 'promo girls in short skirts' and wasn't a program that built a community. The manager's assessment of the program illustrates the difficulties in managing an experiential marketing program, where local stakeholders may have very different concerns and motivations to those strategically planning the brand at a national level.

The corporation appears to have purely economic interests whereas the other cultural industries participants have social and cultural interests. Even though the corporation makes claims about their social responsibility, this extends only as far as it has direct economic pay-offs. In this case, they supported local music because they thought it would immediately translate into higher brand value and increased product sales. When this failed to materialize because they had misjudged the nature of the music scene they were getting involved with, they reverted their marketing spend back to a traditional campaign. To some extent experiential branding requires a change in the corporation's conception of what branding campaigns should achieve and how their impacts and effects should be measured. They require a change in corporate culture toward a more flexible facilitation of meaning-making processes.

Despite the program ultimately ending because it didn't meet its instrumental strategic objectives, the local manager thought that it had created brand value in the local music community:

Bands got to play a good venue, with a proper sound technician, and get advertising and editorial. Every band needs a printed review to feel validated; every band likes to see their name in the street press. You forget when you work in street press how important just that name is. Yeah, and they get the shot at the prizes, at the recording time.

From her local vantage point the manager could articulate the impact the branding program had, where the managers at the corporate level couldn't see the concrete benefits.

The benefits for local bands outweighed any perceived negatives of having corporations involved in the local music scene. The local manager didn't think that the bands performed unpaid brand-building labor, instead, she was keen to emphasize the contribution the program made:

> I'm all for (having brands engage with local music). I'm very interested in a thing called CSR (corporate social responsibility). I think especially when a government becomes less supportive of experimental and emerging art forms, it is the responsibility of corporations and private sector to step up and offer money into that sector and help support cultural development (to support) the cultural production of a city. It's way more creative than straight advertising, a physical manifestation of community and loyalty. It looks to me they enjoy smart marketing and they enjoy doing something toward cultural development.

The venue the program was in has a long history of supporting emerging bands. The program was the first of its kind in the venue (but since then there have been others). The venue owner was hesitant about being involved in a corporate branding program, but thought that it would work if he could choose a manager who ensured the program fit with the venue and the local music scene. The venue owner thought that the program didn't 'damage' the scene: 'It was nice that an alcohol company put money up front to support local bands rather than other alcohol companies who do nothing. It was credible, different to promo girls in short skirts.' As a venue owner, he was very careful to partner with brands that were a 'natural fit' with the local scene. The program helped bring a new audience and new bands to the venue, and he felt good about supporting the local scene. From the corporation's perspective the program wasn't a success because it didn't deliver immediate measurable sales growth from the local cultural implementer's perspective though it did build brand value and recognition by embedding the brand within a local cultural milieu. This value is difficult to quantify and measure.

Experiential branding programs that engage with popular music offer an effective platform to target different youth segments and organize them around cultural content. Popular music can be a practical way of 'engaging the audience in explaining a complex product mix' or telling a brand story. Marketers are keen to emphasize that experiential branding is more ethical, socially responsible and empowering than traditional marketing formats. They are keen to align the ethos of the brand with the ethos of the local culture. The rhetoric of experiential branding doesn't always live up to its promise for marketers when its impacts can't be immediately instrumentally articulated into the decision-making structure of corporations. Corporations want to position themselves as good citizens because they sense this builds brand value, but they also want to see tangible and definitive return on investment.

Corporate citizenship and return on investment

In the 1960s marketing guru Theodore Levitt coined the term 'marketing myopia' to criticize marketing's focus on products rather than consumers and their social world. Levitt's article was a mythical moment for modern marketing. From this moment on marketing inched toward a more concerted engagement with social space. The 1960s and 1970s saw the emergence of hip-consumerism, lifestyle marketing and social marketing (Frank, 1997). By the 1990s services marketing was emerging as the 'dominant paradigm' (Vargo and Lusch, 2004). In the past decade experiential branding approaches together with narratives of social responsibility have emerged. Rather than focus on selling products, marketers increasingly facilitate the social spaces and processes that will enable the production and consumption of commodities (Arvidsson, 2007; Deuze, 2007; Gronroos, 2007).

Since Levitt, marketing gurus have trumpeted the imperative that brands must be an authentic and meaningful part of social life. They espouse mantras like 'the more brands shout, the less they are believed!' Instead, they contend, brands need to be embedded within social life. Marketing's sense of a paradigm shift is that marketers no longer completely invent and control brands and brand messages; they no longer have linear communications with markets. Consumers now have power, and marketers need to be sensitive to that power. Brand-building strategies and corporations need to be 'consumer oriented.'

This marketing discourse has a specific political dimension. It posits that consumers are powerful, they direct meaning, and that corporations are at their service (Zwick, Bonsu and Darmody, 2008). This rhetoric neatly obscures how corporations and marketers construct consumers' desires and the limits of their power in the first instance. Marketers recognize that society, the media and consumers are changing. But they don't articulate how it is that corporations have dramatically changed the media and social system, and that it is these structural changes that have given rise to new forms of consumer action. Consumer 'power' is dependent to a large degree on the media, communications and social spaces that corporations construct. These social spaces are constructed in order to anticipate and harness the productive capacity of empowered consumers (Arvidsson, 2005; Zwick, Bonsu and Darmody, 2008). Consumers have skills and cultural capital that corporations seek to harness by managing social space (Christodoulides, 2009; Deuze, 2007; Zwick, Bonsu and Darmody, 2008).

Marketers recognize a need for a concerted political engagement with social space in order to build brands and to build flexible and profitable corporations. The difficulty that experiential marketing theories have faced is how to articulate these approaches into a corporate decision-making logic that demands empirical and definitive evidence of return on investment (Arvidsson, 2008b). Schultz and Gronstedt argue that 'marketing has traditionally chosen to evaluate its marketplace results on soft, attitudinal data rather than on hard, financial data' (Schultz and Gronstedt, 1997, p. 41). Return on investment in branding is difficult to measure, but marketers recognize that they need to articulate their activity with hard data in order to influence corporate decision makers. Return on investment data would enable marketing strategists to articulate to chief decision makers how brand-building is an investment that pays both short and long-term dividends rather than simply a necessary expense. Return on investment is the 'holy grail' and 'next wave' for marketing communications (Lenskold, 2003; Rust et al., 2004; Schultz and Gronstedt, 1997).

At its most basic, return on investment is calculated by dividing return over investment. Marketing spend is commonly mapped against sales data. Graphs illustrate how a set amount of spend on advertising in particular media channels reaches definable audiences and results in sales activity (Lenskold, 2003; Rust et al., 2004). Return on investment is articulated by demonstrating that when a cer-

tain amount of money is invested in advertising; it results in a greater amount of sales than the initial advertising investment. Advertising spend in particular channels, targeted at particular markets, that doesn't result in definitive sales growth is cut.

On one hand, the challenge for marketers is that return on investment from an experiential brandscape is difficult, if not impossible, to accurately measure. The meaning-making activities of consumers in their mediated social worlds are difficult to quantify. Investments that structure social and political frameworks conducive to brand-building cannot be definitively evaluated, even though they do create the context within which other more direct brand-building activities can unfold. On the other hand, branded social space offers many opportunities for data gathering and digital profiling, as consumers and citizens mediate their activities, enter information online, communicate through digitized networks, and create an ever-expanding digital shadow that connects their social and consumer lives (Andrejevic, 2007a; Schultz and Gronstedt, 1997).

In one sense contemporary consumers are unpredictable and unmanageable; they create their own meanings, take brands in unintended directions, rapidly evolve their tastes, and constantly seek to direct social action. The marketing discourse argues that this 'autonomy' is empowering. This unpredictability, rather than being a hindrance to capital accumulation, can be deployed as a new source of value. Consumers are a source of innovation and brand content. The labor consumers perform in making brands meaningful enables corporations to more efficiently exploit and extract value from social life. Even where consumers resist brands, this non-identity creates the necessary social change and movement to feed further brand adaptations and opportunities for value creation. As Zwick, Bonsu and Darmody (2008, p. 183) explain, 'it is precisely this non-identification with commodities available in the market that brings about the kind of creative labor power of consumers that companies value.' Companies encourage unruly consumers in order to valorize their creativity. This valorization though depends on them bringing consumers into branded social spaces that harness this productivity.

These processes are at work in the interactive branded spaces I have covered throughout this book. They are also being registered in the advertising-funded mass media that are dependent on their advertisers continuing to achieve profitable returns on investment through their media channels. To this end, the mass media strategically set out to produce content and, by extension, audiences, that of-

fer corporations competitive returns on investment. Improving the return on investment measures in corporations is dependent on understanding the media texts and environments that their target markets interact with. For instance, one of the strategic reasons for the rapid growth of reality TV in the past decade has been its superior returns on investment and access to data about audiences compared to other mass media products. Reality TV is cheap to produce; it attracts an audience with a high disposable income; it easily incorporates brand messages into its content; it attracts opinion leaders and generates press, and its audiences frequently create texts about the programs on the web.

The paradox of contemporary brand-building is that while it is harder to quantify it does offer marketers access to data that are much richer and far more quickly analyzed than previous eras. While 'autonomous' and unruly consumers may drive brands in unspecified directions, sophisticated return on investment measures enable marketers to acquire and retain better customers, locate and entice top-tier customers to participate in brand-building labor, better link brand-building with sales activity, collect data from different markets and understand the many different relationships particular segments have with the brand. The most detailed return on investment data enables managers to profit from mobile and reflexive brands and to capitalize on the social life of brands, rather than be overwhelmed by them.

The development of sophisticated surveillance and return on investment measurements enables corporations to profit from the unruliness of consumers (Zwick and Knott, 2009). Marketing used to be most efficient when it could predictably rely on a homogenous mass market that would not change too much over time. This enabled standardized products to be sold through established physical distribution networks to a dependable market. Sophisticated databases and data management are central to profiting from the rapid development of heterogeneous and flexible market and cultural structures. Rather than simply witness social change outrun production and distribution capacities, databases and surveillance enable market heterogeneity to be a source of value (Zwick and Knott, 2009). Rather than masses of invisible consumers, surveillance of digital mediated social space offers valuable 'inventories of branded selves' as sources of capital value (Hearn, 2008, p. 215).

Sophisticated surveillance and return on investment techniques enable marketers to identify unexpected forms of innovation in con-

sumer life. This surveillance depends on social life unfolding within social space that marketers can efficiently track and extract information from. The basic equation is that as long as social life is unfolding in ways that corporations can harness, then it will generate 'future market opportunities' from the 'social and cultural innovations generated in the uncontrolled and undisciplined spaces of consumer culture' (Zwick and Knott, 2009, p. 225). Capital is dependent on its own contradictions. The heterogeneity and apparent autonomy of social life generate value in ways that a homogenous and unchanging mass of consumers would not. Flexible accumulation profits from the autonomy, difference and non-identity of liberal social life. Flexible accumulation refers to the permanent innovation, decentralized production and mobility and change in social life that are key sources of capital value (Harvey, 1989; Hearn, 2008). Marketers don't need to discipline consumers more effectively; they instead need to figure out ways of harnessing their productive capacity more efficiently.

Marketers have always known that their return on investment models only demonstrate some of the impacts of marketing activity (Arvidsson, 2008b; Lenskold, 2003; Rust et al., 2004). Basic return on investment models can over-simplify growth in brand value over time, long-term patterns, latent brand meanings, and how marketing activity contributes to a wider political economy of branding. The most sophisticated experiential branding strategies recognize the customer as a value generating asset that needs to be invested in (Lenskold, 2003; Rust et al., 2004; Schultz and Gronstedt, 1997; Zwick, Bonsu and Darmody, 2008). Marketers need to understand and model the returns on marketing investment in order to bring marketing and branding to the centre of corporate decision making. Brand-building is a long-term value-making strategy, not a short-term promotional expense (Schultz and Gronstedt, 1997). Cutting-edge and critical marketers argue that brands, rather than physical infrastructure, are the real long-term assets of corporations in the global information economy (Lenskold, 2003). Brands have material capital value (Goldman and Papson, 2006). Marketing expert Philip Kitchen recently observed that if Coca-Cola's entire physical infrastructure of production were obliterated today, the corporation would be able to raise enough capital off its brand value alone to rebuild the entire physical operation.[3] Experiential branding is not just a reorganization of brand-building; it is also reflective of a reordering of corporate decision making, global capital, and social space.

The strategic development of experiential branding involves developing institutional structures and market research. Cutting-edge marketers recognize that measuring and evaluating experiential branding involve a more holistic conception of return on investment, one that evaluates the brand and the social, political and economic context within which it is produced. Experiential brands are built most effectively within institutional structures that can facilitate flexible and networked relationships with the cultural industries and social space (Christodoulides, 2009; Deuze, 2007; Louw, 2001; Zwick, Bonsu and Darmody, 2008). Experiential branding both changes the institutional structures within which brands are made and develops more intensive surveillance of social space (Andrejevic, 2007a). Marketers, culture industry workers, musicians and young people all labor and produce surplus value for brands.

Critical conceptions of branding in the past decade are useful to marketers, partly because their own conceptions of culture and meaning-making have been linear and shallow. The more nuanced conceptions of culture in critical, cultural and media studies offer marketers a framework for understanding how brand value is created in social space. Marketers want brands to be self-reporting, data-collecting social spaces and processes. They want them to empirically prove their profitability instantaneously. Experiential branding creates valuable brands because it effectively extracts value from social actors. Brand value is created by extracting surplus value from the labor of, and through surveillance of, participants in branded social space. Marketers facilitate social space where young people build brands. Within that social space young people construct information commodities about themselves and their popular culture.

Marketers argue that their investment in social space, empowerment of consumers, and responsible return on investment are beneficial for both the brand and society at large. This notion of consumer empowerment is dislocated from the media-capital nexus within which consumers are empowered. Marketers and marketing theory do not articulate how the value generated is the surplus value produced by consumer labor within commodified social spaces. Rather than acknowledge these material conditions of brand-building, marketers tend to craft a narrative of empowerment that ignores how branding is central to the production of the contemporary media system and social space. Changes in brand-building are inherently linked to the changes in broadcast advertising-funded media models (like free-to-air television) and the emergence of media models funded by expe-

riential and participatory brand-building. Marketing tends not to think of itself within this wider social, economic and political context. In its own narrative it responds to change that happens 'out there' in society, without implicating itself in driving that change. The notions of social responsibility and empowerment it advances are meaningful to participants, but we must see them as being necessarily limited by and dependent on the capital-accumulating social spaces corporations facilitate.

Marketing's new story

Marketing used to be explicitly about building and controlling brands. Emerging from the management and planning innovation of World War II, it was schematized with the war language of targets, positions and segments. Marketing is now increasingly about a brand-building process which is continual, mutual and experiential. It is schematized with the inclusive language of empowerment and liberal democracy (Kitchen, 2003). In this process of redeveloping marketing's discourse, marketers and marketing theorists have incorporated many of the critiques of branding into their own conceptions of brand-building (Frank, 1997; Heath and Potter, 2005; Holt, 2002). The contradiction in this story is that at the same time marketers are developing sophisticated surveillance and return on investment techniques in order to profit from consumer action in ways that radically disempower them (by more efficiently exploiting their labor), they are crafting a narrative of consumer empowerment. To this end Zwick, Bonsu and Darmody (2008, pp. 176-177) argue that:

> The latest turn toward co-creation represents one of the most advanced strategies of capitalist accumulation and consumer control because of its reconfiguring of marketing into a supply function for free, unpaid, and more or less autonomous consumer labor processes. It is a form of government of consumers that gives birth to an active consumer whose independent, creative, and voluntary activities can now effectively be channeled into raw material for the firm's commodity production. At this particular moment, consumers' labor is expropriated as surplus labor because it is unpaid labor that does not necessarily contribute to the consumer's ability to buy more goods. It is in this sense that we suggest, following Roemer's (1982) exceptional analysis of Marxian exploitation, that co-creation attempts to exploit consumers.

The contradiction is that the more 'empowered' consumers are (in marketing's notion of empowerment), the more value they will create

for corporations. Zwick and Knott (2009, pp. 239-41) suggest that brands create surplus value through the 'endless and efficient modulation of consumer subjectivity' where 'ubiquitous information gathering transforms what has previously been seen as a practical marmarketing problem in need of more control–the mobile, creative and unpredictable consumer–into a productive and economically important force.' Marketing's narratives of empowerment are about it reflexively adapting itself to social life. Marketers want to 'empower' consumers because it enhances their ability to accumulate capital. They savvily craft this strategic motive into a narrative of social responsibility.[4]

Rather than ignore or refute critics of marketing, marketers have become their own critics, pre-empting and incorporating critique ahead of time. In our contemporary moment, marketers craft the 'participatory' and 'empowering' rhetoric of experiential brand-building (Firat and Dholakia, 2006; Venkatesh and Meamber, 2006; Venkatesh, 1999). Marketing has a history of co-opting the tools and models of other theoretical perspectives in order to refit them as strategic marketing tools. Since the middle of the 20th century, marketing has used sociology to engage with the consumer society and constructed consumer behavior from the discipline of psychology. At the turn of the millennium, marketing has moved toward engaging critical cultural theories to make marketing a more 'socially responsible' practice, sensitive to contemporary cultural conditions and savvy consumers.

Critical theory, just like critical and rebellious social practices, has become a significant brand-building resource for corporations. Arvidsson (2008a, p. 329) observes that:

> One of the most interesting and for many academics, astonishing, scholarly developments in the last few decades, has been the almost wholesale incorporation of the theoretical canon, methodological apparatus, and general worldview of cultural studies into marketing.

This process is 'deeply ironic' because critical social theory from the outset has positioned itself against administrative and strategic research (Smythe, 1983). Marketers' adoption of critical cultural theories in the academy aligns with the adoption of identity politics as creative resources and content for brands in practice. Marketers have adopted the emancipatory logic of critical theoretical projects (Arvidsson, 2008a; Holt, 2004). In both theory and practice, critique 'streng-

thens what it rises against.' Arvidsson (2008a, p. 340) sketches out
the dialectical social process at work here:

> The activist approach to brand management is only possible with mas-
> sive amounts of consumer data that allow the activist manager to make
> real time adjustments in their programme, so that consumers always
> recognize the brand not just as something that gives meaning and signi-
> ficance, but as providing the kinds of meaning and significance that they
> always already wanted. In this way, the necessary pre-structuring of
> agency that is a component of this modus operandi, is also, effectively, an
> elimination, or at least significant restriction of agency. From this pers-
> pective, theoretical and methodological practices that aim at uncovering
> and thus empowering such agency also have the consequence of provid-
> ing new surveillance tools that contribute to the efficiency of its sub-
> sumption.

Following the early critical theorists (Adorno, Marcuse), critical theo-
ries of marketing illustrate the capacity of the market to re-route re-
bellion (Arvidsson, 2008a, 2008b; Frank, 1997; Goldman and Papson,
1996; Holt, 2002; Zizek, 1989). Savvy brands critique themselves for
the market (Goldman and Papson, 1999, p. 81).

Critical accounts of marketing by marketers (practitioners and
academics) maintain a liberal notion of agency that routinely ignores
questions of labor and surplus value (for instance, see Scott, 2007).
Bradshaw and Firat (2007, p. 30) in their overview of critical market-
ing argue that critical marketing attempts to critique the institution
of marketing yet 'remain in the service of marketing practitioners.'
Critical marketing aims at an understanding of marketing within its
social and systemic context but necessarily stops short of deconstruct-
ing marketing or the professional ideologies that enable marketers to
make sense of their role in the world (Marion, 2006). Critical marke-
ters, who remain firmly within the marketing paradigm, fall into a
utopian temptation that necessarily ignores the exploitation and alie-
nation of labor and resources that underpin marketing and capitalist
production.

Similar to autonomist Marxist accounts (Arvidsson, 2006), critical
marketers suggest that marketing is ultimately a liberating social
system that increases the agency of consumers to direct social action.
This increasing autonomy will enable consumers to 'perform a takeo-
ver of organizations and marketing to control and run them for their
purposes' (Bradshaw and Firat, 2007, p. 40). This narrative, that ex-
periential marketing lays the foundation for a popular takeover of
marketing, glibly ignores the systemic context of marketing: no mat-

ter who operates marketing at a social, political or organizational level, they operate it in order to efficiently exploit labor and resources to accumulate capital. While Bradshaw and Firat (2007, p. 41) warn against a 'critical marketing project in which marketing is never really critiqued at all,' ultimately any critical project embedded in the marketing academy has to avoid deconstructing marketing and instead contribute to the production of narratives that make marketing appear to be an ethical, socially responsible and critical theoretical discipline and profession. Marketing's new story adapts the emancipation narratives of critical theory to discursively produce consumers as empowered brand builders and marketers as socially responsible corporate citizens (Badot et al., 2007). Marketers want critique that generates strategies for capital accumulation, not critique that destabilizes capital (Gordon et al., 2007).

Marketing's own ability to co-opt hip and savvy consumers outran its theoretical worldview. Critical marketing is a response to the problems posed by the intensification of the relationship between marketing and culture, the rise of hip-consumerism, the emergence of interactive media, and the development of active audiences. Consumers and culture are more reflexive than traditional linear models of marketing management and communication allow. Critical theory explains how corporations can so effortlessly co-opt and profit from rebellious counter-cultures. Critical theory helped to explain marketing's role in society, and in creating a socio-cultural and ethico-political framework for capital, but marketers necessarily functionalize these critical theoretical frameworks. Rather than see the critique of the culture industry as aimed at the system as such and rather than see particular antagonisms written into capitalist relations of production, marketers instead see incremental problems that call for strategic adjustments. Critical theory becomes a functional framework for understanding the relationship between marketing and society in more nuanced terms and crafting the socially responsible discourses required to relate to contemporary consumers. These narratives put forward the consumer as active and powerful and marketing as aiming to create a harmonious balance between stakeholders. They don't register critical theory's fundamental argument: that marketing is a symptom of capitalist relations of production that are founded on an asymmetrical division of labor, resources and power.

To McMillan (2007), not only does corporate social responsibility make claims it can't deliver on, it colonizes the spaces where these claims and social issues might have been worked through in different

ways. Corporations cannot conceive of social issues and causes except in ways that will be beneficial to them (Ritz, 2007). The corporate social narrative influences the way citizens and other social actors think of these issues. Social life is imagined through a corporate prism. For corporations to really act on the claims they are making requires more than changing their branding narratives and practices. A critical examination of marketing's new story eventually brings us to a political predicament: we organise social activity through corporations and thereby expect them to serve public and private interests. Corporate brands and corporate social responsibility create persuasive narratives to argue that these interests are compatible. In this process, public interests get reshaped to suit private interests (Ritz, 2007). Critics of these narratives place corporate social responsibility in its larger political economy (Conrad and Abbott, 2007). Corporate social responsibility and marketing's new story are historical developments in capital's ongoing process of enabling the smooth functioning of capital accumulation.

The development of the socially responsible rhetoric of experiential brand-building enables corporations to assert that their marketing practice is ethical, sustainable and empowering to young people. Throughout this book I have documented many claims to social, political and environmental action within branding programs. These claims need to be evaluated by examining their impact on the real systemic change they speak for. These projects appear to have much voice but little impact. Voice is celebrated in the neo-liberal web 2.0 era: everyone can be a reporter, have a blog, construct their identity online, deliberate with their fellow citizens, use Twitter to protest. There remains, however, a fundamental difference between 'speaking and being heard' (Hindman, 2009). While the contemporary moment offers many opportunities to speak in new ways, the people who get heard tend to come from elite groups and have access to significant economic and cultural capital. Hindman (2009), for instance, illustrates how the top political bloggers are more frequently white, male, wealthy, highly educated, and well connected to the political and industrial elite than the average citizen. The distinction between speaking and being heard is the key systemic issue we must keep in mind when we evaluate celebratory claims about participatory mediated social life. The culture industry may be being reorganized into interactive networks, but the fundamental power structures remain.

The rise of participatory media has been accompanied by powerful and influential rhetoric about social power. This rhetoric is replicated

in different forms across all the sectors of professional and social life impacted by these changes. The empowerment of citizen journalists, the rise of consumer-citizens, the co-producers of experiential brands, the political activists of the blogosphere, the collective networked citizens of Twitter outsmarting oppressive political regimes and so on. These replicas of social power are symptoms of the same political logic.

Participants in brand-building (marketers, culture industry participants, young people), in the process of legitimizing marketing practice, create the notion that they are empowered. The notion of participants in branded social space being empowered is a key intersection of the interface between strategic and critical conceptions of brands, popular culture and politics. The strategic approach embeds empowerment in capital accumulation. Capital accumulation is perceived to lead to the further empowerment of cultural participants. Participation in branded social space simultaneously strengthens discourses of liberal democratic society and the processes of capital accumulation, intractably tying them together. From a critical perspective, these notions of empowerment and authenticity are produced by, and contingent upon, the discursive frameworks of those who already have power. They only empower people to the extent that they will empower further capital accumulation. To the critical perspective, the links between these ideological narratives, elites and these new modes of communication should be the key object of study.

A central feature of Adorno and Horkheimer's (1997) grounding critique of the culture industry was that it systematically excludes real alternatives. The discourses of empowerment within branded social life merely enable cultural participants to speak 'as if' they are empowered. This process of creating discursive constructs for subjects to inhabit and 'feel good' within aligns with a certain populist notion of liberal democratic capitalism. The discourse of empowerment implies that all subjects are equally able to participate within the social world, there are no elites or subjects with more power than others, and it disavows the political economic basis of social life. Capitalism's elites use the empowering rhetoric of experiential branding to disguise their power and the way they structure the social world (Harvey, 2003).

Brands exist in order to create surplus value. Surplus value is created when the knowledge and labor of some people are harnessed by others. Surplus value is the product of an asymmetrical sharing of resources. Any ethical framework, to be functional, has to ignore this

strategic and commercial logic underpinning branded social space. Contemporary marketing programs attempt to create a discourse of participatory legitimacy, rather than elitist authority, over the public.

Corporate citizens

Marketing knowledge (like many professional communications practices: journalism, advertising, politics, public relations) is in transition from being produced in closed, authoritative institutional settings to being produced in diffused participatory spaces. The diffusion of marketing into culture aligns marketing practice with cultural practice and socially accepted ethical frameworks. By engaging with culture, marketers craft narratives that legitimize their profession both to themselves and to society at large. These narratives of social responsibility, ethics and cultural production are key facets of managing global capitalism.

In an interactive commodified social world, culture and brand production are entwined. To be an effective brand builder a cultural industries participant needs to have significant cultural capital, understanding of the key mythologies and values of the cultural setting. And, increasingly, to have any cultural capital, a cultural industries participant has to have access to brand-building spaces. Contemporary savvy subjects are dependent on a thoroughly commodified popular culture. It is difficult for marketers, musicians and creative young people to imagine a subjectivity external of branded social life. They make the forced choice of freely participating because the alternative is the loss of the symbolic framework that makes their life meaningful.

Brands are built through the deployment of cultural capital by musicians, marketers, culture industry workers and young people. These interactions construct cultural knowledge that gets deployed as brand value. The facilitation of brand-building social space by marketers is an attempt to align the strategic interests of corporations, the means of communications and the dominant narratives of contemporary popular culture. The brandscape is an attempt to create a social structure that obfuscates power relationships by making the means of communication appear open and interactive.

Marketers set out to construct a rhetoric that claims to support and empower local producers. Local cultural producers are given access to previously exclusive means of communication (interactive media, special access to live performances, music recording and so on).

By being given this access they appear empowered to construct their own meanings and narratives. The musicians I interviewed participate in brand-building programs because they believe they are performing authentic cultural work, assisted by the corporations involved in their culture. The marketers and culture industry workers I interviewed offered a similar narrative: that their branding programs facilitated meaningful social and cultural spaces. Both of these narratives evoked the idea that corporations can and should play a responsible role in society. These narratives of corporate social responsibility can be deployed as a savvy defense of corporations and capital (Goldman and Papson, 2006). Corporations strategically craft discourses of social responsibility that buttress, protect and reinforce their legitimacy. These discourses of social responsibility are aimed at constructing social spaces more conducive to creating brand value.

Branding and corporate social responsibility need to be understood within their political and economic context. Zizek (1999) argues that we should not be distracted by the appearance of identity politics and claims to social responsibility, these all too frequently obscure the fundamental structure of social relations. The emergence of experiential and cultural brand-building must be examined in the light of its strategic place in the corporate drive to accumulate capital in a networked and interactive popular culture. Experiential branding does not represent a new ethical and participatory form of marketing; instead, it illustrates corporate attempts to reconfigure the means of communication to accommodate contemporary cultural practices and harness value from their meaning-making practices.

Musicians, young people, marketers and culture industry workers may feel empowered by their action in branded social space, and derive meaningful feelings of enjoyment and authenticity from their participation. This social experience though needs to be considered in the context of a series of asymmetrical social relations that ultimately empower capital accumulation. The brandscape is configured so that corporations are able to extract a surplus value from the labor of cultural participants. Musicians and other cultural participants can 'act out' in the brandscape, fight for social and environmental causes, and even criticize brands—ultimately though this activity merely reinforces the brand's claims to being a legitimate and vibrant social space. Brands steer cultural participants toward particular ways of conceptualizing their activity in the social world. These subjectivities, be they marketers, musicians, or young people, are all ultimately productive for the accumulation of capital.

Chapter Eight

The Future of Mediated Youth

Pop brands

I began this book by describing the emergence of experiential branding and the brandscape as a contemporary articulation in the development of marketing as a political, economic and social practice. The history of marketing is characterized by the intensification of the relationship between capital and social space. Having some way of accounting for capitalism is a fundamental ground for studying brand-building. Branding is, and has always been to some degree, a particular embodiment of the communicative logic of capital.

I set out to study brand-building within the social context of young people and the popular music culture of the global west. Here, brand-building and popular culture are symbiotically connected. Popular culture is a key realm of meaning-making in western society. Consequently, branding as a strategic meaning-making process engages with the spaces and practices of popular culture. Any theory of experiential branding, therefore, needs to encompass a critical account of popular culture and the underlying structure of the social context within which it is produced. Popular culture is not simply an 'authentic' resource that brands poach, co-opt and feed off. Popular culture itself needs to be seen as a product of the same industrial mode of production as brands. A critical account of popular culture and branding needs to come to terms with the mythologies and narratives produced in order to make the social world possible, coherent and enjoyable. Here, a contemporary ideology critique is useful. In particular, I draw on Zizek's (1989) notion of ideological fantasy, that encompasses the productive capacity of ideology and the (ultimately unproductive) ironic and cynical distance contemporary subjects take toward it.

The framework I use draws on a critical account of branding and popular culture, drawing on critical theories of capital, society and culture. I have illustrated how this critical account of experiential branding is paralleled by an account of the same process in marketing theory that takes experiential branding to be an empowering and ethical intervention in the social world. I used this framework to guide

my ethnographic fieldwork. I followed the relationships between brands and popular music in social space. I explored how brands are articulated and how, as objects built in social space, they are the products of human labor. In particular, I attempted to account for the work that young people, musicians and marketers perform, often in relationship to one another, in the production of valuable brands.

In Coca-Cola's Coke Live brandscape, the brand offered a pious and sincere manifesto of authentic cultural values. The brand set out to defend a notion of what authentic culture was. The young participants in the brandscape by and large recognized Coca-Cola's strategic motivations in making these proclamations and cynically distanced themselves from them with their ironic and savvy dispositions. Despite their distance however, the young people I encountered avidly participated in the Coke Live brandscape, both online and at the music event. They entered demographic, behavioral and cultural data about themselves online and spent time mediating the event throughout social networking sites. This cultural labor created information commodities in two ways. Firstly, as a 'digital shadow' or profile of their own identities useful to Coca-Cola and their partners in future brand strategies. And secondly, as valuable and authentic textualizations of the brand (as photos and texts in the social networks of young people). Surveillance and media-making emerged as key aspects of experiential branding.

At Virgin's V festival I illustrated how live music (as one of many elements of popular culture that audiences distinguish as being authentic) is central to the meaning-making processes in the brandscape. Virgin strategically constructs both the infrastructure of meaning-making (the festival site, cell phones, web 2.0 connectivity) and the popular cultural object to mediate (the bands, music, and brand). Live music provides an authentic 'quilting point' of enjoyment and shared social experience around which young people gather. The brand provides the authentic cultural mythologies and objects for the audience to gaze upon and mediate. Virgin reflexively harnesses the audience's sincere and savvy notions of authenticity by selecting bands to play the festival that evoke strong feelings of nostalgia and strong evocations of the contemporary moment, replete with its style, savviness and irony. The V festival is a brandscape that weaves together meaning-making practices of popular music with the meaning-making practices of brands. These meanings are simultaneously produced. This weaving together of brands and popular culture implicitly constructs the groundwork for participants' perceptions of what public

space might be. These implicit narratives authenticate and legitimize the brandscape.

Brands make claims to authenticity, politics and ethics in the social world. I examined how these claims are lived out and related to by the marketers, musicians and young people in branded social space. Experiential brand-building is labor intensive. Marketers, musicians and young people work hard in the brandscape to construct surplus value in a material sense. At the V festival the audience and bands work to produce information commodities in a social context where this work is embedded in an economy of enjoyment. The V festival invites the audience to 'enjoy' popular culture in ways that 're-lieve them of the duty to think' (Dean, 2006). The audience enjoys by 'knowing' (for instance, by knowing which bands to be reverently nostalgic for and which to be ironically nostalgic for). Experiential branding is most effective when it gives young people the opportunity to enjoy 'knowing,' to enjoy deploying their cultural capital by making distinctions about performances. This enjoyment obfuscates the material labor they perform within social space. At the V festival, Virgin put this enjoyment to work to build their brand. Virgin harnesses surplus enjoyment from the audience (Arvidsson, 2005).

Virgin appeared frequently in this part of the book because they capture two particularly contemporary elements of the brandscape. They reward their audience's 'knowing,' give them the sense that they are directors of the cultural action, and give them the capacity to enjoy. Virgin says to their audience 'we know that you know' and we want to embrace that, empower you to deploy your knowledge in enjoying your popular culture. In addition to rewarding the knowing audience, Virgin offers them a reflexive politics that is critiqued in advance of their participation. They offer a politics that is alive to its contradictions. Virgin offers ideas of citizenship (green politics, carbon neutral festivals, Virgin Unite foundation, and supporting local music) at the same time the audience sees right through these claims. Despite the fact that they see right through them, they continue to participate in them because these savvy discourses of authenticity, politics and ethics enable them to enjoy popular culture and find it ethical and meaningful.

This 'ideological fantasy' (Zizek, 1989) is productive for both Virgin and the audience. It enables Virgin to appropriate the audience's and bands' labor, and it enables the audience to continue to enjoy. Bands and audiences at Virgin's V festival 'work twice as hard' or 'pay twice as much' as they initially appear to. Bands both attract the au-

dience that makes the festival financially viable and create surplus value for the brand via their performance. And the audience pays once for the ticket to the festival and then again with their meaning- and media-making labor. The brandscape produces value as a social space that harnesses the labor of its participants. Audience members might well know this is happening but don't care because it's an embedded part of their popular culture.

Brands are ultimately a productive mechanism, a way of making capital. The claims they make on social and political space are first and foremost claims that will be value producing. Brands don't undermine their own material base in any of their social or political programs. The form of experiential brand-building that I have examined in this book illustrates a change in the way brands are built and therefore necessarily changes the role of the people who make brands too. For instance, I have illustrated how musicians commodify themselves in the brandscape in new ways beyond just the traditional recording and live performance of their music. New mythologies to support these practices emerge. For instance, brands and musicians craft new narratives of being an authentic musician. The notions of authenticity constructed are strategically aligned with the subject positions the brandscape constructs. The brandscape's mythologies of authenticity are ones that empower capital accumulation.

These narratives can be cynical, ironic and nonsensical as musicians attempt to make sense of their place and their perceived agency in commodified social spaces. Where they come up against the limits of particular narratives of authenticity they reflexively reach for others. They fall back into the traditional narratives of authenticity in the culture industry by defending the idea that they 'just play real music and that's it,' disavowing the social context within which they produce that music. They also fall forward into the strategic narratives of the brands they partner with when they argue that the brandscape enables them to reach their audience, offers great publicity and more income than they have previously had. They also adopt the ethical narratives of brands when they argue that the brand supports and invests in the local music scene. Here, contemporary musicians live out the complex and contradictory forces of popular culture. Ultimately, they mediate brands' narratives in ways that obfuscate their own internal contradictions. Marketers and bands craft narratives that enable them to make sense of and validate their role in the social world.

Young people also work as brand builders and also craft narratives that explain that work. These narratives bring the brand to life and co-construct narratives of citizenship for both citizens and corporations. Young people build individual brands and construct branding as a holistic political and social logic. While marketing has a contemporary story that attempts to make branded social life an authentic and ethical ground for political action, these discourses evade their real political implications. The brandscape wants young people to assume its narratives of political and ethical life as their own. Young people for their part often recognize the strategic intentions of corporations, but this doesn't stop them from embracing the cultural and political narratives of the brandscape partly because these stories offer them a meaningful identity in a commodified and interactive social world.

The rhetoric of interactive social life as empowering and ethical masks some uncomfortable material realities. Marketing theory offers one example of this rhetoric that obfuscates its political-economic grounds. Experiential branding is a 'disavowed' argument for a capitalist politics and social world. Marketing is, in the first instance, an argument for what the world ought to be like. The narratives and mythologies of marketing work at the level of the brand by creating suites of seductive meanings and values that attach to particular commodities and corporations. The narratives are also imperative at the level of branding, where they create meaningful and ethical identities for marketers, musicians and young people. Experiential branding crafts mythologies that enable these subjects to make sense of their role in the social world and their work in building brands. At key moments in the fieldwork I attempt to demarcate how marketing's material structural reality thwarts what its rhetoric argues for. For instance, at the V festival there is a contradiction between Virgin's professed attitudes to the socially responsible consumption of alcohol and the centrality of alcohol consumption to the authenticity of a live music festival and their partnerships with leading alcohol brands. Or, very few musicians actually believe that corporations really do care about local music culture, even though they provide the symbolic content for this rhetoric via their participation.

Young people and musicians simultaneously both see right through and embrace marketers' persuasive discourse of ethics and social responsibility. They see through the sincere manifestos, social programs, and claims to support authentic music. And they discredit the material effectiveness of the programs. At the same time, howev-

er, they embrace these claims in what they do: they participate in the brandscape, and they also support the noble (if thwarted) intentions. Here, we see the 'decline of symbolic efficiency' (Zizek, 1999), a reluctance to believe what is said. This disbelief in marketing's symbolic rhetoric is accompanied by a thorough participation in the social action of branding. Savvy subjects don't 'believe' but they let the system believe for them. Their identity, enjoyment and stable sense of who they are as subjects depend on the system they purport to see right through.

What arises, I contend, is a suite of pressing issues in my study of experiential branding that are connected to a broader critique of the global, capitalist, interactive, mediated era. These issues include the limits of a cynical and ironic popular culture, the limits of brands' claims to positive political action, and the future of research about and with mediated youth in a thoroughly commodified social world.

Branding: a vision for society

Experiential branding doesn't just change the way brands are built, it is also part of a wider reordering of social space (Deuze, 2007; Lash and Urry, 1994; Louw, 2001). In her work on branding and consumer culture Lury (1996, 2004) demonstrates how the reflexive and ironic practices of consumer culture are a product of the tense interface between notions of authenticity and commodification. Lury attempts to detail the search for authenticity within consumer culture. Lury (1996, pp. 239-240) plays this out by drawing on Giddens' (1991) distinction of emancipatory politics from life politics:

> Life politics, in contrast to emancipatory politics, is said to be a politics of self-determination. The protests, campaigns, strikes and rallies associated with emancipatory politics were an attempt to reveal the invasion of people's everyday lives by social and political forces of domination and exploitation. Life politics is said to work at a different level. It concerns a reflexive relation to the self in which the individual is less concerned with protesting about the actions of others than with taking control (that phrase again) of the shape of his or her own life through the negotiation of self-identity.

This description of life politics, which also gets called post-politics or identity politics, centers politics around identity and meaning-making processes. Throughout this book, through the conceptual idea of the brandscape, I've attempted to illustrate how corporations strategically

incorporate life politics into brand-building practices. In contemporary capitalist society, political action becomes located in identity and meaning-making processes, and those meaning-making processes become located in the social spaces and practices of consumption. Consumption is then put forward by corporations as a political act in and of itself.

Identity politics dissolves political action into atomized individual acts. We live as individuals in an economy of risk seeking to offset that risk through our reflexive identity and meaning-making processes. Claims to consumer power, through meaning- and identity-making practices in the consumer world, need to be placed within the historical and material development of capitalist society. Irony, reflexivity and playful meaning-making are not the empowering political actions they appear to be. David Harvey (1989) in *The Condition of Postmodernity* wrote that there had been a 'seachange in the surface appearance of capitalism since 1973, even though the underlying logic of capitalist accumulation and its crisis-tendencies remain(ed) the same.' Harvey (1989, 2000) argued strongly then, and has done since, that flexible accumulation is a temporary fix rather than a solid transformation, the underlying political economic structure of capital continues as the bedrock of society, replete with its antagonisms and internal contradictions. Harvey reflected in (1989) that even though flexible accumulation provided for the possibility of new modes of social, economic and political life (much as early critics of the culture industry did) the reality was that these changes were ultimately beneficial to capital's elites. Harvey (1989, p. 343) argued that:

> Capital is a process not a thing. It is a process of reproduction of social life through commodity production, in which all of us in the advanced capitalist world are heavily implicated. Its naturalized rules of operation are such as to ensure that it is a dynamic and revolutionary mode of social organization, restlessly and ceaselessly transforming society within which it is embedded. The process masks and festishizes, achieves growth through creative destruction, creates new wants and needs, exploits the capacity for human labor and desire, transforms spaces, and speeds up the pace of life. It produces problems of over-accumulation for which there are but a limited number of solutions.

Harvey's description of capital in the context of flexible accumulation provides a neat description of contemporary branding and the claims it makes on social life. The brandscape flexibly accommodates itself to social life in order to achieve growth through creative destruction, en-

gage consumers in the production of information and immaterial commodities and produce all-encompassing ideological fantasies of power, politics and enjoyment.

Lash and Urry (1994) in *Economies of Signs and Space* provide another comprehensive and compelling account of the emergence of the post-industrial society. Their examination of reflexive accumulation parallels with Harvey's analysis. They describe the 'aestheticisation of everyday life' as part of capital's reordering of social, political and economic structures to accommodate new technologies and communication networks. The post-industrial world is characterized by the flow of information, capital and people throughout the globe, on one hand empowering a new middle-class with the right cultural and economic capital and, on the other, creating new disempowered underclasses in the third world and the de-industrialized urban centers of the first world. The post-industrial era is characterized by the growth of capital into new realms of natural, social and political domains. Experiential branding is situated within the context of these global developments. Experiential branding and the brandscape are a product of, and bound up within, the post-industrial world. Experiential branding is connected to reflexive and flexible accumulation; it is a product of a commodified and mediated social world; it is a symptom of global flows of capital, ideas and people; it is connected to the political rhetoric that celebrates the empowerment of a global middle class and glibly forgets the global underclass (Harvey, 1989, 2000; Lash and Urry, 1994; Lash, 2002; Lury, 1996).

Experiential branding is symptomatic of a larger political moment in liberal democratic capitalist society. It is symptomatic of the identity and lifestyle politics of the post-modern era, where political projects are increasingly envisioned around particular causes rather than holistic political demands. Slovenian philosopher Slavoj Zizek (1999, 2008) offers a compelling critique of capitalism, popular culture and post-politics. In *The Ticklish Subject* (1999, p. 429) he argues that post-politics ultimately 'radically depoliticizes' the economy. The way the economy functions is taken as objective and beyond politics. Consequently, he argues, that for 'as long as this fundamental depoliticization of the economic process is accepted' all our talk of active citizenship, collective participation, and deliberative decision-making within our digital democracies and interactive societies will be limited to cultural and lifestyle differences. The focus on cultural values in politics obscures the fundamental issue that affects us all: the organization of the economy. To Zizek, 'the problem with today's post-politics

is that it increasingly undermines the possibility of a proper political act' because the depoliticization of economics accepts capitalism as the neutral, objective and only possible grounds for a society. David Harvey (2000) too argues that we are caught in a political moment that evades a critical analysis of capitalism itself, even though it seems most apparent that all of our pressing social, political and ecological crises are products of capitalism's internal contradictions.

Experiential branding follows this post-political logic. The brandscape directs political and social action toward particular issues that are conceptualized within a brand- and capital-producing framework. The market becomes the totalizing domain of social action. In the brandscape, brands can be celebrated and critiqued and put to work to achieve social and political ends. Brands can defend the poor and argue for fair work practices, environmental sustainability and so on. Critique of the political economic context of branding though is off limits. Goldman and Papson (1999, p. 183) argue that criticism is always directed at brands, not branding:

> Media criticism rarely identifies, and it certainly never inflates, the root logic of capital, or the structure of the global economy. Instead, criticism on television and in the newspapers flows out of the gap between representation and practice.

Above all else, experiential branding has to empower capital accumulation, so its notion of politics necessarily excludes any critique of the material economic context of branding. Such a critique would seek to determine how the brandscape functions as a social space that creates capital value through an asymmetrical division and use of resources and labor.

The brandscape engenders feverish action. We *must* act on climate change now; we *must* support local culture, we *only* believe in authentic music and so on. Why does the brandscape produce these pious manifestos? Zizek (1999, p. 429) argues that this activity is really a pseudo-activity that ensures that the fundamental basis of our social world will not be disturbed. The brandscape celebrates and enforces particular kinds of political action. It attempts to thwart social space from having a radically contingent character. The brandscape incorporates a critique of itself ahead of time. Participants in the brandscape 'know' that the brandscape's claims are strategically motivated, ultimately insincere, there only to serve the real aim of accumulating capital, but nonetheless they feel unable to undertake any kind of action against it. Acting or speaking out against the

brandscape is thwarted and uncool. I might 'know' but I still do in order to enjoy and be relieved of the world-disrupting 'duty to think' (Dean, 2006).

Zizek's argument has a radical character, which often doesn't sit well with intuitively liberal-democratic readers. For liberals, the idea that our social space is radically unfree is a preposterous idea. Regardless of its political content, Zizek's argument offers a philosophical frame through which we can attempt to think a critique of branding as the communicative logic of capital and interrogate its claims to authentic and ethical action in the social world. We routinely and intuitively take a cynical distance toward the sincerity of brands' ethical, social and political claims. We need to reflect upon this cynical distance. The question we need to ask, regardless of our political persuasion, is do we really feel comfortable with our politics and our conceptions of ethical action being subsumed into corporate brand-building campaigns?

If we feel that that the brandscape's claims to social and political action in the world are somehow inauthentic, contrived or strategic, then we need to determine if that points to a basic antagonism in the organization of a capitalist world. Contemporary critics like Harvey (2000), Lash and Urry (1994), Zizek (1999, 2008) and others argue that capitalism, the economic organization at the root of our society, culture and politics is the source of real antagonisms and problems. From this position we cannot hope to solve social, cultural, or environmental challenges without addressing the underlying economic structure of those problems. The brandscape, and its strategic creators, would argue vigorously against this notion. If we are to think about branding, participatory media, web 2.0 or other features of mediated social life then we need to come to terms with this deadlock. Mediated social life is always-already the product of capitalism, and so it comes replete with the same social, economic and political advantages and antagonisms that capitalism has always engendered.

We increasingly perceive that we live in a 'risk society' (Beck, 2002, Giddens, 1990) characterized by the specter of inconceivably large challenges. global warming, biogenetics, epidemics, nuclear war, endemic poverty, and so on. The brandscape is symptomatic of the risk society; it offers pre-packaged, easy-to-digest, solutions to these problems. For instance, corporate music festivals are now 'carbon neutral.' Concert-goers pay extra for 'green' tickets, put rubbish into recycling bins, offset their travel to the festival, and know that part of the festival profits will go to development initiatives in the third world.

Brands offer avenues for political action that obfuscate the gravity of the problems. Furthermore, they build the solution into the ethical substance of the brand. Within branded and commodified social space, Zizek (2008, p. 430) argues that these fundamental social antagonisms that are the consequence of an asymmetrical division of labor, resources and power, turn into discreet problems with definite solutions. Interfacing a radical political critique like Zizek's with the rhetoric of the brandscape enables us to consider what is at stake in corporate branding's intervention in our social and political world. Zizek illustrates how brands set out to be politics (2008, p. 430):

> Corporations such as Whole Foods and Starbucks continue to enjoy favour among liberals even though they both engage in anti-union activities; the trick is that they sell products that claim to be politically progressive acts in and of themselves. One buys coffee made with beans bought from the growers at fair prices, one drives a hybrid vehicle, one buys from companies that provide good benefits for their employees (according to the corporation's own standards), and so on. Political action and consumption become fully merged. In short without the antagonism between the Included and the Exluded, we may well find ourselves in a world in which Bill Gates is the greatest humanitarian fighting against poverty and diseases, and Rupert Murdoch the greatest environmentalist mobilizing hundreds of millions through his media empire.

Brands set out to be 'political acts in and of themselves.' While brands provide immediate enjoyment and easy solutions, there is a sense that they hollow out our social world. The branded social world offers a decaffeinated post-politics (Zizek, 2008). Furthermore, there is a sense that we cynically and ironically 'know' the limits of branding but participate all the same. Forms of contemporary post-politics, of which brands are one of the most compelling instances, preclude any action that takes on the 'economy' or 'capital' itself, any action which wants to critique the system as such. The way we organize society and the structure of communications is automatically precluded.

Fighting for 'capital with a human face' (Zizek 2008, p. 458) is the manifesto of the brandscape. The social problems we confront today, according to this manifesto, aren't the result of the economic and political organization of society itself, they are instead the consequences of a few 'bad eggs', a few 'honest mistakes' some 'inefficiencies' in the allocation of resources. Ultimately, brands and liberal democratic politics demand a thorough participation within the system. Post-politics is a politics that turns away from politics as such and instead devises

ways of making the system work more efficiently to achieve strategic ends.

The fundamental gap or deadlock between strategic and critical ways of thinking about branding (and society, economics, and politics) is one of the key frameworks in this book. Strategic marketers (and their allies in the cultural industries) ultimately buy into a politics where they think that through better tactics we can have profitable corporations and brands, and a healthy environment, vibrant cultural spaces, and so on. Even more than this, brands actively defend the social world. In fact, the more profitable corporations are, the more resources they have to fight and solve these problems. This kind of logic can never pause to think where these profits and resources come from (labor in the developing world and the natural environment). The acquisition of these resources often causes the social and environmental problems that the very same brands accrue value off pretending to solve.

A critical approach to branding argues that the problem is the system as such. The problem isn't particular corporations or inefficiencies in the way the economy runs. It doesn't argue that it would be better if brands were more profitable and had more resources to save the environment, fight third world hunger, help growers in the developing world or invest in local cultural spaces. To the critical approach, it is the very logic of branding that is most problematic. In the past generation the critical approach has become caught up in a largely unproductive deconstruction that offers little by way of practical interventions. Culture jamming, protesting, and boycotting all seem counter-productive. Critical theoretical accounts of branding either ignore the question 'what is to be done?' and focus entirely on deconstruction, or offer what seem to be utopian visions of branding and the capitalist system being overtaken by the networked creativity of the empowered users (Arvidsson, 2006; Bradshaw and Firat, 2007). Experiential branding, and marketing's contemporary discourse of ethics and corporate social responsibility, is alluring in part because they at least offer a vision for action in the social world.

The problem, of course, is that liberatory politics are easily accommodated into, and demobilized by, experiential branding. They are put to work to accumulate capital. Harvey (1989, p. 353) sensed that liberatory projects would not ultimately challenge the contradictions and antagonisms of the capitalist process. My examination of the brandscape offers an illustration of how his intuition has proven to be correct. The critical perspective often isn't as compelling to us

because it doesn't offer a clear path of action (like brands do). It does offer us a more thorough explanation of branding, and through it we can arrive at a more holistic understanding of how brands and brand value are produced. As Harvey (1989, p. 345) argues, while we may feel that antagonisms and crises in capital demand political and cultural changes:

> The sufficient conditions (for those changes) lie more deeply embedded in the internalised dialectics of thought and knowledge production. For it is ever the case that, as Marx (1967, p. 178) has it, 'we erect our structure in imagination before we erect it in reality.'

The significant theoretical work (Harvey, 1989, 2000; Lash and Urry, 1994; Lury, 1996; Zizek, 1999) that aims to connect up our current cultural and political moment to the structures of capitalism, liberalism, and democracy points us toward the continuing need to analyze the processes of class, material and symbolic production as part of the 'almighty totality' (Adorno, 1991) of capital. Attempts to understand branding and the brandscape without a thorough analysis of the wider social, political and economic context will surely miss both the strategic and critical point.

The limits of cynical interactivity

The rhetoric of the brandscape mirrors the rhetoric of popular culture and the politics of the web 2.0 era. Cynicism is one of the symptoms of the savvy reflexivity that the brandscape and popular culture engenders (Holt, 2002; Zwick, Bonsu and Darmody, 2008; Zizek, 1989). We take ourselves to be 'non-dupes' who get how the culture industry really works. We think that because we can see how the culture industry works we aren't subject to it (Andrejevic, 2004). Cynicism is the product of cultural participants who do not completely misrecognise social reality. Instead they know very well what they are doing, but still, they are doing it. Ideology is enacted in the doing not the knowing (Althusser, 1971; Zizek, 1989; Adorno and Horkheimer, 1997). Despite what a brandscape's participants might believe, they still do the process of producing popular culture within a commodified social space (Andrejevic, 2004; Zizek, 1989). This freedom is the very opposite of effective freedom (Zizek, 1989, p. 21).

The cynical humor of participants in the brandscapes I have examined is reflective of the cynical humor of *The Daily Show*, *The Onion*, *The Chaser*, and the rest of web 2.0's non-duped active au-

diences (in the frequently snarky and dismissive blogosphere). The limitation of this celebration of non-duped cynics is that it obscures how shallow these claims to empowerment are. *The Daily Show*, *The Chaser*, branded social life and web 2.0 aren't the answers to the perceived limits of the old 'top-down' culture industry; they are instead the symptoms of the participatory rhetoric the culture industry has constructed around itself. Rather than arguing that these new forms of popular culture are radically different from the old, we need instead to see them as products of the same old culture industry. If I've read him right, Jon Stewart (of *The Daily Show*) would agree with me here. Whenever people level claims at his show's role in the political process, he replies 'But we're a comedy show!' He seems exasperated that people expect *The Daily Show* to stand in for 'real' politics.

Cynicism and savviness aren't the 'answer' celebrants of new media think they are. They are in fact symptoms of a kind of institutionalized lying. We 'know' very well that we are following a false idea but we follow it anyway. We don't believe in the system, but we want the system to believe for us. Zizek argues that 'This is how we are believers today—we make fun of our beliefs, while continuing to practice them, that is, to rely on them as the underlying structure of our daily practices.' Consequently, 'when we think we are making fun of the liberal ideology, we are merely strengthening its hold over us' (Zizek, 2004, p. 103). The cultural arrangements of the brandscape need to be taken seriously. In their comedy and irony, their color and vibrancy, in their appearance of 'unseriousness' and apparent inconsequence to real cultural relations, they mask a production of ideology in the social world of young people. The tendency of academics and commentators to celebrate new participatory technology and new 'ethical' and 'soft' interventions into social life need to be put in this context. The brandscape, as a symptom of interactive participatory media, naturalizes capital as a cultural, social and political system.

The argument that interactive popular culture like the brandscape, web 2.0, and reality TV gives ordinary citizens voice obscures the ways in which it is directly instructional about social life and politics in a neo-liberal society (Andrejevic, 2004; Couldry, 2009). Celebratory narratives about new media focus on consumer and citizen power without considering the context within which this power is generated and what ends it serves. The notions of community, citizenship and participation that emerge are ultimately benign, thwarted and cynical because they systematically disavow their political and economic context. Actors in participatory media are bound up within a

particular context of production. A critical account of new media has to consider how these participatory spaces would function without the infrastructure of the culture industry and other central political economic institutions. The social spaces of the brandscape and interactive media are tethered to broader social and political structures.

In the clouds

While IT gurus call the coming age of interactivity 'cloud' computing, as if mediated youth experiences will take place in amoebic, instantaneous clouds of information, in reality these 'clouds' are the material products of a political and economic media system. Rather than the data and social action of the interactive era being airborne in 'clouds,' it is in fact grounded in the vast, polluting, server farms sprouting up in the physical spaces where land and electricity are cheap (Andrejevic, 2007b). Mediated youth experience is the product of a weaving together of physical and virtual space. Virtual space brings with it a 'sublime' rhetoric about the empowerment of participants within this space (Mosco, 2004). What is invisible in these interactive 'clouds' is the way they are connected to the material accumulation of information and capital and how communication in these spaces is always-already commodified.

Within this context any social or political action we might envisage, any performance by a band with whatever critical or political content, any collective action using social media, any deployment of the cell phone to communicate is undertaken within a space that harnesses this action to accumulate capital. The populist account of mediated social life posits that participants construct radical and resistant political discourses. Regardless of the social structure, participants retain a sense of agency and autonomy. Participation in social life can never be completely commodified or colonized; it can always generate an excess and an impetus for change within the social world. Such an account risks simply celebrating the excess without glancing ahead to see how the 'excesses' participants generate are harnessed by the brandscape as surplus value. Our labor, no matter how political or radical, produces value. Rather than follow the fashionable populist rhetoric that interactive media makes us empowered, makes structures more open, increases our agency, we should instead consider how capital is a totalizing political, economic and social system. We should turn our gaze on capital and consider what the

material effects of this totalizing logic are on our society and our identities.

One concrete way of illustrating this abstract philosophical argument is that there remains the uncomfortable reality that the mediated youth experience I've documented throughout this book is dependent on a profound and disturbing exploitation of young people in the developing world. Young people make the cell phones, digital cameras and IT hardware that underpins the empowerment of the mediated youth of web 2.0 (Andrejevic, 2007b, p. 15). There are different kinds of participation and production, from physically building the hardware in sweatshops to making the content in the mediated social spaces of the first world. In her examination of the branded self and 'global value subjects' Hearn (2008, p. 208) argues:

> The extent to which, as individuals and groups, we are able to exert meaningful control over the methods and means for the extraction of surplus value varies greatly across class and social position.

There is a profound and material limit to any celebration of digital media that systematically ignores how it is a product of the global political economy.

One of the most enduring contributions Naomi Klein (2000) made to a criticism of branding and youth culture was the way she captured the criticism of corporations like Nike in the 1990s. She articulated the moral gap that people saw between the philosophy of the brand (the 'Just Do It' of personal empowerment) and the material reality of its production. This critique though seems to have run out of steam in the past 10 years, as celebrations of new media and participation have taken over, and as brands have become savvy to the political demands being made of them. Sneakers are now sweat-free; coffee is fair trade, and flights are carbon neutral (we are assured). These reforms obfuscate the uneven distribution of labor that is still the material base of the sensitive new-age brandscapes and interactive media spaces. The physical technologies and commodities of the brandscape I have examined are the product of human labor, and often that human labor is young. I have examined the labor that predominantly first world young people expend as part of growing up in a commodified social world.

There is also a story of mediated youth that I, like nearly all media researchers and scholars, am ill-equipped to tell, but I think must form part of any comprehensive account of mediated social life: the experience of being young and producing media hardware in factories

on the fringes of the global economy. Naomi Klein isn't the only commentator, theorist or critic to make this argument, of course. I single her out because her book *No Logo* signaled a particular moment in public concern about branding. Critical theories of the global information economy in the past decade have also attempted to some degree to document the labor conditions of the production of technology (for instance, David Harvey (2000), Goldman and Papson (1999) and Kline, Dyer-Witheford and De Peuter (2003)). In each of these accounts an attempt is made to place interactive media within its global systemic context.

This concrete political economic base brings us back to the issue of the 'non-dupes who err' (Zizek, 1999). This is the problem with cynical distance, in divorcing itself from the material context of production (that is, the political economy) it misses how its savviness and reflexiveness, its 'knowing,' is only skin deep and is bounded within a brandscape that effortlessly accumulates value off the refusal to *really* know. The critique Klein made of 1990s branding is just as acute a decade later. In some ways, it is even more critical to an understanding of contemporary social life because corporations listened to what Klein and other critics of branding had to say (the culture jammers, the people who took to the streets in the battle of Seattle, the anti-sweatshop movement) and reflexively incorporated these ideals into their brand values.

'You want brands that care?' They said, 'Sure thing we can give you whatever you want! (Because we think what you really want is to be 'relieved of the duty to think').' Corporations and their marketers understood that the idealistic youngsters of the west didn't really want to overthrow the system just because they couldn't enjoy Nike's brand values anymore (because they found out they were untrue), they just wanted the system to suture over the antagonism so they could continue enjoying. And that, I would argue, is exactly what the brandscape delivers.

The interactive era of mediated youth represents a deeper penetration of production into social life that the rhetoric of interactivity sutures over. Andrejevic (2007b, p. 115) argues that:

> The all too familiar critique of the industrial-era mass media as being top-down and non-participatory has lead to an uncritical embrace of participation in all its forms. Just as we remain critical of attempts to equate democracy with the market, we should interrogate the assimilation of participation in the commercial sphere with political power-sharing.... The model of digital enclosure highlights the socially con-

structed character of networked interactivity—we have choices, as a socie-
ty, about how to build and manage interactive technologies. In making
such choices, we must consider that costs of convenience and the unfree-
dom of 'free exchange' in order to start thinking outside the privatized
digital enclosure.

Interactive mediated social life is the product of the nexus between
elites, means of communication and their dominant messages (Louw,
2001). Marketers and other meaning makers in the interactive era
need to construct mythologies of participation and empowerment that
legitimize their construction of social life. These narratives reflexively
account for us as cynical, savvy, non-dupes.

The future of mediated youth

In the *Journal of Communication's* seminal issue 'Ferment in the
Field' (1983), Dallas Smythe and Tran Van Dinh articulated the in-
tractable links between the ideological orientation of researchers, the
problems chosen and the research methods used. They argued that
society is shaped by power struggles between elite groups who have
power and other groups who want power. Within this context, strateg-
ic and administrative researchers seek to defend and strengthen so-
cial, political and cultural institutions, while critical researchers set
out to critique and change the social world. Critical researchers posi-
tion their analysis within a systemic and historical context. In the
neo-liberal context of the past generation, administrative researchers
have assumed that the market is a 'universal solvent for institutional
problems' (Smythe and Dinh 1983), whereas critical communications
researchers have been at their best where they have sought to analyze
'communications within their systemic context.' Mosco (1983, p. 247)
follows their critique:

> Critical communications research connects communications to the wider
> social order. Specifically, it situates communications within a class sys-
> tem marked by domination, contradiction and social struggle. ...the re-
> surgence of interest and research from a critical perspective does in fact
> reflect the social struggle over who will control the information society.

This argument is worth recalling here, a generation later, because
their work implores critical communications researchers to engage
with administrative and professional communications discourses and
practices, such as marketing, to understand how these discourses are
used to operate a liberal democratic capitalist society.

Studying branding as emblematic of the communicative logic of capital leads to an understanding of how marketing responds to and repairs crises in capital by reinventing and reinvigorating its discourses. Marketing's strategic translation of critique into brand value demonstrates the powerful adaptive processes of capital. Criticisms of brands are a kind of creative resource, in the sense of creative destruction and reinvention, for brands and marketers. The paradox of the brandscape is that it continually claims to defend authentic culture as it simultaneously exploits that culture to accumulate capital.

Marketing reflects the problem-oriented and strategic focus of strategic research in liberal democratic capitalist society (Bramson, 1971; Smythe and Dinh, 1983). Conceptions of social problems in both corporations and universities are shaped by their social and political context. Marketing's notion of critique, like other technical and strategic social research, is enclosed within its strategic frame (Arvidsson, 2008; Bramson, 1971; Smythe and Dinh, 1983). Further, its reading of radical and critical theory (like the culture industry and other critiques of capital) doesn't read those theories as a critique of capital but as explanatory tools that can be functionalized to make marketing more efficient. Marketers, as culture and meaning makers, make both the meanings of individual brands and the social and political framework in which marketing is made a legitimate knowledge-making and social activity (Deuze, 2007).

Critical marketers critique the passivity of mass culture. They mythologize 'old' mass society as an oppressive and disempowering structure that needs to be replaced with empowering and interactive popular culture. This focus on 'bad' mass culture neatly shifts the focus away from examining the structure of social relations of production. To marketers, old mass culture is seen as an oppressive social structure and, consequently, as *the* problem rather than a symptom of capitalist relations of production. This critique is apolitical and ahistorical. Marketers, like other mass communications and social researchers, risk not seeing how their research questions and methodologies shape their conception of the social world (Bramson, 1971; Smythe and Dinh, 1983). Ideology is productive. It enables strategic researchers to achieve material ends. But it is also restrictive, critical marketing will always thwart the critical ideas it attempts to take up by simply bringing those ideas within the philosophical and methodological framework of marketing.

The research projects of marketers and cultural researchers will continue to unfold in significant and diverging paths. Marketers, with

their strategic orientation to mediated youth, will take up at least two significant research trajectories. These will play out in both universities and in corporations. One is return on investment and strategies of surveillance in the brandscape. The other is the intensification of links between corporate social initiatives and brand-building. The purpose of these two research endeavors will be the strategic empowerment of capital accumulation.

One research trajectory cultural researchers will continue to follow is the search for active audiences and savvy cynics to celebrate. And they will find them. Mediated social worlds do empower a middle class of consumers and media makers whose cultural capital enables them to inhabit a privileged position in the mediated world. Another research trajectory cultural researchers will follow is the critical deconstruction of commodified social worlds. These projects will be informed by, to greater and lesser degrees, a political project that aims at the perceived inequities and injustices of capitalism. The debate here will continue to circle around the best understandings of the commodified social world, what philosophy can provide and what politics can emerge.

Each of these research trajectories is embedded within a particular political and economic context of knowledge production. Over the past generation there has been a developing nexus between corporate concerns and social research. The emergence of the 'creative industries' has merged together the concerns of corporations, policy makers and universities. The marketization of research in universities has led to a pressure to commercialize research in all fields. The best funded research projects on mediated youth are often those that attract investment from corporate partners or convince funding agencies that their outcomes will be commercially viable. The political economic context of research will have a determining effect on the knowledge we produce about mediated youth.

If brands are built in a thoroughly capitalist context, then increasingly our knowledge about brands and the mediated social world is also built within this market-driven context. Commercialization of research at universities will, in the long term, fundamentally undermine knowledge production processes and create the kind of crises that capital creates in every other social and environmental system it encounters. Research geared toward the short-term commercialization agenda of corporations thwarts the creativity of pure research because it proceduralizes research around discreet outcomes. Commercialization undermines pure research in ways that are ultimately unproduc-

tive and inefficient for society (Baert and Shipman, 2005). This is not to say that commercialization doesn't necessarily have a place; it is to query commercialization as an over-arching logic for knowledge production.

In this context, a critical approach to studies of mediated youth seems more relevant than ever before. It does though face significant challenges. Whatever the critical project produces it finds its ideas feeding innovation in administrative media and marketing research projects. In this regard, critical research has an ambiguous relationship with the wider process of knowledge production at universities and in society. It is an open and creative mode of research; it does produce unintended results and findings, and regardless of its initial political motivations, these results can be useful to other fields of thought. Critical understanding of culture and meaning-making have been very useful to marketers in conceptualizing experiential brand-building. Critical theory called for emancipation, marketing has adopted the rhetoric of emancipation. One reaction to this poaching of its ideas is to retreat into a hermetic, dislocated and reflexive deconstruction. It abandons its early impulse to emancipation and locates itself in space that cannot be easily accessed or co-opted. In doing so it gets caught up in a philosophical and political futility. Critical research projects need to find ways to engage actively with citizens, young people, and meaning makers. There is a pressing need for thoughtful critical analyses of mediated youth experience that inform a wider field of political debate. In the current climate critical research can at best work to keep social and cultural fields of practice lively and contingent.

The young people I interviewed often wanted to understand how the brandscapes they were embedded in made money; they often referred to the 'mass levels of finance' needed to run music festivals; they could articulate how demographic, cultural and behavioral data were collected and what they were used for; they knew that their Facebook pages were a valuable source of data for corporations. To an extent they recognize the commodified nature of their social world even if they aren't well equipped to understand its consequences and the way that social world is the product of a particular organization of resources and human endeavor. Within this context, research that sets out to determine young people's literacy of the mediated social world needs to take this into account in the way it relates to young people. One of the salient features of mediated youth culture is that no matter what parents, schools or governments might do, young

people are still bound up in a thoroughly commodified social world. Young people need some productive frameworks for making sense of, negotiating with, and taking on a social world and its vision for what their politics should be.

In our current epoch, all research projects ultimately construct themselves in relation to living in and thinking about a capitalist social world. Research with and about young people living in a mediated social world needs to grapple with the social and political contexts that it critiques and contributes to. With respect to young people, branding and popular music, several key research trajectories emerge.

A continued engagement with experiential brandscapes offers insight into the discourses corporations construct, the cultural practices of young people in making media and meaning, the labor of marketers, musicians and young people, and the symbiotic relationship of popular culture, corporate brands and notions of ethics and social responsibility. This engagement with the brandscape needs to mobilize political economic, ethnographic and textual approaches. And, it needs to engage with both strategic and critical theoretical perspectives. The reflexivity, savviness, irony and cynicism of contemporary popular culture needs to be studied and theorized. There is a tendency to celebrate cynicism and savviness in contemporary accounts of popular culture. It seems implausible to me that being cynical and ironic amounts to any real political power in today's culture. Instead of power it seems to afford an enjoyment of social life that disavows its antagonisms.

Marketers and corporations will continue to develop more enhanced return on investment measures by increasing the sophistication of data collection and surveillance in brandscapes and other commodified social spaces. Researchers of all perspectives need to continue to critically track these trends and consider them from critical, policy-making, education and strategic perspectives. Information collection and surveillance are key strategic drivers in the construction of the mediated social world. Increasingly, the mediated social world is being shaped around commercially viable digital enclosures. The professional production of brands in advertising, marketing communications and other corporate organizations is a largely secretive affair (Deuze, 2007). We can infer what professional communicators do, but we need a far more developed account of what happens in these contexts of production and the interrelationships between marketers and other cultural producers. Brands and popular culture are constructed through the interrelated labor and production processes

of marketers, culture industry workers, musicians and young people. Our account of the human labor that goes into brands and how surplus value is extracted from this labor process needs a more holistic conception of the multiple sites of production and how they interrelate.

Critical research needs to engage more robustly with the social world that it finds itself within. It can't ignore strategic researchers in universities, research institutes and corporations. It needs to engage with them and understand the social world that they set out to construct. Critical disengagement and deconstruction seem unproductive. Each of these research trajectories is best served by a research approach that brings together multiple research approaches like audience and ethnographic study, political economy and textual analysis. The mediated social world of young people is a prism through which we can grapple with many of the complex cultural, political and social questions of our time.

Branding

Marketers are engaging in cultural space in more intense and systematic ways as they build valuable brands. Culture makers (like musicians and young people) are finding themselves living and working within branded social spaces and being courted as brand builders by marketers. Marketers are co-opting cultural, critical and media studies approaches and concepts to make sense of their new brand-building practices. And, some cultural theorists are retooling their discipline as a source of knowledge creation for brand builders. Instead of critiquing power relationships and imagining alternative social arrangements, they contribute to the development of the creative and cultural industries as more efficient and valuable sites of capital accumulation.

Marketing's new story of populist political empowerment is underwritten by a fundamental paradox. On one hand brands demarcate popular culture as a site of participatory political empowerment for citizens, consumers and culture makers. On the other hand, new modes of brand-building rely on the exploitation of cultural space and culture makers as a new source of capital value. Marketers and cultural theorists who celebrate the coming together of the market, economic growth and cultural production as a new source of knowledge and value creation routinely ignore the role of global capital and its attached politics in our social world. From the moment the cultural

and creative industries were identified by corporations and government policy makers as a source of economic growth and capital value, a new politics emerged centered around identity and culture.

The populist politics of global brands offers a limited vision of society and social problems. In the first instance, it sutures over the role that global capital plays in creating the social and political problems that its brands claim to solve. The nexus between marketing and culture is becoming ever more intense. As marketers and brands tell us that they are becoming more like an implied ideal culture (that is, inclusive, empowering, liberating and enjoyable), the opposite is really true. Culture is becoming more of a valuable resource of the accumulation of capital. Culture conforms more and more to the logic of branding and marketing. The empowering politics brands speak for are really sources of capital value for brands. Furthermore, the resistance, irony and cynicism directed at these political claims also become sources of capital value. Brands increasingly stand in for politics, even though they are radically limiting as political agents and leaders.

The young people of this mediated social world live at the interface between being empowered, interactive meaning makers and being subjects of social spaces designed to accumulate capital. At the same time they create mobile and creative identities online and network with each other in vibrant and lively interactions, they are subject to intensive surveillance, and they construct detailed digital shadows of their own identities and their social world. Researchers, critics and young people concerned with the practices and politics of mediated youth must aim to consider this social world holistically. We must confront the real contradictions which make the experience of mediated youth emblematic of the political and social impasses, paradoxes and antagonisms of the global capitalist world.

Notes

Preface

1 From *The Sydney Morning Herald* accessible at: http://www.smh.com.au /news/Music/Show-of-strength/2005/ 01/21/1106110925660.html

Chapter 1: 'Money and TV Destroyed This Thing!'

1 My ethnographic exploration of branding in Australia since 2003 has recorded over 50 prominent global brands using popular music as a source of brand content. Of these brands, market-leading corporations like Coca-Cola, Nokia, Motorola, and Virgin have created sophisticated experiential programs. These market leading corporations are complemented by partner brands in fashion, alcohol, tobacco, entertainment and other youth-oriented brand categories.

2 Cincotta, K. (2007) 'Make a big noise with Gen Y,' *BandT*, http://bandt.com.au, November 2007: p. 35.

3 Rushkoff, D. (2000). *The Merchants of Cool*, PBS Frontline.

Chapter 2: Music...as It Should Be

1 Many global corporations construct an ideology of authentic popular music in their advertisements. They make claims about what authentic popular music is and how their brand supports those values. Here I've listed some other examples of these practices by brands other than Virgin and Coca-Cola to demonstrate how the discourse of authenticity isn't peculiar to these two brands. Jack Daniel's explicitly supports authentic popular music by claiming that 'Jack Daniel's supports Australian music.' Coopers Dark Ale advertisements feature the words 'Dark Glasses' beside an image of two glass beer bottles full of dark beer. The words have a double meaning. They refer to both the dark glasses of beer and to the image of a rock star wearing dark sunglasses. The two bottles of beer are a savvy portrait of a rock star. The alcohol brands profess particular cultural knowledge and values. The ideology of authenticity is also evoked through savvy portraiture. Celebrities featured in advertisements convey a studied sense of disinterest (Holt, 2002). Advertisements for Otis sunglasses and Nixon watches are framed as portraits of artists who just happen to be wearing the featured product. In an Otis advertisement a member of rock band Eskimo Joe sits on his amplifier wearing Otis sunglasses. In a Nixon advertisement pop star Tristan Prettyman is featured holding a microphone and singing while wearing a Nixon watch. The brand logo and copy are merely a frame for the portrait of the artist at work.

The silhouette is also deployed to convey intrinsic and essential notions of musical enjoyment. In Apple's ubiquitous iPod advertisements the silhouette strips musical enjoyment back to its bare coordinates: the relationship be-

tween the listener and the musical device. The silhouette emphasizes the place of the device in authentic musical enjoyment, while blanking out cultural markers like gender, identity, ethnicity, dress and cultural context. The silhouette is strategically geared for multiple markets and cultural contexts. It captures only the coordinates of musical authenticity.

2 Richards, S. (*Thought by Them*). *Right Music Wrongs,* copyright, 2009. Reprinted by permission of Virgin Mobile Australia. All rights reserved.

3 Coca-Cola only grants permission to reprint text from their advertisements under certain terms and conditions which I was unable to meet. You can view one of the advertisements online here (as part of the director's professional portfolio): http://davidgaddie.com/Coca_Cola_%22Music_as_it_Should_Be%22 .html. This is one of the advertisements from a series that included that summer music festival advertisement also discussed in the text.

4 For instance on YouTube at http://au.youtube.com/watch?v=jghsFXZWs2U; http://au.youtube.com/watch?v=QMKGjSZI2Zw; and Flickr at http://www. flickr.com/photos/shespeaksoceans/2917677292/; and blogs like Skywritings at http://sky-writings.blogspot.com/2008/11/fleet-fox.html and From *This is Fake DIY* accessible at: http://www.thisisfakediy.com/articles/live/fleet-foxes-grand-ballroom-manhattan-centre and *I Made a Blog* accessible at: http://made-a-blog-i-made-a-blog.blogspot.com/2008/10/fleet-foxes-grand-ballr oom-100408.html; and music news site Faster Louder at http://www.faster louder.com.au/reviews/events/16473/Fleet_Foxes_Luluc__The_Tivoli_Brisban e_04012009

5 I attended the V festival with a group of friends in 2007, 2008 and 2009. I observed all aspects of the site and took fieldnotes and photographs. Following the V festival in 2008 I had a semi-structured email communication with 15 people who had attended the V festival.

6 Goldman and Papson (1999, p. 30) illustrate the way popular music and art with particular political content are depoliticized in advertisements.

7 Debates about the V festival in the blogosphere demonstrated further dimensions of the apolitical nature of the festival. For instance, conversations about the V festival on music site Drowned in Sound (http://www.drownedinsound .com /articles/964874) captured two fan narratives about corporate branded rock festivals. First, there was the 'corporate rock sucks' narrative, '(This is a festival) with all the best quality organic bands stripped of their soul, neatly packaged into small bite-sized bandette's, with nothing too scary or any surprises, overpriced beer, ...WOO HOO we're partying now, government approved rock and roll!!! Rant over.' In this narrative, corporations destroy the authentic culture they set out to capture and commodify. Then there is the fan narrative that takes authentic music to be incorruptible. To these fans, corporations merely support and facilitate authentic music, 'But this year's line up is tops. Radiohead for crying out loud! When was the last time they played a non-Glasto festival in this country!?' One position dismisses the V festival and the other embraces it. The argument is about whether the bands have been stripped of their soul or not. No one is disputing that authentic bands *do* have a soul. The argument is about whether that soul can exist

within a corporate rock festival or not. The two opposing sides have a fundamental similarity. Both of their ways of judging popular music are grounded in an ideology of taste. Frith (2007) argues that judgments of taste are spurious, a way of 'concealing from myself and other consumers the ways in which our tastes are manipulated' (Frith, 2007). We fashion an aesthetic framework, and draw on acquired cultural capital, to make distinctions about music regardless of its conditions of production. Popular music is popular not because it reflects some intrinsic, essential, aesthetic value but because it cultivates the audience's understanding of what popular music is in the first place (Frith, 2007).

8 Field interviews were conducted at the Coke Live event. Interviews were semi-structured and ranged in length from a few quick comments (a couple of seconds) to longer interviews of several minutes. Some of the interviews were conducted with groups of participants.

9 Rowley and Williams (2008) in their study of audience perceptions of branded music festivals in the United Kingdom (including Virgin's V festival and oth er festivals sponsored by cell phone and alcohol corporations) noted similar trends. Corporate involvement in music festivals increased brand recall, awareness and positive attitudes to the brand, though increase in purchasing was less clear. Furthermore, their sample of UK music fans registered some similar perceptions to the Australian music fans. They thought that brand sponsorship kept ticket prices down but were critical of brands when they interrupted their festival experience or restricted their access to other brands (e.g., when there was only one kind of beer sold because of sponsorship deals). They were also critical where they thought branding was being unethical, for example, by branding alcohol within an all-ages festival. Cummings (2008) also finds that festival goers have both positive and negative reactions to festival sponsorship. They are positive about increased exposure of music through the media; they think that sponsorship subsidizes ticket costs (though there is no material evidence that it does), and they think that advertising can largely be ignored because it doesn't interfere with their enjoyment of the music. Music fans are often ambivalent and naïve about sponsorship. Brands capitalize on this ambivalence about their presence by supporting socially responsible causes like environmental, health and cultural programs. These narratives of social responsibility give festival goers a ready-made rationale for supporting the brand's presence at the festival.

10 Quilting point or point de caption, a Lacanian term which I borrow here from Zizek, is a point where signified and signifier are knotted together providing the illusion of fixed meaning. The live music performance is a quilting point in the sense that it embodies the fixed and immoveable notions of authenticity.

Chapter 3: 'I Pushed My Way to the Front With Every Band I saw'

1 The Coke Live website is similar to several others corporate websites in the past few years. For instance, pop bands recorded moblogs on Nokia cell phones for the Nokia Music Goes Mobile website; Toyota used interactive DJ software to have people record mixes online; Jagermeister launched an online community for indie musicians; Jack Daniel's ran live music awards; HP established a citizen-reporter blog linked to the Big Day Out music festival.

2 The interviews were conducted while participants used the Coke Live site. The interviews were semi-structured and went for approximately 1 hour. The interview participants were 17 or 18 years of age, 3 female and 2 male.

3 Reference to research young people and media literacy online.

4 Over a three-month period I collected over 250 posts on the MySpace pages of bands playing the Coke Live tour. Of these 250 posts, over 180 related to Coke Live. Over 180 posts from band MySpace pages were used. MySpace (http://myspace.com) is a social networking site. Examples of bands' MySpace sites examined in this analysis include The Veronicas at myspace.com/theveronicas, Evermore at myspace.com/evermore and After The Fall at myspace.com/afterthefallaustralia. No individual MySpaces were analyzed; only posts to the public pages of the bands and brands were analyzed.

Chapter 4: 'We Are Not Here to Endorse Products...'

1 Worship the Glitch accessible at http://worshiptheglitch.com/2006/08/mike-patton-tells-it-like-it-is.html

2 A 360 deal (also known as a multiple rights deal) is a deal between musicians and record companies that extends the recording companies' rights beyond just the musical recording. The record company also takes an interest in any earnings the band makes from touring, merchandise, branding deals and other applications of their music, performances, images or personality. In the most comprehensive 360 degree deals, the recording company owns an interest in nearly any source of revenue the artist generates. Record companies feel that if they invest in making the band a valuable commodity, then they should have access to all the revenue the band generates beyond the recording. Live Nation has led the industry in 360 deals, signing Madonna, Jay Z and U2. Live Nation was not a record company, but held interests in live music venues; they are signing artists so that they can get access to the revenue they generate beyond their live performance, major record companies have now embraced this kind of deal. Labels sell the deal to artists with the assertion that a 360 deal represents a comprehensive investment in the artist to generate revenue from multiple sources rather than just an investment in their recordings.

3 Clinton Walker speaking at the Pig City Symposium, University of Queensland, 13 July 2007.

⁴ The interviews in this chapter are based on nine substantial interviews with bands involved in experiential branding programs. These included programs run by Jagermeister, Coca-Cola, Virgin and Tooheys. I have kept the identity of these participants and their bands anonymous, owing to the small nature of the local scene. These interviews were complemented by many informal conversations with musicians who play in bands around my home town, and people involved in the local music scene.

Chapter 5: 'Enjoy Responsibly!'

¹ My approach to youth culture is defined by some of the following scholars and concepts. The emergence of interpretive and critical approaches to youth culture post-World War II led to a conceptualization of youth that was ambiguous and referenced to social practices and spaces rather than 'age' (Butcher and Thomas, 2003; Campbell, 2004; Frith, 1992). Academic approaches to youth culture are often preoccupied with identifying young people with (or organizing them into) 'subcultural' groups, and criticisms of the subcultural approach have reorganised them into 'scenes' and 'tribes' (Hesmondhalgh (2005) offers an account of these formations). Young people are often seen as 'isolated' and 'othered' from the public spaces and political and economic processes that impact on their lives (Campbell, 2004; Gelder and Thornton, 1997; Hebdige, 1979; Kearney, 1997; Polhemus, 1997; Solomon, 2003; Willis, 1977). This conceptualization of young people as othered, isolated or living in subcultural spaces has led to varied interpretations and accounts. Some perspectives celebrate the creativity and agency of young people as meaning makers who creatively engage with social space to create their own resistant identities. Other perspectives are concerned with public policy to engage young people more effectively in economic and political processes. Young people are problematic for public policy, public spaces and increasingly for contested private-public spaces like shopping centres and malls (Butcher & Thomas, 2003; Fine and Weis, 1998; Goodman and Saltman, 2002; Kasesniemi, 2003; Kenway and Bullen, 2001; Lankshear and Knobel, 2003; McLeod & Malone, 2000; Morris, 2004; White, 1993, 1999). Young people are not just problematic for policy makers, they are also a source of value for corporations, they are 'preyed upon' and their social world is commodified (Doherty, 2002; Klein, 2000; Saltman, 2000; Saltman and Gabbard, 2003). Developing since the mid-twentieth century youth culture has been characterized by the ongoing process of 'mediation.' Young people increasingly live their lives in mediated social space (Haenfler, 2006; Klein, 2000; Lalander, 2003; Polhemus, 1997; Stern, 2007; Sternberg, 2006; Williams, 2006).

² The Big Day Out is similar to a festival like Lollapalooza in the US. Lollapalooza, like the Big Day Out, also commodifies its audience by selling media rights to the festival space and developing experiential co-branding programs with corporate partners. Both festivals are keen to assert that their audience offers a unique value proposition for corporate partners. The 2008 Lollapalooza recap (a record of the festival for sponsors and advertisers) articulates the

heritage and history of the festival, its musical credentials, and the environmental and social initiatives it supports. Most significantly though, the recap details the size and shape of its audience. The festival describes their audience as a 'quarter-million fans that don't blend into the crowd' (offering a unique value proposition for brands) and lists their gender, education, age, income and residence. In addition to detailing the value of their audience commodity, they demonstrate the media content the festival generates: '2.3 billion media impressions were purchased, traded for, or earned across sprint, broadcast, online and out-of-home.' This included their co-branding activities with corporate partners. Lollapalooza demonstrates how the festival both constructs a valuable audience and has the capacity to communicate with that audience beyond the festival through multiple media channels and social spaces including the sought-after social networking spaces of web 2.0. Music festivals, like traditional media businesses, produce audiences for sale (Smythe, 1981). The advantage they have over the traditional media business is a capacity to integrate multiple media channels and social spaces around the enjoyment of popular music culture. Moving beyond traditional sponsorship of cultural event, experiential branding undertakes a managed interaction between corporations and the festival audience.

3 These claims are frequently made in the press and in press releases from corporations. Cummings (2008, p. 680) notes that media agencies like Peer Group Media 'point out that the festival does not accept sponsorship deals from just anyone…festival goers 'have to see the value from the brand, rather than it just being parasitic to the event.' Media agencies are keen to assert that they make a positive and worthwhile contribution to cultural space, and this is how they create brand value. The narrative has a political dimension. That is, the brand doesn't just poach or co-opt cultural space, but rather, it contributes to a mutual exchange in value.

4 Bradbury, V. (2009) Novice's taste of the big time. *Hills Shire Times*. Accessed at: http://hills-shire-times.whereilive.com.au/news/story/novice-s-taste-of-the-big-time on January 26, 2009.

5 Cummings (2008, p. 682) records a similar experience with a local band at the Big Day Out who played the V Energy Drink Local Produce stage. As part of playing the festival the band were 'required' to attend a signing in a V branded tent where audience members were encouraged to have V merchandise signed by the band. The band didn't want to do it, but it was part of their agreement. So the band wrote things like 'Don't drink this stuff, it'll kill you' on the V branded merchandise that they gave to the young fans. Here, the brand 'overdo' the interaction with the festival space and are caught 'sticking out.' In these situations the brand appears to be gaining awareness and recall but perhaps losing positive attitude and value from its target market. Cummings (2008) claims that these moments are 'not successful' for the brands; I would argue that the interactions going on here are more complex. The brand does look out of place, but it is still a fundamental part of the action, and the band members take the brand on a unscripted and rebellious adventure, which in a contradictory fashion may well add value to the brand. It is too

simplistic to suggest that mere criticism of brands by opinion makers like popular musicians necessarily decreases their value. I encountered another instance of this at the Jack Daniel's JD Set where musician Tim Rogers claimed that Jack Daniel's had ruined his marriage. This stunning and tragic criticism of the product arguably delivered more 'authentic' value to Jack Daniel's. Goldman and Papson (1999) suggest that even advertisements that garner negative reactions can still stir debate and create value for brands.

6 Following the Big Day Out I interviewed via email six participants in HP's Go Live.

Chapter 6: 'I'm Here to Party'

1 Corporate claims to authenticity and particular social values are met with demands from consumers and activists to evidence how they 'live out' these claims. In particular, this has led to a desire to see the 'real backstage' of brand and commodity production. For instance, consumers were not satisfied of the authenticity of Nike's 'Just Do It' philosophy when they discovered the production of Nike commodities rested on the exploitation of labor on the fringes of the global economy (Harvey, 2000). Ultimately, capital accumulation rests on an asymmetric accumulation of value from human labor and the natural environment (Harvey, 2000). Postmodern brand narratives suture over this asymmetry, their value rests on the extent to which they can present narratives that consumers find useful in their meaning- and identity-making practices. Brands attempt to implicate consumers in identity-making projects where they attain political empowerment through branding. While Holt (2002) laments that identity-making work in this intense symbolic economy is too taxing for time-poor consumers, the more fundamental issue it raises, I argue, is the anointing of branding as a communicative logic for social and political life.

2 While in this chapter I focus on narratives of social responsibility at the V festival, these narratives are evident at other music festivals. For instance, at the Big Day Out many brands undertake a savvy 'duty of care' to the audience. The Big Day Out is held in the middle of the Australian summer. It is a very hot day out. Many fans overdo it with the combination of crowds, heat, alcohol and drugs. The brands are there to help out though. Lipton had athletic men wearing large Lipton branded tanks on their backs move through the crowd distributing ice tea to audience members via a large hose. Duracell, a global battery brand, erected large battery-shaped water tanks on site where patrons could fill specially distributed Duracell water bottles for free. The Big Day Out has a duty of care to distribute water to their audience. The Duracell water tank was a way of turning that duty of care into a branded experience. Duracell claimed that the water kept the audience 'powering through the day,' just like Duracell batteries. Around these Duracell spaces promotional models dressed as the Duracell bunny played and joked around with audience members and sprayed them with water guns. The branded characters fit in with the cacophony of costumes people wear to the Big Day

Out each year. Several other brands engaged with the Big Day Out site: V energy drink kept the crowd cool with a mist tent and sponsored a local music stage; Converse sponsored an indie music stage; Tooheys beer had a 'snow-dome'-themed bar; Durex handed out condoms and Le Specs had a resort-themed relaxation area. The brands both piously supported 'authentic' music and poked fun at themselves and the Big Day Out. The Tooheys snowdome poked fun at how hot and sweaty the Big Day Out is. When you are at the Big Day Out you dream of being at the snow. The brand 'gets it.' They display an intimate cultural knowledge and have savvy and ironic fun with audience members. The brand reflexively builds in a critique of itself by, it makes fun of how ridiculous brands, and their claims to helping gout, really are. In each of these instances the brand is embedded in the social action taking place at the festival. Distributing fans, sweatbands, water, cold beer and ice tea in the middle of the Australian summer is a good way to make friends. The brand is at your service. The brand wants to be an integral and valuable part of the experience and appear socially responsible. It acts like a caring and responsible friend on a very hot day. The brands encourage the audience to 'enjoy responsibly!'

3 One Punch Can Kill accessible at http://www.onepunchcankill.com.au/home.html

4 In addition to the implicit branding of cigarettes I examine here, the Federal Health Minister Nicola Roxon, has recently announced her department is investigating the way tobacco corporations use social networking sites to market to young people and avoid national laws ('Roxon orders Facebook tobacco probe,' *ABC Online*, 7 October 2009, accessible at: http://www.abc.net.au /news /stories/2009/10/07/2707492.htm).

5 In Australia and much of the world sponsoring music and other public events is illegal for cigarette companies. In other parts of the world less regulation means that cigarettes can engage in experiential branding just like other corporations. In Indonesia for instance cigarette brand L.A. Lights runs the Indiefest music festival targeted at young Indonesian music fans (Thompson, G. (2009). 80 Million a Day. *Foreign Correspondent*. Australian Broadcasting Corporation. Accessible online at http://abc.net.au/foreign/content/2009/s267 3564.htm).

6 Hornery, A. and Moses, A. (2003). Cig Day Out. *The Sydney Morning Herald*. Accessed at: http://www.smh.com.au/articles/2003/01/28/1043534056370.html

7 What isn't clear in Rojek's (2008) account is whether or not he is critical of the 'social conscience' of brands and the populist politics of brands and CEOs like Richard Branson. He appears to laud Branson's ability to relate to ordinary people and engage actively with social issues. It isn't clear if he is praising this as a form of capital accumulation, or as a form of new and engaging politics, or both. This ambiguity is perplexing.

Chapter 7: Brand Builders

1 I interviewed by phone and email marketing managers at corporations whose branding programs I explored throughout this research. Most corporations wanted questions beforehand and chose to respond via email. Two managers agreed to semi-structured telephone interviews, and two managers at local level agreed to face-to-face interviews. Three other interviews were conducted via email.

2 http://peergroupmedia.com/news/peer-in/andrew-reid-joins-peer-group-and-unveils-research-arm-peerin/

3 Philip Kitchen, keynote 'IMC–New Horizon or False Dawn for a Marketplace in Turmoil?' at the Australia New Zealand Communications Association conference, July 7-9, 2009 at Queensland University of Technology.

4 Similar to the narratives of social responsibility in marketing and branding, Pieczka's (2002, p. 307-308) analysis suggests that social responsibility in public relations is 'bracketed with freedom and growth as attractive aspirations, as opposed to economic imperialism, commercial selfishness and decline.' Social responsibility is positioned as a strategy of capital accumulation in the new flexible economy.

Bibliography

Aaker, D. (1996). *Building Strong Brands*. New York: The Free Press.

Aaker, D. (1991). *Managing Brand Equity: Capitalizing on the Value of a Brand Name*. New York: The Free Press.

Adorno, T. (1991). *The Culture Industry: Selected Essays on Mass Culture*. London: Routledge.

Adorno, T. and Horkheimer, M. (1997). *Dialectic of Enlightenment*. London: Verso.

Althusser, L. (1971). Ideology and Ideological State Apparatuses. In Althusser, L. (Ed.), *Lenin and Philosophy and Other Essays*. New York: Monthly Review Press.

Andrejevic, M. (2004). *Reality TV: The Work of Being Watched*. Lanham: Rowman and Littlefield.

Andrejevic, M. (2007a). *iSpy: Surveillance and Power in the Interactive Era*. Lawrence, Kansas: University Press of Kansas.

Andrejevic, M. (2007b). Ubiquitous Computing and the Digital Enclosure Movement. *Media International Australia*, 125, 106-117.

Ang, I. (1996). *Living Room Wars: Rethinking Media Audiences for a Postmodern World*. London: Routledge.

Appadurai, A. (1990). Disjuncture and Difference in the Global Cultural Economy. *Theory, Culture & Society*, 7(2-3), 295-310.

Arvidsson, A. (2005). Brands: A Critical Perspective. *Journal of Consumer Culture*, 5(2), 235-258.

Arvidsson, A. (2006). *Brands: Meaning and Value in Media Culture,* London: Routledge.

Arvidsson, A. (2007). Creative Class or Administrative Class? On Advertising and the 'underground.' *Ephemera: Theory and Politics in Organisation*, 7(1), 8-23.

Arvidsson, A. (2008a). The Function of Cultural Studies in Marketing: A New Administrative Science? In Tadajewski, M. and Brownlie, D. (Eds.) *Critical Marketing: Issues in Contemporary Marketing* (pp. 329-344). Chichester: John Wiley and Sons.

Arvidsson, A. (2008b). The Ethical Economy of Customer Coproduction. *Journal of Macromarketing*, 28(4), 329-338.

Auge, M. (1995). *Non-places: Introduction to an Anthropology of Supermodernity*. London: Verso.

Auslander, P. (1999). *Liveness: Performance in a Mediatised Culture*. London: Routledge.

Badot, O., Bucci, A. and Cova., B. (2007). Beyond Marketing Panaceas: In Praise of Societing. In Saren, M., Maclaran, P., Goulding, C., Elliot, R., Shankar, A., and Catterall, M. (Eds.) *Critical Marketing: Defining the Field* (p. 83-98). Oxford: Butterworth-Heinemann.

Baert, P. and Shipman, A. (2005). University Under Siege? Trust and Accountability in the Contemporary Academy. *European Societies*, 7(1), 157-185.

Bartels, R. (1976). *The History of Marketing Thought*. Columbus, Ohio: Grid.

Bauman, Z. (2000). *Liquid Modernity*. Cambridge: Polity Press.

Beck, U. (2002). The Terrorist Threat: World Risk Society Revisited. *Theory, Culture and Society*, 19(4), 39-55.

Borden, N. (1964). The Concept of the Marketing Mix. *Journal of Advertising Research*, June (4), 2-7.

Botterill, J. (2007). Cowboys, Outlaws and Artists: The Rhetoric of Authenticity and Contemporary Jeans and Sneaker Advertisements. *Journal of Consumer Culture*, 7(1), 105-125.

Bourdieu, P. (1984). *Distinction: Social Critique of the Judgement of Taste*. Cambridge: Harvard University Press.

Bradshaw, A. and Firat, A.F. (2007). Rethinking Critical Marketing. In Saren, M., Maclaran, P., Goulding, C., Elliot, R., Shankar, A., and Catterall, M. (Eds.) *Critical Marketing: Defining the Field* (p. 30-43). Oxford: Butterworth-Heinemann.

Bradshaw, A., McDonagh, P., and Marshall, P. (2006a). No Space: New Blood and the Production of Brand Culture Colonies. *Journal of Marketing Management*, 22, 579-599.

Bradshaw, A., McDonagh, P. and Marshall, D. (2006b). Response to 'Art versus Commerce as a Macromarketing Themes'. *Journal of Macromarketing*, 26(1), 81-83.

Bramson, L. (1971). *The Political context of Sociology*. Princeton: Princeton University Press.

Branson, R. (2008). Now or Never. *Quarterly Essay,* 32, 97-100.

Brennan, M. (2007). This Place Rocks! The Brisbane Street Press, Local Culture, Identity and Economy. *Continuum: Journal of Media and Cultural Studies*, 21(3), 433-444.

Brown, S., Fisk, R. and Bitner, M. (1994). The Development and Emergence of Services Marketing Thought. *International Journal of Services Industry Management*, 5(1), 21-48.

Butcher, M. and Thomas, M. (Eds.) (2003). *Ingenious: Emerging Youth Cultures in Urban Australia*. Melbourne: Pluto Press.

Campbell, N. (2004). *American Youth Cultures*. Edinburgh: Edinburgh University Press.

Chesher, C. (2007). Becoming the Milky Way: Mobile Phones and Actor Networks at a U2 Concert. *Continuum: Journal of Media and Cultural Studies*, 21(2), 217-225.

Christodoulides, G. (2009). Branding in a Post-internet Era. *Marketing Theory*, 9(1), 141-144.

Connolly, M. and Krueger, A. (2006). Rockonomics: The Economics of Popular Music. In Ginsburgh, V.A. and Throsby, D., A. *Handbook of the Economics of Art and Culture*. Amsterdam: Elsevier.

Conrad, C. and Abbott, J. (2007). Corporate Social Responsibility and Public Policy Making. In May, S., Cheney, G. and Roper, J. *The Debate over Corporate Social Responsibility* (pp. 417-437). Oxford: Oxford University Press.

Cote, M. and Pybus, J. (2007). Learning to Immaterial Labour 2.0: MySpace and Social Networks. *Ephemera: Theory and Politics in Organisation*, 7(1), 88-106.

Couldry, N. (2009). Rethinking the politics of voice. *Continuum: Journal of Media and Cultural Studies,* 23(4), 579-582.

Cummings, J. (2008). Trade Mark Registered: Sponsorship Within the Australian Indie Music Festival Scene. *Continuum,* 22(5), 675-685.

Dean, J. (2006). *Zizek's Politics.* New York: Routledge.

Deuze, M. (2007). *Media Work.* Cambridge: Polity.

Doherty, T. (2002). *Teenagers and Teenpics: The Juvenalisation of American Movies in the 1950s.* Philadelphia: Temple University Press.

Duncan, T. (2003). *IMC: Using Advertising and Promotion to Build Brands.* Boston: McGraw Hill.

Fine, M. and Weis, L. (1998). *The Unknown City: The Lives of Poor and Working-class Young Adults.* Boston: Beacon Press.

Fisk, R., Brown, S. and Bitner, M. (1993). Tracking the Evolution of Services Marketing Literature. *Journal of Retailing,* 69(1), 61-103.

Florida, R. (2002). *The Rise of the Creative Class: and how it's Transforming Work, Leisure, Community and Everyday Life.* New York: Basic Books.

Frank, T. (1997). *The Conquest of Cool.* Chicago: University of Chicago Press.

Frith, S. (2007). *Taking Popular Music Seriously: Selected Essays.* Burlington: Aldershot.

Frith, S. (1992). The Industrialisation of Popular Music. In Lull, J. (Ed.), *Popular Music and Communication* (pp. 47-92). London: Sage.

Firat, A.F. and Dholakia, N. (2006). Theoretical and Philosophical Implications of Postmodern Debates: Some Challenges to Modern Marketing. *Marketing Theory,* 6(2), 123-162.

Firat, A.F. and Dholakia, N. (1998). *Consuming People: From Political Economy to Theatres of Consumption.* London: Routledge.

Firat, A.F. and Venkatesh, A. (1995). Liberatory Postmodernism and the Reenchantment of Consumption. *Journal of Consumer Research,* 22(3), 239-267.

Gandy, O. (1989). The Surveillance Society: Information Technology and Bureaucratic Social Control. *The Journal of Communication,* 39, 61.

Gelder, K. and Thornton, S. (1997). *The Subcultures Reader.* London: Routledge.

Giddens, A. (1990). *The Consequences of Modernity.* Stanford: Stanford University Press.

Giddens, A. (1991). *Modernity and Self-Identity: Self and Society in the Late Modern Age.* Cambridge: Polity Press.

Goggin, G. (2006). *Cell Phone Culture: mobile technology in everyday life.* New York: Routledge.

Goggin, G. and Gregg, M. (2007). Wireless Technologies and Cultures: Towards an Agenda for Research. *Media International Australia,* 125, 41.

Goldman, R. and Papson, S. (1996). *Sign Wars: The Cluttered Landscape of Advertising.* London: The Guilford Press.

Goldman, R. and Papson, S. (1999). *Nike Culture: The Sign of the Swoosh.* London: Sage.

Goldman, R. and Papson, S. (2006). Capital's Brandscapes. *Journal of Consumer Culture,* 6(3), 327-353.

Goodman, R. and Saltman, K. (2002). *Strange Love: Or How We Learn to Stop Worrying and Love the Market.* New York: Rowman and Littlefield Publishers, Inc.

Gordon, R., Hastings, G., McDermott, L., Siquier, P. (2007). The Critical Role of Social Marketing. In Saren, M., Maclaran, P., Goulding, C., Elliot, R., Shankar, A., and Catterall, M. (Eds.) *Critical Marketing: Defining the Field* (p. 159-173). Oxford: Butterworth-Heinemann.

Gracyk, T. (1996). *Rhythm and Noise*. London: Duke University Press.

Gracyk, T. (2001). *I Wanna Be Me*. Philadelphia: Temple University Press.

Gramsci, A. (1971). *Selections from the Prison Notebooks of Antonio Gramsci*. London: Lawrence and Wishart.

Gronroos, C. (2007). *In Search of a New Logic for Marketing: Foundations of Contemporary Theory*. Chichester: John Wiley and Sons.

Gye, L. (2007). Picture This: the Impact of Mobile Camera Phones on Personal Photographic Practices. *Continuum: Journal of Media and Cultural Studies*, 21(2), 279-288.

Haenfler, R. (2006). Rethinking Subcultural Resistance: Core Values of the Straight Edge Movement. *Journal of Contemporary Ethnography*, 33(4), 406-436.

Halbert, M. (1964). The Requirements of Theory in Marketing. In Cox, R. (Ed.), *Theory in Marketing*. Homewood, Illinois: Richard D. Irwin.

Harvey, D. (1989). *The Condition of Postmodernity: An Enquiry into the Origins of Cultural Change*. Oxford: Basil Blackwell.

Harvey, D. (2000). *Spaces of Hope*. Edinburgh: Edinburgh University Press.

Harvey, D. (2001). *Spaces of Capital: Towards a Critical Geography*. Edinburgh: Edinburgh University Press.

Harvey, D. (2003). *The New Imperialism*. Oxford: Oxford University Press.

Hearn, A. (2006). 'John, a 20-Year-Old Boston Native With a Great Sense of Humour': On the Spectacularization of the 'Self' and the Incorporation of Identity in the Age of Reality Television. *International Journal of Media and Cultural Politics*, 2(2), 131-147.

Hearn, A. (2008). Meat, Mask, Burden: Probing the Contours of the Branded 'Self'. *Journal of Consumer Culture*, 8(2), 197-217.

Heath, J. and Potter, A. (2005). *The Rebel Sell: Why the Culture Can't be Jammed*. Chichester: Capstone.

Hebdige, D. (1979). *Subculture: The Meaning of Style*. London: Methuen & Co.

Hesmondhalgh, D. (2002). *The Cultural Industries*. London: Sage Publications.

Hesmondhalgh, D. (2005). Subcultures, Scenes or Tribes? None of the Above. *Journal of Youth Studies*, 8(1), 21-40.

Hindman, M. (2009). *The Myth of Digital Democracy*. Princeton: Princeton University Press.

Holt, D. (2002). Why Do Brands Cause Trouble? A Dialectical Theory of Consumer Culture and Branding. *Journal of Consumer Research*, 29(1), 70-90.

Holt, D. (2004). *How Brands Become Icons*. Boston: Harvard Business School Press.

Holt, D. (2006). Jack Daniel's America: Iconic brands as Ideological Parasites and Proselytizers. *Journal of Consumer Culture*, 6(3), 355-377.

Jameson, F. (1991). *Postmodernism, or, the Cultural Logic of Late Capitalism*. Durham: Duke University Press.

Jameson, F. (1998). *The Cultural Turn: Selected Writings on the Postmodern.* London: Verso.

Jarvis, S. (1998). *Adorno: A Critical Introduction.* Cambridge: Polity Press.

Jhally, S. (1990). *The Codes of Advertising: Fetishism and the Political Economy of Meaning in the Consumer Society.* New York: Routledge.

Kasesniemi, E. L. (2003). *Mobile Messages: Young People and a New Communication Culture.* Tampereen: Tampere University Press.

Kearney, M. (1997). The Missing Links. In Whitely, S. (Ed.), *Sexing the Groove: Popular Music and Gender.* London: Routledge.

Kenway, J. and Bullen, E. (2008). New Times, New Identities: The Global Corporate Curriculum and the Young Cyberflaneur as Global Citizen. In Dolby, N. and Rizvi, F. (Eds.), *Youth Moves: Identities and Education in Global Perspective.* New York: Routledge.

Kenway, J. and Bullen, E. (2001). *Consuming Children: Education–Entertainment–Advertising.* Philadelphia: Open University Press.

Kitchen, P. J. (2003). *The Future of Marketing: Critical 21st Century Perspectives.* New York: Palgrave Macmillan.

Klein, B. (2008). In Perfect Harmony: Popular Music and Cola Advertising. *Popular Music and Society,* 31(1), 1-20.

Klein, N. (2000). *No Logo.* London: Flamingo.

Kline, S., Dyer-Witheford, N. and De Peuter, G. (2003). *Digital Play: The Interaction of Technology, Culture and Marketing.* Montreal: McGill–Queen's University Press.

Klumpenhouwer, H. (2002). Commodity-form, Disavowal, and Practices of Music Theory. In Qureshi, R. (Ed.), *Music and Marx: Ideas, Practice, Politics.* New York: Routledge.

Kotler, P. (1989). *Social Marketing: Strategies for Changing Public Behaviour.* New York: Free Press.

Kotler, P. (2000). *Marketing Management.* New Jersey: Prentice Hall Inc.

Kotler, P. and Lee, N. (2005). *Corporate Social Responsibility: Doing the Most Good for Your Company and Your Cause.* New York: Wiley.

Kozinets, R. (2002). Can Consumers Escape the Market? Emancipatory Illuminations from Burning Man. *Journal of Consumer Research,* 29 June, 20-38.

Lalander, P. (2003). *Hooked on Heroin: Drugs and Drifters in a Globalized World.* London: Berg.

Lankshear, C. and Knobel, M. (2003). *New Literacies: Changing Knowledge and Classroom Learning.* Philadelphia: Open University Press.

Lash, S. (2002). *Critique of Information.* London: Sage.

Lash, S. and Urry, J. (1994). *Economies of Signs and Space.* London: Sage.

Latham, R. (2002). *Consuming Youth: Vampires, Cyborgs, and the Culture of Consumption.* Chicago: University of Chicago Press.

Lazer, W. (1969). Marketing Changing Social Relationships. *Journal of Marketing,* 33(1), 3-9.

Lefebvre, H. (1991). *The Production of Space.* Oxford: Blackwell.

Lenskold, J.D. (2003). *Marketing ROI: The Path to Campaign, Customer, and Corporate Profitability.* New York: McGraw–Hill.

Livingstone, S. (2003). The Changing Nature of Audiences: From the Mass Audience to the Interactive Media User. In Valdivia, A. (Ed.) *Companion to Media Studies* (pp. 337-359). Oxford: Blackwell.

Louw, P.E. (2001). *The Media and Cultural Production*. London: Sage.

Lury, C. (1996). *Consumer Culture*. Cambridge: Polity Press.

Lury, C. (2004). *Brands: The Logos of the Global Economy*. London: Routledge.

Marcuse, H. (1965). Repressive Tolerance. In Wolff, R. P., Barrington, M. and Marcuse, H. (Eds.), *A Critique of Pure Tolerance*. Boston: Beacon Press.

Marion, G. (2006). Marketing Ideology and Criticism: Legitimacy and Legitimisation. *Marketing Theory*, 6(2), 245-262.

Marx, K. (1990). *Capital: Volume One*. London: Penguin.

McCarthy, E. J. (1960). *Basic Marketing: A Managerial Approach*. Homewood: Richard D. Irwin Inc.

McCracken, G. (2005). *Culture and Consumption II: Marketing, Meaning and Brand Management*. Bloomington: Indiana University Press.

McInnes, W. (1964). A Conceptual Approach to Marketing. In Cox, R. and Alderson, W. (Ed.), *Theory in Marketing*. Illinois: Richard D. Irwin.

McLeod, J. and Malone, K. (2000). *Researching Youth*. Hobart: National Clearinghouse for Youth Studies.

McMillan, J.J. (2007). Why Corporate Social Responsibility?: Why Now? How? In May, S., Cheney, G. and Roper, J. *The Debate over Corporate Social Responsibility* (pp. 15-29). Oxford: Oxford University Press.

McQuire, S. (2008). *The Media City: Media, Architecture and Urban Space*. London: Sage.

McRobbie, A. (2002). Clubs to Companies. Notes on the Decline of Political Culture in Speeded up Creative Worlds. *Cultural Studies*, 16(4), 516-532.

Mickelthwaite, J. and Wooldridge, A. (2003). *The Company: A Short History of a Revolutionary Idea*. London: Weidenfeld & Nicolson.

Mittelstaedt, J., Kilbourne, W. and Mittelstaedt, R. (2006). Macromarketing as Agorology: Macromarketing Theory and the Study of the Agora. *Journal of Macromarketing*, 26, 131-142.

Moor, E. (2003). Branded Spaces: The Scope of New Marketing. *Journal of Consumer Culture*. 39(3), 41-60.

Morris, S. (2004). Make New Friends and Kill Them: Online Multiplayer Computer Game Culture. In Goggin, G. (Ed.), *Virtual Nation: The Internet in Australia*. Sydney: UNSW Press.

Mosco, V. (1983). Critical Research and the Role of Labor. *Journal of Communication*, 33 (3), 237-248.

Mosco, V. (2004). *The Digital Sublime: Myth, Power, and Cyberspace*. Cambridge: MIT Press.

Muggleton, D. and Weinzierl R. (2003). *The Post-Subcultures Reader*. Oxford: Berg.

Muller, F., van Zoonen, L. and de Roode, L. (2008). We Can't 'Just Do It' Alone! An Analysis of Nike's (Potential) Contributions to Anti-Racism in Soccer. *Media, Culture and Society*, 30(1), 23-39.

Muniz, A. and O'Guinn, T. (2001). Brand Community. *Journal of Consumer Research*, 27 (March), 412-432.

Nightingale,V. (2003). The Cultural Revolution in Audience Research. In Valdivia, A. (Ed.) *A Companion to Media Studies*. Oxford: Blackwell Publishing.

Pettinger, L. (2004). Brand Culture and Branded Workers: Service Work and Aesthetic Labor in Fashion Retail. *Culture, Markets and Consumption*, 7(2), 165-188.

Pieczka, M. (2002). Public Relations Expertise Deconstructed. *Media, Culture and Society*, 24, 301-323.

Polhemus, T. (1997). In the Supermarket of Style. Redhead, S., Wynne, D. and O'Connor, J. (Eds.) *The Clubcultures Reader*. Oxford: Blackwell Publishers.

Ponsoby-McCabe, S. and Boyle, E. (2006). Understanding Brands as Experiential Spaces: Axiological Implications for Marketing Strategists. *Journal of Strategic Marketing*, 14 (June), 175-189.

Regev, M. (2002). The 'Pop-Rockization' of Popular Music. In Negus, K. and Hesmondhalgh, D. (Eds.), *Studies in Popular Music* (pp. 251-264), London: Arnold.

Ritz, D. (2007). Can Corporate Personhood Be Socially Responsible? In May, S., Cheney, G. and Roper, J. *The Debate over Corporate Social Responsibility* (pp. 190-206). Oxford: Oxford University Press.

Rogers, I. (2008). 'You've Got to Go to Gigs to Get Gigs': Indie Musicians, Eclecticism and the Brisbane Scene. *Continuum: Journal of Media and Cultural Studies*, 22(5), 639-649.

Rojek, C. (2008). *Cultural Studies*. Cambridge: Polity.

Rowley, J. and Williams, C. (2008). The Impact of Brand Sponsorship of Music Festivals. *Market Intelligence and Planning*, 26(7), 781-792.

Rust, R. Lemon, K. and Zeithaml, V. (2004). Return on Marketing: Using Customer Equity to Focus Marketing Strategy. *Journal of Marketing*, 68 (January), 109-127.

Saltman, K. J. (2000). *Collateral Damage: Corporatizing Public Schools–A Threat to Democracy*. New York: Rowman & Littlefield Publishers, Inc.

Saltman, K. J. and Gabbard, D. A. (2003). *Education as Enforcement: The Militarisation and Corporatisation of Schools*. New York: Routledge–Falmer.

Scammel, M. (2000). The Internet and Civic Engagement: The Age of the Citizen-Consumer. *Political Communication*, 17, 351-355.

Schembri, S. (2006). Rationalising Service Logic, or Understanding Services as Experiences? *Marketing Theory*, 6(3), 381-392.

Schiller, D. (1999). *Digital Capitalism: Networking the Global Market System*. Cambridge: MIT Press.

Schroeder, J. (2009). The Cultural Codes of Branding. *Marketing Theory*, 9(1), 123-126.

Schultz, D.E., and Gronstedt, A. (1997). Making Marcom an Investment. *Marketing Management*, 6(3), 40-9.

Scott, L.M. (2007). Critical Research in Marketing: An Armchair Report. In Saren, M., Maclaran, P., Goulding, C., Elliot, R., Shankar, A., and Catterall, M. (Eds.) *Critical Marketing: Defining the Field* (p. 3-17). Oxford: Butterworth-Heinemann.

Seiter, E. (1999). *Television and New Media Audiences*. Oxford: Clarendon Press.

Shaw, E. and Jones, D. (2005). A History of Schools of Marketing Thought. *Marketing Theory*, 5(3), 239-281.

Sherry, J. F. (1998). *Servicescapes: The Concept of Place in Contemporary Markets*. Lincolnwood: NTC Business Books.

Sheth, J., Gardner, D. M. and Garrett, D. E. (1988). *Marketing Theory: Evolution and Evaluation*. New York: Wiley.

Silverman, D. (2004). *Qualitative Research: Theory, Method and Practice*. London: Sage Publications.

Smith, S. (1956). A Realistic Approach to Advertising Instruction. *Journal of Marketing*, 20(3), 281-283.

Smythe, D. (1981). *Dependency Road: Communications, Capitalism, Consciousness and Canada*. Norwood: Ablex Publishers.

Smythe, D. and Dinh, T.V. (1983). On Critical and Administrative Research: A New Critical Analysis. *Journal of Communication,* 33(3), 117-127.

Sobel, R. (1978). *They Satisfy: The Cigarette in American Life*. New York: Anchor Press.

Solomon, M. R. (2003). *Conquering Consumerspace: Strategies for a Branded World*. New York: American Management Association.

Stafford, A. (2004). *Pig City: From The Saints to Savage Garden*. Brisbane: University of Queensland Press.

Stern, S. (2007). *Instant Identity: Adolescent Girls and the World of Instant Messaging*. New York: Peter Lang Publishing.

Sternberg, J. (2006). Youth Media. In Cunningham, S. and Turner, G. (Eds.) *The Media and Communications in Australia*. Crows Nest: Allen and Unwin.

Terranova, T. (2000) Producing Culture for the Digital Economy. *Social Text,* 18(2), 33-58.

Tharp, M. and Scott, L. (1990). The Role of Marketing Processes in Creating Cultural Meaning. *Journal of Macromarketing*, 10(2), 47-60.

Thompson, J.B. (1995). *Media and Modernity*. Oxford: Polity.

Thompson, C. and Arsel, Z. (2004). The Starbucks Brandscape and Consumers' (Anticorporate) Experiences of Globalisation. *Journal of Consumer Research*, 31(3), 631.

Thompson, C. and Coskuner-Balli, G. (2007). Countervailing Market Responses to Corporate Co-optation and the Ideological Recruitment of Consumption Communities. *Journal of Consumer Research,* 34, 135-152.

Toynbee, J. (2002). Mainstreaming, from Hegemonic Centre to Global Networks. In Negus, K. and Hesmondhalgh, D. (Eds.), *Popular Music Studies*. London: Arnold Group.

Vargo, S. and Lusch, R. (2004). Evolving to a New Dominant Logic for Marketing. *Journal of Marketing*, 68(1), 1-17.

Veloustsou, C. (2009). Brands as Relationship Facilitators in Consumer Markets. *Marketing Theory*, 9(1), 127-230.

Venkatesh, A. (1999). Postmodern Perspectives for Macromarketing: An Inquiry into the Global Information and Sign Economy. *Journal of Macromarketing*, 19(2), 153-169.

Venkatesh, A. and Meamber, L. (2006). Arts and Aesthetics: Marketing and Cultural Production. *Marketing Theory*, 6(1), 11-39.

Wasson, C. (1960). What is 'New' about a New Product. *Journal of Marketing*, 25(1), 52-56.

Wasson, C. (1968). How Predictable are Fashion and Other Product Life Cycles? *Journal of Marketing*, 32(3), 70-73.

White, R. (1993). *Youth Subcultures: Theory, History and the Australian Experience*. Hobart: National Clearinghouse for Youth Studies.

White, R. (1999). *Australian Youth Subcultures: On the Margins and in the Mainstream*. Hobart: National Clearinghouse for Youth Studies.

Wilkie, W. and Moore, E. (1999). Marketing's Contributions to Society. *Journal of Marketing*, 63 (Special Issue), 198-218.

Wilkie, W. and Moore, E. (2003). Scholarly Research in Marketing: Exploring the '4 Eras' of Thought Development. *Journal of Public Policy and Marketing*. 22(2), 116-146

Willis, P. (1977). *Learning to Labour: How Working Class Kids Get Working Class Jobs*. Fairborough: Saxon House.

Williams, J. P. (2006). Authentic Identities: Straightedge Subculture, Music and the Internet. *Journal of Contemporary Ethnography*, 35(2), 172-200.

Zizek, S. (1989). *The Sublime Object of Ideology*. London: Verso.

Zizek, S. (1999). *The Ticklish Subject*. London: Verso.

Zizek, S. (2004). *Welcome to the Desert of the Real*. London: Verso.

Zizek, S. (2006). *The Parallax View*. Cambridge: MIT Press.

Zizek, S. (2008). *In Defence of Lost Causes*. London: Verso.

Zwick, D. and Knott J.D. (2009). Manufacturing Customers: The Database as New Means of Production. *Journal of Consumer Culture*, 9(2) 221-246.

Zwick, D., Bonsu, S. and Darmody, A. (2008). Putting Consumers to Work: 'Co-creation' and New Marketing Govern-mentality. *Journal of Consumer Culture*, 8(2), 163-197.

Index

mediated youth

Sharon R. Mazzarella
General Editor

Grounded in cultural studies, books in this series will study the cultures, artifacts, and media of children, tweens, teens, and college-aged youth. Whether studying television, popular music, fashion, sports, toys, the Internet, self-publishing, leisure, clubs, school, cultures/activities, film, dance, language, tie-in merchandising, concerts, subcultures, or other forms of popular culture, books in this series go beyond the dominant paradigm of traditional scholarship on the effects of media/culture on youth. Instead, authors endeavor to understand the complex relationship between youth and popular culture. Relevant studies would include, but are not limited to studies of how youth negotiate their way through the maze of corporately-produced mass culture; how they themselves have become cultural producers; how youth create "safe spaces" for themselves within the broader culture; the political economy of youth culture industries; the representational politics inherent in mediated coverage and portrayals of youth; and so on. Books that provide a forum for the "voices" of the young are particularly encouraged. The source of such voices can range from in-depth interviews and other ethnographic studies to textual analyses of cultural artifacts created by youth.

For further information about the series and submitting manuscripts, please contact:

SHARON R. MAZZARELLA
Communication Studies Department
Clemson University
Clemson, SC 29634

To order other books in this series, please contact our Customer Service Department at:

(800) 770-LANG (within the U.S.)
(212) 647-7706 (outside the U.S.)
(212) 647-7707 FAX

Or browse online by series at WWW.PETERLANG.COM